ANCIENT EGYPT
AND NUBIA

In the Ashmolean M

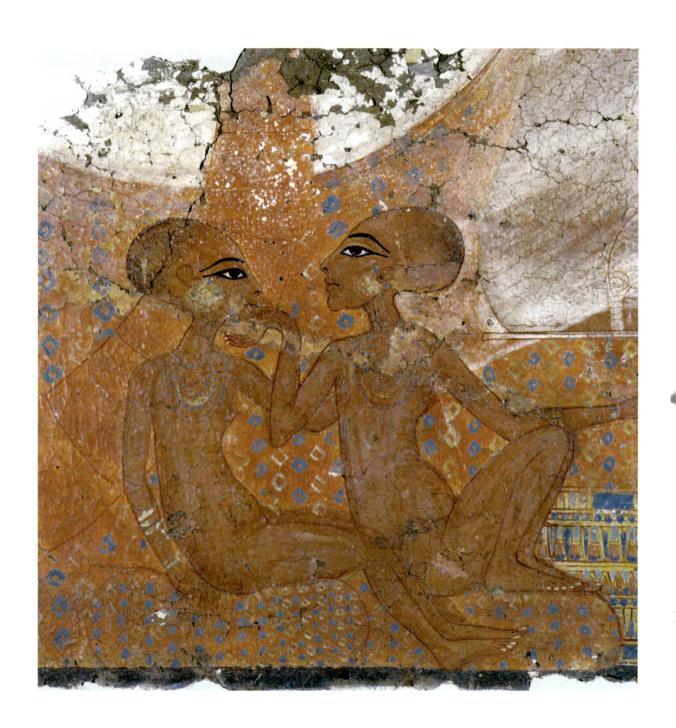

ANCIENT EGYPT AND NUBIA

In the Ashmolean Museum

Helen Whitehouse

Ash̄molean

Ancient Egypt and Nubia

First published in the United Kingdom in 2009 by the Ashmolean Museum,
Publication Department, Beaumont Street, Oxford OX1 2PH
Copyright © Ashmolean Museum, University of Oxford, 2009

Helen Whitehouse has asserted her moral right to be identified as the author of this work.

British Library Cataloguing in Publication Data

A catalogue record for this book is available from the British Library

ISBN 10: 1 85444 202 3 (paperback) ISBN 13: 978 185444 202 4
ISBN 10: 1 85444 201 5 (hardback) ISBN 13: 978 185444 201 7

All rights reserved. No part of this publication may be transmitted in any form or by any means, electronic or mechanical, including photocopy, recording or any storage and retrieval system, without the prior permission in writing of the publisher.

Designed and typeset in Quadraat by Geoff Green Book Design, Cambridge

Printed and bound in Great Britain by Cambridge Univerity Press

For further details of Ashmolean Museum publications please visit:
www.ashmolean.org/shop

New photography by
David Gowers and Nick Pollard

Other photo credits:
Fig. 8: Heinz Schneebeli
Figs. 11, 16–19, 21–22, 24: Griffith Institute archives
p.18: Birmingham Museums and Art Gallery

Drawings: Marion Cox pp.22–23; Pat Jacobs pp.38, 40; Liam McNamara p.72

Frontispiece: The princesses Neferure and Neferneferuaten, two of the younger daughters of Akhenaten and Nefertiti: detail of the fragmentary wallpainting illustrated on p. xv

The Ashmolean

Contents

Acknowledgements	vi
Introduction: Egypt in Oxford	vii
Maps of Egypt and Nubia	xxvii
The Predynastic and Early Dynastic Periods	1
Dynastic Egypt, from the 4th to the 25th Dynasty	47
From the Late Period to the Arab Conquest	101
Ancient Nubia	127
Glossary	145
Further reading	147

Acknowledgements

The impetus for this book was the reinstallation of the Ashmolean's core Egyptian gallery devoted to Dynastic Egypt, reopened in September 2003 as the Sackler Gallery of Egyptian Antiquities. The Dr Mortimer and Theresa Sackler Foundation which supported that work has also contributed to the financing of this volume, in which many Sackler Gallery 'stars' are featured. Its production has been overseen by the Ashmolean's Publication Department, especially the patient Declan McCarthy and Emily Jolliffe; and if, as hoped, readers are seduced by the fascination and beauty of Egyptian artefacts, that will in large part be due to the photographs taken by David Gowers and Nick Pollard, of the Ashmolean's Photographic Studio.

Volunteers Janet Huins and Rachel Sholl kindly undertook the spadework of tracing and checking information in departmental records, and my colleague Arthur MacGregor read the Introduction in the light of his unrivalled knowledge of the Ashmolean's history. Tom Hardwick helped to select the objects, and searched out additional information. For reading and commenting on parts of the text, or supplying information, I am grateful to Helen Hughes Brock, Biri Fay, Elizabeth Frood, Liam McNamara, Richard Parkinson, Susanne Petschel, and Christina Riggs. Thanks are due to Stephen Harris, of the University's Plant Sciences department, for providing wood identifications for objects which it would not be possible to sample, and to James Harrell, of the University of Toledo, Ohio, for advice on the dendrites that feature on some limestone artefacts. Jaromir Malek and his staff in the Griffith Institute kindly provided images and information from its archives.

Beyond this particular help provided by colleagues, I note with pleasure that virtually every object description in this book owes something to the insights provided over the years by those who have worked on the Ashmolean's collections, from visiting academics with international reputations to undergraduates taking their first steps in research. The stimulus and *amicitia* provided by these contacts is undoubtedly one of the best parts of being a curator in the Ashmolean Museum. No-one was more aware of this, or did more to foster (and indeed personify) this beneficial atmosphere, than the late Roger Moorey, staff member of the Department of Antiquities from 1961, and its Keeper from 1983 to 2002. This book was conceived as a successor to his handbook *Ancient Egypt*, and it is dedicated to his memory.

Introduction: Egypt in Oxford

The Ashmolean Museum contains one of the finest collections of Egyptian antiquities in the United Kingdom, largely derived from British excavations in Egypt from the 1880s to the end of the 1960s. An equally important assemblage of Nubian material was added to this by Oxford University expeditions, and others, working in southern Egypt and Sudan from 1910 to the late 1960s. Donations, bequests, and acquisitions have from time to time extended the range of these archaeological collections with objects of special interest, or complete individual collections, some of these connected with Oxford scholars whose work has contributed substantially to the study of Ancient Egypt. Indeed, much of the history of Egyptological research is reflected in the development of the Ashmolean's Egyptian collections, going well back before the point generally taken to mark the emergence of Egyptology as an academic subject – J.-F. Champollion's initial announcement of the decipherment of hieroglyphs in 1822.

This introduction is intended to set the scene for the picture-gallery that follows, by sketching the development of the collections over more than three hundred years, and highlighting some of the figures who have made a special contribution to their formation. The objects illustrated in the following sections are arranged according to the conventional chronology of Ancient Egypt, beginning with prehistory; Nubia has its own section following Egypt. Where they are of particular relevance in the text below, the illustration numbers are given in parentheses.

The Ashmolean Museum was inaugurated in 1683, towards the end of a century that witnessed a growing curiosity about Ancient Egypt amongst scholars all over Europe. The initial impetus for this was the re-emergence during the Renaissance of classical texts containing descriptions of Egypt, its history, antiquities, and religion. The seventeenth century brought its own particular focus to the study of Ancient Egypt: the increasing interest in science fostered a more methodical approach to other studies, setting a high value on direct observation and recording. There continued to be fanciful speculation about the mysterious hieroglyphic script of Egypt, which was most notably visible on the great monumental obelisks imported to imperial Rome by a succession of emperors; but a more rational attempt to decipher the unknown language of Egypt, particularly by relating it to Coptic, its latest native form, became a goal for scholars. An increasing number of Europeans visited Egypt, some of them settling there for lengthy periods as traders, diplomats, and members of religious orders.

The University of Oxford was given its first significant Egyptian artefacts in the very year that the Ashmolean was founded. They took their place in the original museum building on Broad Street (now the Museum of the History of Science), where they were far outnumbered by the botanical specimens, scientific instruments, ethnographic items, and 'curiosities' that made up the Ashmolean's foundation collection. This was substantially the material accumulated by the royal gardeners, John Tradescant father and son, and subsequently acquired by Elias Ashmole. The new Egyptian gifts came from a former student of Merton College with direct knowledge of the country: the Revd Robert Huntington spent 11 years from 1670 at Aleppo, serving as chaplain to the English merchants of the Levant Company. During this time, he made two

lengthy visits to Egypt, in 1678–9 and 1681. He had studied Oriental languages at Oxford and was particularly interested in acquiring Coptic manuscripts (now in the Bodleian Library) and good specimens of hieroglyphic inscriptions (**58**, and see p.54). These were were quite large pieces, and Huntington was unusual for the time in acquiring such items: his merchant contacts perhaps helped with the shipping arrangements.

Most visitors to Egypt contented themselves with smaller, more portable objects such as amulets, statuettes of faience, bronze, or wood, and the ubiquitous funerary figures later known as shabtis; for seventeenth-century collectors, however, all these small images were 'idols'. Early inventories of the Tradescant collection list a group of such pieces – glazed faience amulets which had been acquired in Egypt by George Sandys (1578–1644) and published by him in 1615. These precise pieces are not now identifiable in the Ashmolean collections, but there are others given to the University in the seventeenth century and kept for some time thereafter in the Bodleian Library. Amongst these are a shabti figure, the gift of Archbishop William Laud in 1636 while he was Chancellor of the University, to exemplify the 'ludicrous creations of superstition'; and one of the earliest examples of a pseudo-Egyptian antiquity (Fig. 1), reminiscent of the smallest type of shabti but actually modelled on a wooden funerary statue published in an engraving of 1647.

Two years before the foundation of the Ashmolean, the University had been given a specimen of the one substantial Egyptian antiquity that all seventeenth-century collectors sought to obtain: a mummified human body. In 1681, Aaron Goodyear, a merchant trading in the Turkish markets, donated a collection of Egyptian objects and other souvenirs of his Levantine travels: the star item, 'brought from Alexandria', was 'a complete human Body ... treated with aromatic substances in the manner of the Egyptians, swathed in plaster and bandages ...' Goodyear's mummy apparently did not survive the centuries, but the Ashmolean still has another early mummified entrant to the

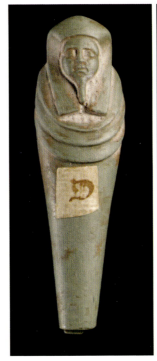

1. 'Bodleian D', a mummiform figure made of green mudstone (ht. 6.5 cm); inscribed on the back with bogus hieroglyphs, it was made some time after 1647

University collections, the body of a child 'preserved in balsam and marked, in the Egyptian manner, with letters and characters', presented in 1766 by Isaac Hughes of London.

In the course of the eighteenth century, European visitors to Egypt began to travel much further afield than their predecessors had done. Tourism in the seventeenth century had been mostly restricted to places in the immediate vicinity of Cairo, including Giza (Fig. 2), and the area to the south, around the village of Saqqara – 'The Field of Mummies', dotted with tombs and cemeteries which were the source of most of the antiquities acquired by foreign visitors. Some of the new explorers had specific scholarly and scientific aims, and by the middle of the eighteenth century, the first substantial and well-illustrated publications had begun to appear – the *Description of the East* (1743–5) by the Revd Richard Pococke, of Corpus Christi College, and the *Travels* (1751) of the Danish sea captain Frederik Norden, illustrated with his own drawings. These heavyweight publications did much

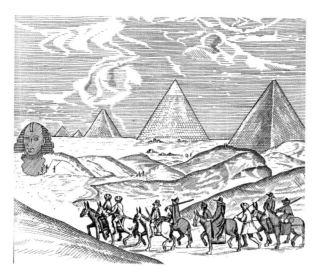

2. Visiting the Great Pyramid and sphinx at Giza: illustration from George Sandys, *The Relation of a Journey begun An. Dom. 1610* (1615)

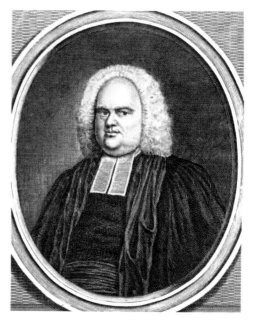

3. Thomas Shaw (1694–1751) became Regius Professor of Greek at Oxford in 1741. His published *Notes* encompassed a wide range of information on the geography, topography, and natural history of the countries he visited, and he also brought back to Oxford botanical collections

to foster the growing interest in Egypt that reached a climax at the end of the century with the French invasion of 1798, which brought in its wake an army of scholars as well as fighting men.

Anticipating the more exhaustive tomes of Pococke and Norden, *Notes or Observations relating to several parts of Barbary and the Levant* (1738, with a Supplement, 1746) was the work of another Oxford man who at the beginning of his career served as chaplain to a merchant company, this time in Algiers. During his twelve-year posting, Thomas Shaw (Fig. 3) travelled extensively through North Africa eastwards as far as Syria, and brought back to Oxford a collection of antiquities which was first displayed in The Queen's College (in 1740 Shaw became Principal of St Edmund Hall, then a dependency of Queen's) before being transferred to the Bodleian Library. Although consisting mostly of the small items typical of earlier travellers' collections, Shaw's Egyptian antiquities include a rarity of Early Dynastic date, the first thing of its kind to reach Europe (**23**).

In the course of the eighteenth century, significant private collections of Egyptian antiquities were formed: Edward Harley, 2nd Earl of Oxford (1689–1741), possessed a number of Egyptian shabtis and other statuettes (described at the time as *Lares*, the Latin

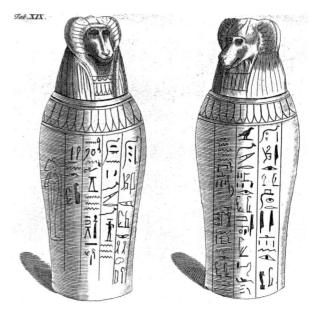

4. The Earl of Oxford's canopic jars, illustrated in Gordon's *Essay towards explaining the Hieroglyphical Figures ...* (1737); with lids in the shape of the baboon Hapy, the jars are inscribed with the usual formulae invoking protection for the mummified organs inside, but do not include the name of their deceased owner. Subsequently given to the Earl's former college, Christ Church, they are currently deposited on loan in the Ashmolean Museum

Introduction

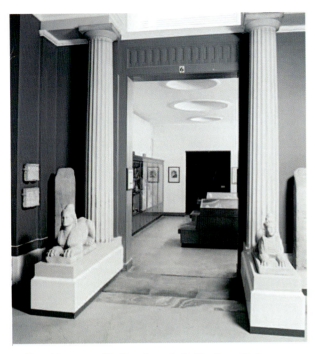

5. The sphinxes, guarding the entrance to the Egyptian galleries

word for small devotional figures of the gods), bronze and stone sculptures, and canopic jars. Two jars from his collection were illustrated in one of the antiquary Alexander Gordon's pioneering publications on inscribed Egyptian antiquities (Fig. 4). An unusual addition to the University's collections in the course of the century was a pair of Egyptianizing sphinxes which arrived in 1755 with the sculpture from Easton Neston, Northamptonshire, given by the Dowager Countess of Pomfret. The smaller of the two is probably a Roman creation, and may have been one of the 'Arundel marbles' which formed the nucleus of the Pomfret Collection, but its corpulent companion was probably sculpted in the eighteenth century so as to complete the pair – sphinxes were fashionable garden ornaments, usually flanking steps or entrances. Garden ornaments they remained until the 1980s, when they were recovered from the University's Botanic Garden to sit as guardians of the entrance to the Ashmolean's Egyptian galleries (Fig. 5), gazing out into the Randolph Gallery where the collection of classical sculpture formed in the early seventeenth century by the 2nd Earl of Arundel is now displayed.

When the invading French forces landed at Alexandria in July 1798, they began a process which was to lead to the decipherment of Egyptian hieroglyphs, a steadily evolving understanding of the ancient Egyptian language, and the creation of Egyptology as a scholarly subject. The key artefact in this process, the Rosetta Stone, was discovered by the French, then appropriated by the British; in 1802, Oxford University was one of the four recipients (along with Cambridge, Edinburgh, and Dublin) of plaster casts of the inscribed surface of the stone. These were made at the behest of the Society of Antiquaries of London, where the stone had been lodged on arrival in England (it was transferred to the British Museum in 1802). The intention was to stimulate British scholars towards achieving that long-sought decipherment of Egyptian promised by the stone's bilingual inscription (Egyptian and Greek, written in three scripts, Egyptian hieroglyphic and demotic, and Greek). The plaster cast now in the Ashmolean is probably that of 1802.

Along with Champollion's triumph in carrying through the definitive decipherment of hieroglyphs, the first half of the 19th century saw the foundation of the great national collections of Egyptian antiquities in London, Paris, Berlin, Leiden, and Turin, and the dispatch of the first scientific expeditions since Napoleon's invasion to record the monuments. At the same time, the independent activities of individuals such as Giovanni Belzoni, Bernardino Drovetti, and Henry Salt, were contributing to the growth of collections and public interest. Although the odd item from these early years of Egyptology in due course came to the Ashmolean, the Oxford collections did not grow in any significant way until travel in Egypt became a more generally accessible experience for *amateurs* and scholars, and the nascent discipline of archaeology began to be practised there. The need to regulate the situation regarding Egypt's ancient sites and monuments was perceived some time before the development of any serious archaeology (Fig. 6); after an unsuccessful attempt at its creation in 1835, an official Antiquities Service was finally founded in

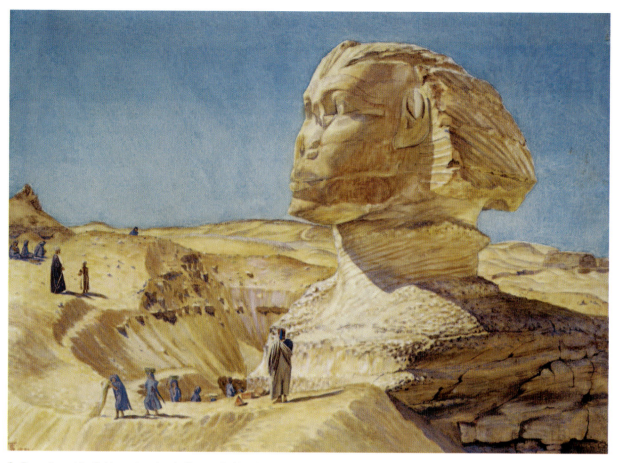

6. *Excavations at the Sphinx*, watercolour by Thomas Seddon. A Pre-Raphaelite painter whose landscapes were admired by Ruskin, Seddon visited Cairo in 1853 and again in 1856, the date of this painting: he fell ill and died there, aged 35, on this second visit. (*WA 1944.30*)

1858, with Auguste Mariette as the first of a succession of French directors; the first museum (at Bulaq) followed in 1863.

The first printed catalogue of the Ashmolean's holdings (1836) lists some 24 Egyptian items, a minority compared with the other components of the collection at that date, which was still true to its origins in a 'cabinet of curiosities', embracing natural history, geology, and ethnographic specimens as well as antiquities. At that time it was still in its original home on Broad Street. In 1845 the present home of the Ashmolean, the splendid neoclassical building on Beaumont Street designed by C.R. Cockerell, was opened as the University Galleries, to house the collections of sculpture together with paintings and drawings. As yet there was no substantial archaeological element in the old Ashmolean, but as that

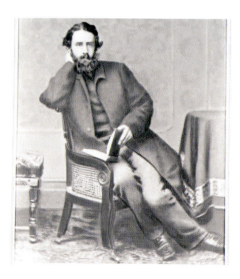

7. Greville John Chester (1830–92) took holy orders after studying at Balliol College, and was a man of wide interests: he founded the Sheffield Naturalists' Society, and published several novels, as well as poetry and sermons

Introduction

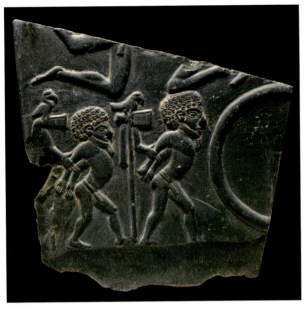

8. Probably the most important Egyptian object given to the museum by Chester is this fragment of the 'Battlefield Palette', which he acquired at Abydos in the winter of 1892 (*1892.1171*, dating to about 3100 BC; ht. 16.5 cm). A larger piece had been purchased for the British Museum in 1888, and another small fragment survives in a private collection. Decorated siltstone palettes of this kind were amongst the prestigious artefacts associated with the ruling elite in Egypt in the period which saw the creation of a unified state: the piecemeal emergence of this broken example began seven years before excavations at Abydos revealed the tombs of the first kings of Egypt

collection started to diminish, with the removal in 1854 of the scientific specimens to the new University Museum of Natural History (South Parks Road), the presence of archaeological material began to increase. For Egypt, the first significant expansion came with the acquisition of pieces from the collection of the anthropologist Henry Christy (1810–65), shortly followed by the entry on to the scene of a figure who was to act as a catalyst in the shaping of a new Ashmolean, from 1865 onwards – the Revd Greville J. Chester.

Chester (Fig. 7) had taken early retirement from parish work, in which his tendency to adopt a vigorous and uncompromising stand on issues such as social inclusion and education seems to have made his life difficult, and weakened his health. Thereafter he spent his winters travelling all over the Middle East and Egypt, studying and collecting antiquities, often acting as a semi-official agent for various museums in this country. He maintained a good network of academic contacts and often served as an intermediary in archaeological affairs, as well as being himself an occasional explorer in the field. Many Egyptian and Near Eastern objects acquired by him (including his collection of seals) had already been donated to the Ashmolean or placed there on loan, when his death in May 1892, on his return to England after the usual winter travels, robbed the museum of its 'constant benefactor', but brought it virtually the whole of his collection, by bequest. The objects amassed by Chester testify to his discerning eye and informed appreciation of what was archaeologically significant (Fig. 8); and he set no chronological limits on his collecting, his Egyptian donations to the Ashmolean running from Predynastic flints to Coptic textiles (**66**).

Chester's interest in the Ashmolean extended beyond enlarging its collections: in 1881 he published a catalogue of the entire Egyptian collection as it then stood (some 1,500 items: the total today is close to 40,000). Many of the objects listed therein were his own gifts, and it is not surprising that he felt strongly about the way that Oxford University was apparently neglecting its archaeological collections, despite the efforts of the then Keeper of the Ashmolean, John

9. Archibald Sayce (1845–1933) became Professor of Assyriology at Oxford in 1891. In addition to his bequest of Egyptian, Near Eastern, and Greek antiquities, and also paintings, to the Ashmolean, he laid the foundations for the museum's Eastern Art Department (opened in 1961) with the gift of an Oriental collection

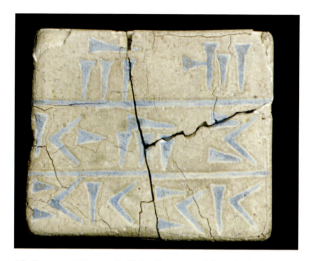

10. There was little opportunity for Sayce to use his particular knowledge of Near Eastern languages in Egypt, but one of his most interesting purchases was this unusual faience tablet (*1933.720*; 3.6 x 4.3 cm), apparently from a group found at Saqqara. It is inscribed on both sides in cuneiform script: the language is Old Persian, and the tablet dates to the 5th century BC, when Egypt was under Persian rule. The text is somewhat enigmatic, but includes the formula 'King of Kings', the standard Persian royal title

Henry Parker (himself excavating in Rome at that time) to promote the cause of archaeology. In a return to the style of his young days as a fiery cleric, Chester published a pamphlet – *Notes on the Present and Future of the Archaeological Collections of the University of Oxford* (May 1881) – in which he pointed out that the way in which those collections were kept, distributed between five institutions with no systematic records, inhibited study and research. Worst of all was the situation in the Ashmolean Museum, the very place where they should all be concentrated, but where '… access to the principal case of Egyptian antiquities is altogether prevented by a large work-table, at which the attendant sits before the fire to do his work of ticketing, and sometimes, alas! of cleaning and *polishing up* the treasures of the Museum' (and, in a footnote: 'This polishing process ought to be forbidden altogether to one unacquainted with Archaeology. It generally means destruction of the object polished').

Two years later, Parker's successor as Keeper was to achieve the revolution that Chester, and others, so hoped to see: Arthur Evans (1851–1941) rationalised the collections, dispatching the ethnographic material to the new museum of anthropology (the Pitt Rivers Museum) but concentrating the University's archaeological and numismatic holdings (the latter till then kept in the Bodleian Library) in what was to become the Ashmolean Museum of Art and Archaeology. To house these greatly expanded collections, Evans built new galleries (completed in 1894) on to the back of the Beaumont Street building. The merger of the existing University Galleries with the archaeological collections under the new name took effect in 1908, the year of Evans's retirement.

In his campaign for the 'New Ashmolean', Evans was supported not only by Chester but also by two other significant donors to the museum – Charles Drury Edmund Fortnum (1846–99), the 'Second Founder' of the Ashmolean, who was to enrich the museum both financially and in the breadth of its collections (**52**); and Archibald H. Sayce, the University's first Professor of Assyriology (Fig. 9). Sayce was a regular winter visitor to Egypt from 1881 on, for the sake of his health. A Fellow of The Queen's College, he fostered the careers of several Egyptologists and was instrumental in ensuring that the subject acquired academic status at Oxford. Amongst the many Northern Europeans who sought relief in the dry warmth of Egypt, Sayce led an unusually privileged, scholarly existence there: he acquired his own *dahabia* – the vessel akin to a houseboat, on which

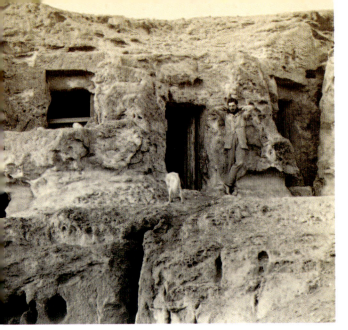

11. The young Petrie outside the rock-tomb that was his accommodation at Giza. During his first stay, in 1880, he had met Greville Chester, then apparently making his thirty-eighth visit to Egypt. *Griffith Institute archives*

visitors could cruise the Nile – but in addition to the usual crew and domestic staff, Sayce's boat, the *Istar*, carried his working library. The books that travelled the Nile with him eventually formed the nucleus of the Peet Memorial Library at Queen's.

Although Egyptology was not his own field of study, Sayce was a competent reader and copyist of both Egyptian and classical inscriptions, and a discerning purchaser of antiquities (Fig. 10, **38** and pp.87, 91). His collection came to the museum by bequest in 1933, but his most distinctive contribution was perhaps his realization of the importance of ostraca, the potsherds and flakes of limestone which were the most readily-available writing surface in Egypt, and have preserved for us the bills, receipts, tax documents, letters, and school exercises of antiquity. Sayce gave his collection of pottery ostraca of the Ptolemaic and Roman periods to the Bodleian Library in 1914, comprising 21 boxes containing some 3,000 ostraca, mostly inscribed in Greek, the language of government and administration in Egypt (as well as the native tongue of a growing proportion of its inhabitants) from Alexander the Great's conquest until the seventh century AD. Together with the other Bodleian ostraca and wooden boards and labels, these came to the Ashmolean in 1946 to join the museum's own collections of documents from Egypt. In recent years, these humble survivors have made a notable contribution to the writing of the social and economic history of Egypt, but at the time of Sayce's donation, they were not regarded with such favour – in 1915, a don wrote to Bodley's Librarian in response to the news of Sayce's gift: 'I hope it is true that the bulk of these ostraka are valuable. What I was told by a person who knows a good deal about such things was that most ostraka are worthless; some are valuable and should be published; all might then be buried.' A more appreciative note was published in the Bodleian's *Quarterly Record*.

Arthur Evans's vigorous initiative in consolidating the archaeological collections of Oxford University could not have been more timely in relation to the development of scientific archaeology in Egypt. With the creation of the Egypt Exploration Fund in 1882, British excavations became an established part of the Egyptian scene, and Evans appreciated the value of helping to fund such work in order to receive a share of the finds for the Ashmolean. With his own expertise in Aegean archaeology, he was particularly interested in the connections between Bronze Age Egypt and the early civilizations of Greece, recognizing the 'unique chronological importance' of excavated groups of material which included Minoan and Mycenaean artefacts that had been imported into Egypt. He was keen that the Ashmolean should have a stake in excavations which were yielding such finds, but was also aware of the importance of the sites connected with the earliest rulers of Egypt that were investigated through the 1890s.

The years of Evans's creation of the 'New Ashmolean' thus also saw the greatest expansion of its Egyptian collections. Much of this material came from the work of William Matthew Flinders Petrie (1853–1942), generally seen as the most influential early practitioner of Egyptian archaeology (Fig. 11). He introduced innovatory practices of recording and analysis, stressing the importance of documenting the material as found, observing the relationship of

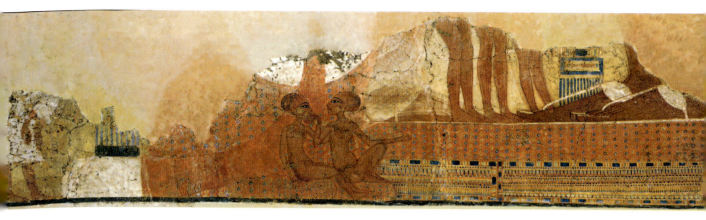

12. The princesses saved by Petrie, from the 'King's House' at el-Amarna; about 1345–1335 BC. The fragmentary painting, 1.65 m wide, is the lowest part of a scene showing Akhenaten and Nefertiti seated with their six daughters, the kind of informal view of the royal family which is typical of Amarna art. *1893.1–41 (267)*

one object to another, and creating corpora of specific categories of object through which typological and chronological changes could be charted. The Ashmolean was to benefit directly from this work, not only in the objects it received, but in his help with arranging and labelling the new Egyptian displays.

After two seasons of surveying at Giza, Petrie began working for the new Egypt Exploration Fund late in 1883, exploring sites in the Delta and excavating at San el-Hagar (Tanis). His relations with the Fund were never easy, however, and he broke with the EEF after his early work in the Nile Delta, though he worked for it again from 1896 to 1905. Thrown back on to his own resources and in acute need of financial support, Petrie in due course set up the Egyptian Research Account (1893) to fund his student assistants, and then the British School of Archaeology in Egypt (1906). Through the 1880s and into the next decade, his major sponsors were the Manchester cotton magnate Jesse Haworth, and the collector Henry Martyn Kennard, via whom the Ashmolean received much material from Petrie's excavations. Kennard, it seems, was no armchair antiquary: he joined Petrie on site at Hawara during the 1888 season (**65**), and his protégé (not always the most tolerant of excavation directors), noted with satisfaction in his journal, 'Mr Kennard is on the wander about nearly all day long, being much stirred by the successive finds.'

Petrie had no formal education but possessed an abundance of practical skills, as well as a penetrating intelligence. The recovery of one of the most famous pieces in the Ashmolean's Egyptian collection is due to his deftness and ability to improvise solutions in the field: in his memoirs, *Seventy Years in Archaeology* (1931), he gave an account of how he had salvaged the fragmentary and friable wallpainting of the daughters of Akhenaten and Nefertiti (Fig. 12) from the mudbrick wall on which it was executed, cutting away the bricks behind it so as to leave just the mud plaster as a supporting layer behind the painted surface. 'I brought up a box lid against the face with newspaper padding on it, grasped the sheet of mud against the lid, and turned it down. On getting it to my hut I brushed the dust off the back, made a grid of wooden bars ... put a layer of mud on each bar and then pressed it down on the back of the mud ... On reversal, there was the fresco unhurt resting on the grid.'

When Petrie obtained the academic post he so deserved it was at University College London: the Chair of Egyptology endowed by the 1892 bequest of Amelia B. Edwards, a moving spirit in the creation of the EEF, but also a steadfast supporter of Petrie. Oxford University was, however, to benefit quite exceptionally from Petrie's discoveries when it agreed in 1894 to give a home to two of the three Predynastic statues revealed by his work at Koptos, in the enclosure of the temple dedicated to the ithyphallic god Min (Fig. 13). In his memoirs, Petrie gleefully recounted how the British Museum refused these

 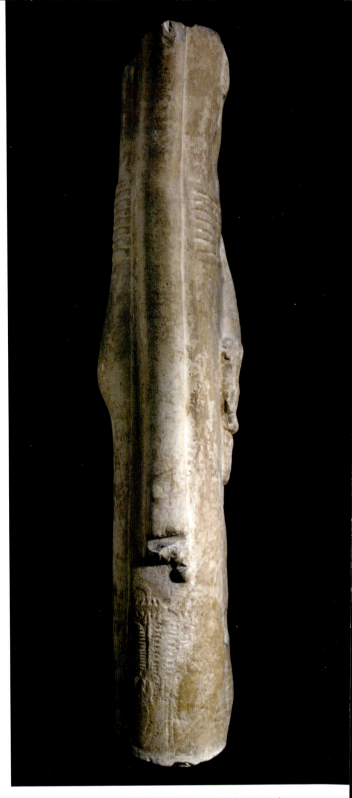

13. The larger of the two limestone Min statues in Oxford (*1894.105e*; end of the Predynastic Period, about 3300 BC; the legs of a third statue are in Cairo). Now measuring 1.96 m, with its missing head and shoulders and the completion of its legs (it is not know whether these statues had feet), it would probably have stood about 4 m tall. The bearded figure is nude, save for an eight-stranded girdle from which a decorated sash hangs at the right side. The carvings in low relief on the sash show two poles carrying the emblem (tentatively identified as a fossil belemnite) later associated with Min, two saw-fish (*Pristus*) saws, and two shells of the *Lambis*, a mollusc which occurs in the Red Sea, flanking a harpoon; the shallow carving of a seated quadruped below these seems to be a later addition. The statue's right hand is perforated to hold something, perhaps the flail with which the god is shown in later sculpture. Key routes extended from Koptos through the mineral-rich eastern desert to the Red Sea; as the town's pre-eminent god, Min was the patron of the expeditions which set out from Koptos, in addition to his role as a fertility god, manifest in his erect phallus. The three prehistoric statues remained fallen but at least partly accessible within the temple area over a long period of time, hence the disfiguration of their surfaces with cavities where the stone has been ground to provide 'magic powder'

'unhistoric' colossi (the dismissive opinion probably came from Ernest Wallis Budge, Keeper of Egyptian Antiquities there, with whom Petrie never enjoyed cordial relations); the offer was diverted to the Ashmolean, 'where they were at once accepted'. This had a fortunate consequence for the museum in the following season's work, when Petrie excavated a vast cemetery at Naqada, with graves containing artefacts of a completely unfamiliar kind (**1,3,5,7,8**): they were in fact prehistoric (though Petrie did not immediately recognize this), and with the agreement of his sponsors, Haworth and Kennard, he presented a type-series of objects from Naqada to the Ashmolean, thus establishing Oxford, as he later noted in his memoirs, as 'the standard place for the early Egyptian art'.

This special focus of the Ashmolean collections was to be further enhanced by objects from Petrie's subsequent work on the royal tombs of the first kings of Egypt, at Abydos (**19**), and especially by a generous share of the material from the excavations at Hierakonpolis directed by one of Petrie's early assistants, James Quibell. A preliminary instalment arrived from the site after the first season (1897–8), thanks in part to the architect Somers Clarke, who had worked there, and the engineer Joseph J. Tylor. Arthur Evans had been frustrated by the museum's failure, through lack of money, to secure any objects directly from Émile Amélineau's work at Abydos, which preceded Petrie's excavations there (cf. **18, 19, 22**, acquired at the later sale). He was determined that the same should not happen with the excavations at Hierakonpolis, a site 'pregnant ... with such important accessions to the University collections', and he launched a public subscription in November 1898 to raise funds for the excavation (**12–17, 20**).

In Evans's 'New Ashmolean', Egyptian sculpture and Assyrian antiquities were displayed on the ground floor, and the smaller Egyptian objects upstairs (Fig. 14). Together with the newly-built extension, new recording systems were introduced: on Petrie's recommendation, Margaret Murray, graduate of University College London and the first woman to be professionally trained and employed as an

14. The Egyptian section at the north end of Gallery I in 1922

15. An abundance of small objects: the new Egyptian Room (later, the Drapers' Gallery, housing the Ancient Near Eastern collections) in 1939

Egyptologist, was engaged in 1905 to begin a series of thematic catalogues of the Egyptian material, but only the volumes on amulets and beads were completed. Such was the mass of archaeological material now arriving that it was difficult to keep up the basic registration process, and in 1909 Miss Murray was re-engaged by Evans's successor, D.G. Hogarth (now styled Keeper of the Ashmolean and Keeper of the Antiquarium) to record the 'E'-prefixed accessions

16. The Shrine of Taharqa after its clearance on site at Kawa during the 1930–31 season. The sand which had covered it to roof level had protected its sandstone walls from erosion. *Griffith Institute archives*

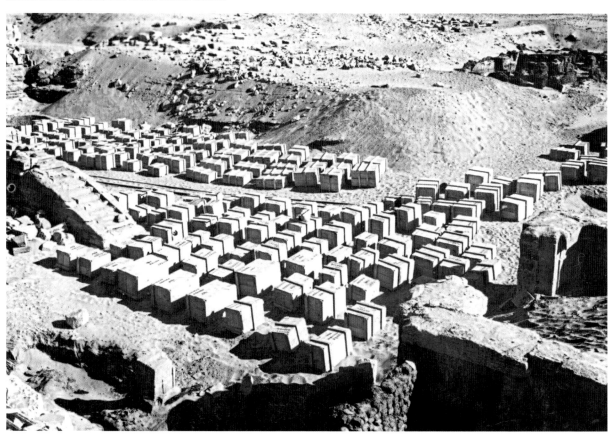

17. The shrine after dismantling on site in 1936, packed for transport in some 150 crates. *Griffith Institute archives*

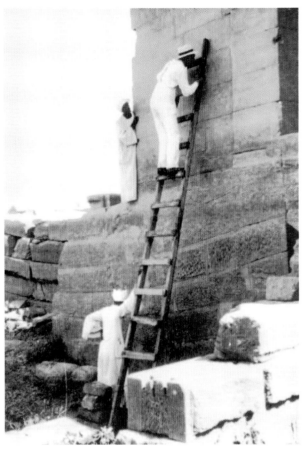

18. Frank Griffith collating an inscription at Philae. *Griffith Institute archives*

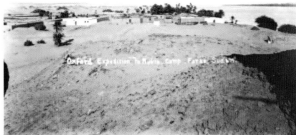

19. The Oxford expedition's camp at Faras. *Griffith Institute archives*

that belong to the period 1896 to 1908.

In tandem with its support for Petrie, the museum continued to fund also the excavations of the EEF (in 1919 renamed The Egypt Exploration Society), receiving material from them which often complemented that discovered by Petrie and his assistants. The finds allotted to the Ashmolean from successive seasons of work at Tell el-Amarna through the 1920s and 1930s, in particular, amplified the quantity of fragmentary sculpture and paintings received from Petrie's single but productive season at the site in 1891–2 to form in total a representative collection of the distinctive art and artefacts of the brief 'Amarna Period' (**40–43**). With the resumption of excavations in Egypt after the war, the Ashmolean received material from the work of the EES at Saqqara (**62**), Tell el-Farain, Qasr Ibrim, and Buhen – the last objects to come to Oxford under the old system where, in an agreed division with the Egyptian Antiquities Service, foreign excavators were allowed to keep a proportion of their finds.

When a benefaction from the Drapers' Company in 1935 enabled the building of a further extension to the Department of Antiquities, a new first-floor gallery was allotted to Egypt (Fig.15). Shortly afterwards, the building of a new ground-floor room for Egyptian sculpture provided the space which was to become the Griffith Gallery, and house the largest item ever added to the Ashmolean's collections, a complete shrine (Figs 16–17, 20).

Like Petrie, Francis Llewellyn Griffith (1862–1934) was an aspiring Egyptologist whose early career was fostered by the EEF. He was the first Student sponsored by the Fund, working for four seasons with its first field directors, Petrie and the Swiss Edouard Naville. A brilliant scholar of the language, with the support of Sayce he had taught himself Egyptian while he was an undergraduate at The Queen's College, where his family had expected him to study classics. He went on to become Oxford's first Professor of Egyptology (1924), a post attached to The Queen's College, where Sayce had actively promoted the Ancient Near East and Egypt, and where, since 1841, there had been a collection of Egyptian antiquities, the bequest of a Queen's man, the Revd Robert Mason (**55**).

Griffith's early experience of fieldwork gave him a lifelong conviction of its importance (Fig. 18). In the inaugural lecture of his first Oxford appointment as Reader, in 1901, he described it as 'far more arduous than work in the study, but … also from every point of

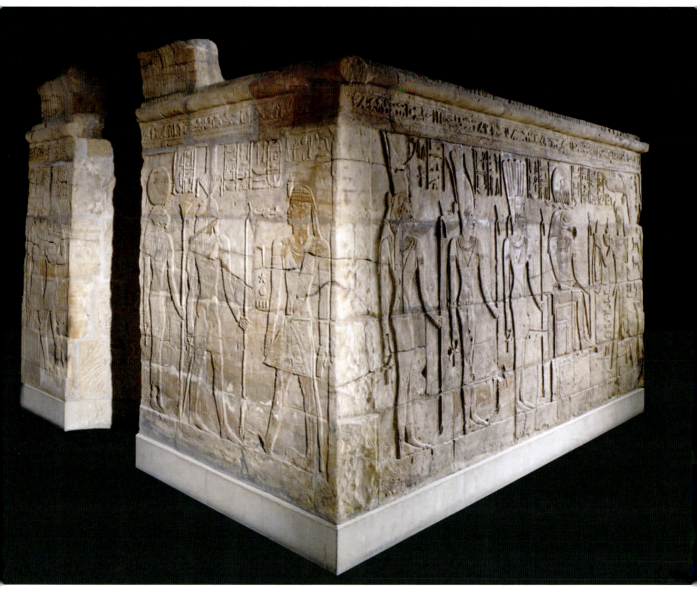

20. The gift of the Shrine of Taharqa (*1936.661*; 2.3 x 3.95 x 3.95 m), made via Mrs Nora Griffith in recognition of her late husband's services to Nubian archaeology, brought a spectacular centrepiece – the only pharaonic building in Britain – to the Griffith Gallery, inaugurated in 1941. 'I had no idea our basement would hold so much', wrote the Keeper, E.T. Leeds, in his letter of thanks to Mrs Griffith after the arrival of the crated blocks in the summer of 1936.

The sandstone shrine was originally erected as a self-contained structure within the temple of Amun-Re at Kawa built by Taharqa (about 690–664 BC), one of the pharaohs of the 25th Dynasty who ruled over both Egypt and Nubia. Its walls are carved in raised relief with scenes showing him receiving 'all life and power' from the gods of Heliopolis, Memphis, Thebes, and Kawa. No objects or decoration were found inside the shrine; it may originally have housed an image of Amun-Re or Taharqa

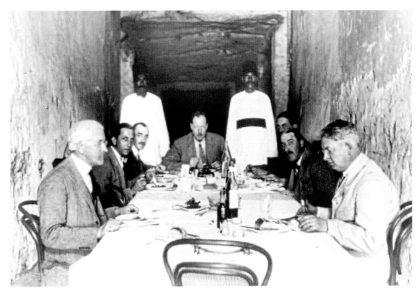

21. A ram from Kawa (see **68**) arrives through the back gate of The Queen's College. *Griffith Institute archives*

22. Luncheon in a tomb: in 1923, Gardiner, a long-time friend of the Earl of Carnarvon, joined the group of specialists working on the Tutankhamun discoveries on site in Western Thebes. Here he sits (far right) at the lunch table set up in the tomb of Ramesses XI; Howard Carter is next to him. *Griffith Institute archives*

view more praiseworthy'. He acted out this conviction in his own career, pressing the EEF in 1889 to begin recording the surviving monuments, and editing 25 volumes of the resulting series, the *Archaeological Survey of Egypt*. In 1910, he launched the Oxford Excavations in Nubia, responding to the call for rescue archaeology consequent on the decision in 1907 to raise the height of the first Aswan dam, which had been inaugurated in 1902; the increased height created a seasonal lake behind the dam, flooding the ancient sites of Lower Nubia. He was following the lead given by George Reisner, with the Archaeological Survey of Nubia, and John Garstang, who had initiated excavations at Meroe, with the assistance of Sayce and the financial support of Sir Henry Wellcome, founder of the pharmaceuticals company. Griffith directed, and largely financed, Oxford excavations in Nubia between 1910 and 1913, and again from 1929 to 1931 (Fig. 20). Together with the finds from the work of Garstang, Wellcome, Reisner, Woolley and MacIver, and the EES, these excavations brought to Oxford a comprehensive array of material representing the ancient cultures of Nubia from prehistory to the Christian era (**67–76**). Griffith was preparing for another field season at the time of his sudden death in 1934; with the support of his widow Nora, his work at Kawa was completed in 1935–6 by Laurence Kirwan, who went on to lead an Oxford expedition to Firka (**76**).

Griffith was, in the memory of all who knew him, a shy man, the very essence of the abstracted scholar, but in raising funds for his Nubian expeditions he was an astute publicist. Each season's work was celebrated in an exhibition in the Examination Schools at Oxford, shrewdly timed to coincide with Eights Week, and the unfamiliar cultures of Nubia were suitably framed within the more familiar territory of Biblical and classical associations. The technique seems to have worked: of the second annual show, the *Banbury Advertiser* reported, 'The exhibition was of that pleasant quality where the visitor left without sense of bewilderment ...' When the material was literally too heavyweight for the Schools, it was shown instead in the garden of Queen's.

In his personal life, Griffith enjoyed both professional and financial support from his marriages to Kate Bradbury (1854–1902), his ally on the EEF Committee even before they married in 1896, and

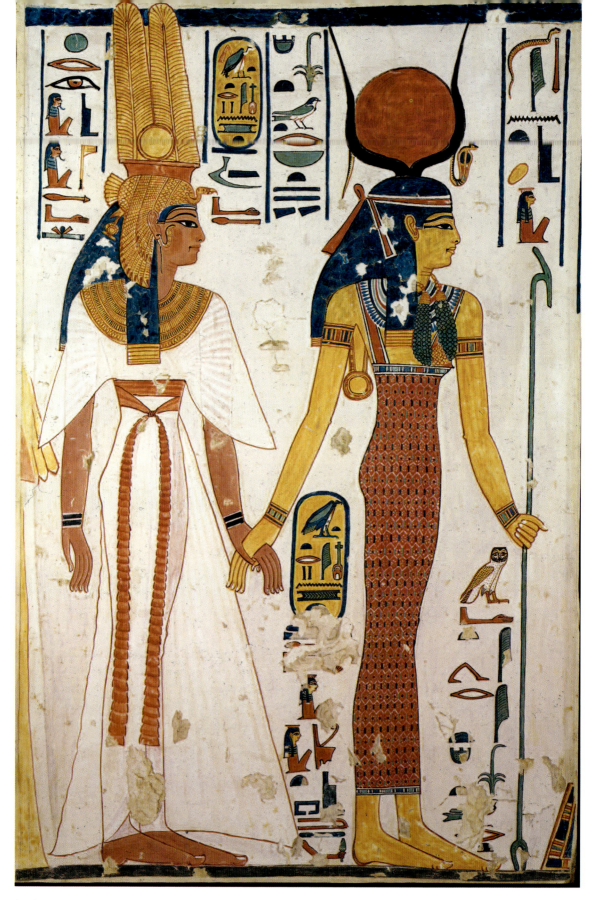

23. Queen Nefertari and the goddess Isis. Copy by Nina Davies (1881–1965) of the painting in the tomb of Queen Nefertari, Western Thebes, about 1230 BC (*1939.581*). Her choice of tempera as a medium, rather than the more usual watercolour paint, gave Nina Davies's facsimiles an unparalleled fidelity to the colouring and texture of the original paintings

Nora Macdonald (1873–1937), who, after their marriage in 1909, helped to organize the fieldwork in Nubia. On her death, the Griffiths' combined estate was bequeathed for the building and endowment of the University's centre for Egyptology, the Griffith Institute, now part of the Sackler Library complex behind the museum.

Griffith was the most brilliant scholar of the Egyptian language of his generation, and his work in Nubia led to one of his outstanding achievements, the decipherment of the Meroitic script. In May 1896, his help in the form of postal tuition was sought by a 17-year-old who was as intent as he himself had been on learning Egyptian. After further studies in Oxford and Berlin, Alan H. Gardiner (1879–1963) in turn became the leading philologist of his generation (Fig. 22). The son of a wealthy businessman, Gardiner never held a full-time appointment in Egyptology, but in 1927 he published the standard teaching grammar of Egyptian, a best-seller which has gone through many editions and is still widely used. 'The book is a large one, and it is cheap!', remarked its author, somewhat disingenuously, when noting its success. His published output was prodigious, but he also used his resources to sponsor the work of others – amongst them the artist Anna ('Nina') Macpherson Cummings,

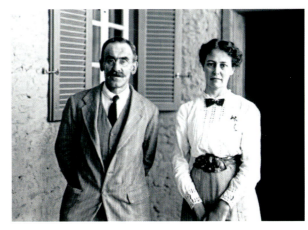

24. Nina and Norman de Garis Davies, a photograph probably taken during the early years of their work in Western Thebes. *Griffith Institute archives*

who, with her marriage to the Egyptologist Norman de Garis Davies in 1907, directed her training as a painter to the work of copying Egyptian tomb paintings.

Living in a house at Qurna, in the midst of the Theban tombs they were recording, the Davieses worked from 1907 until the outbreak of the Second World War, assembling material for the publications of the Metropolitan Museum of New York, as well as the EEF's *Theban Tomb Series*, which Gardiner launched

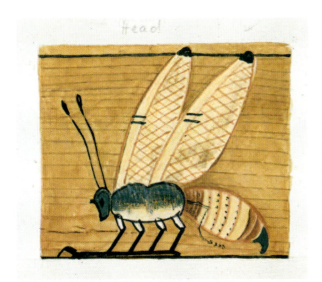
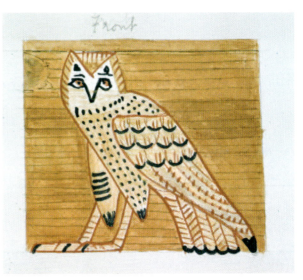

25. Hieroglyphs painted on the wooden coffin of Mentuhotp called Buau, from Deir el-Bahri (Cairo CG 28027, about 1975–1940 BC): tempera copies by Nina Davies (*1939.586*)

26. Most recently the core gallery of the 1956–8 suite, devoted to Dynastic Egypt, has been totally refurbished and reopened as The Sackler Gallery of Egyptian Antiquities (2003)

and financed (Fig. 24). In addition, Gardiner commissioned a number of painted facsimiles of tomb paintings from Nina Davies each year, dispatching her also to the Cairo Museum to copy selected items there. The resulting corpus of paintings, partly exhibited at the Victoria and Albert Museum in 1923, was the foundation for their magnificent joint publication in two folio volumes, *Ancient Egyptian Paintings* (1936). In addition, at Gardiner's behest, the Davieses selected and copied the best examples of painted hieroglyphs in Theban tombs to serve as patterns for the signs in the hieroglyphic fount which Gardiner commissioned for Oxford University Press. Used for Gardiner's own *Grammar* and hundreds of other publications thereafter, this is generally deemed to be the most elegant of all hieroglyphic typefaces.

In 1939, Gardiner presented to the Ashmolean a collection of Nina Davies's paintings (Figs. 23, 25), which was augmented in 1947 by her gift of a comparable collection. By that time, she was living permanently at the house on Hinksey Hill which had been the Davieses' Oxford home since the 1930s. Norman Davies had died in 1941, and in the following year Nina gave to the Ashmolean the collection of antiquities amassed during their years of work in Egypt, an especially relevant part of this being the pictorial ostraca – the work of those Theban draughtsmen whose finished tomb paintings had been their life's study (**50**).

Gardiner himself was an astute purchaser of Egyptian antiquities, some of which he gave to the Ashmolean in his lifetime, while others were bequeathed to the museum on his death in 1963, along with a body of material particularly close to his own interests – his collection of hieratic ostraca, formed over his working life (**51**). It is one of the most important elements in the Ashmolean's holdings of over 8,000 ostraca, the combined collections of the

museum and the Bodleian Library (deposited in the Ashmolean since 1946), comprising every script used in Egypt over some 3,500 years. Other Egyptian antiquities were transferred from the Bodleian to the museum in 1887 (**23**), and The Queen's College collection, with additions made to Mason's original benefaction by the college's support of excavations in Egypt, was placed on long-term loan in the Ashmolean in 1949 (**55**). Thus was rounded-out the ideal of a unified Oxford collection for which Chester and Evans had lobbied.

In 1956–8, the museum built the suite of Egyptian galleries, plus staff- and study-rooms, in which (together with the Griffith Gallery on the eastern side of the new wing) the collections are currently displayed (Fig. 26). The opportunity was taken at this point to mark Petrie's contribution, in the naming of the first room, which houses the Predynastic collections so substantially owed to his excavations. Installation of the new displays, a lengthy business, was not completed until 1966, by which time Sir Alan Gardiner's bequests to the Ashmolean had arrived. These were to be the last of their kind, the gift of a gentleman scholar who was also a collector, and they marked the end of an era in Egyptology. Since the 1960s the Egyptian collections have grown only fitfully, sometimes by the addition of material which in itself belongs to an earlier phase, such as the splendid collection of amulets transferred from the Wellcome Museum of the History of Medicine in 1983 (**56**), or the objects from Howard Carter's private collection (**61**). In the twenty-first century, the world in which these colourful personalities of an earlier period of Egyptology moved may seem remote, and, at least as far as the material remains of Ancient Egypt are concerned, the goals have been redefined: survey, conservation, preservation, and scientific analysis are now the overriding objectives, where once the continuing accession of new material into museum collections was a prime aim. Where it involves collections formed outside Egypt, such activity has come to be viewed in recent years in a somewhat negative light, tinged with the perceived flaws of the colonial background against which such collecting began. Yet had it not been for these early initiatives, Egyptology would never have come into existence, and the possibility of appreciating the unique culture of Ancient Egypt would not have been accessible to so many people. Each generation of explorers and workers in the field has, within the constraints of the society and politics of its time, made its own contribution, and its own revisions to the practices of its predecessors. Egyptology is still a comparatively young subject, but one which itself has a prehistory, reflected in the formation of the Ashmolean's collections as described in this introduction; and it has a continuing history which will undoubtedly bring new discoveries and fresh insights.

References (listed according to the order of topics in the text)

A. MacGregor, *The Ashmolean Museum. A Brief History of the Institution and its Collections* (2001); H. Whitehouse, 'Egyptology and forgery in the seventeenth century', *Journal of the History of Collections* 1 (1989), 187–95; R. Parkinson, *Cracking Codes* (London, 1999); D.M. Reid, *Whose Pharaohs? Archaeology, Museums, and Egyptian National Identity from Napoleon to World War I* (Berkeley/Los Angeles/London, 2002); A.H. Sayce, *Reminiscences* (London, 1923); M.S. Drower, *Flinders Petrie. A Life in Archaeology* (London, 1985); M. Norman, 'Early conservation techniques and the Ashmolean', in S.C. Watkins and C.E. Brown, *Conservation of Ancient Egyptian Materials* (London, 1988), 7–16; N. Strudwick, 'Nina M. Davies. A biographical sketch', *Journal of Egyptian Archaeology* 90 (2004), 193–210

Note on chronology and spelling, and excavation details

The following text is divided into four sections covering the Predynastic and Early Dynastic Periods; Dynastic Egypt to the end of the 25th Dynasty; the Late Period to the Arab Conquest; and Nubia. Each section begins with a chronological outline presented in tabulated form.

Until 664 BC, all dates are approximate, and those used in the tables here are a synthesis of current published chronologies. For the Predynastic Period, dates have been based on those published by Ciałowicz (2001) and Wengrow (2006); for the Dynastic and later periods, the chronology of Baines and Malek (2000) has been followed (for these references, see p.147). Small changes will continue to be made in Dynastic chronology, and large ones in Predynastic, where dating is constantly being refined by the discovery of new sites and the publication of further radiocarbon dates.

For the individual objects, the closest dating is given where possible (e.g. when apparent from a royal portrait, an inscription, or the site history), otherwise the dates are based on contextual or stylistic information.

Egyptian names appear in modern publications in a variety of spellings: there is no absolute standard form. Ancient Egyptian did not utilize a full set of vowels in writing; as in present-day Arabic and Hebrew, native speakers would have known the vowel sounds to be inserted in any word in a given context, and – as in our own language – pronunciation changed over the course of time. Modern scholars thus do not know how to vocalize Egyptian, and when Egyptian names have been recorded by Greek authors in fully spelt-out forms, these versions are sometimes preferred: for example, 'Amenophis', for Amenhotep/Amenhetep/Amenhotpe. The forms of name used in this book are mostly those adopted by Baines and Malek (2000). Readers using the earliest archaeological publications will notice a further complication – the individual elements in some royal or personal names seem to be in reverse order compared with current writings. The reason for this is that not all early writers were aware of the principle of 'honorific transposition': in Egyptian, the name of a god or goddess had to be put before any other word, even if its syntactical position was later in the name or phrase. Almost all royal names, and many private ones, were compounded with divine names.

Directors of excavations are noted in parentheses in the provenance information: details of their careers and bibliographies can be found in the invaluable *Who Was Who in Egyptology* (see p.147). For institutional bodies referred to in abbreviated form, see the Glossary (pp. 145–6). A list of sites in Egypt and Sudan from which the museum holds excavated material can be found on the website: www.ashmolean.org and follow these links: Departments>Antiquities> About the Department> Ancient Egypt and Sudan

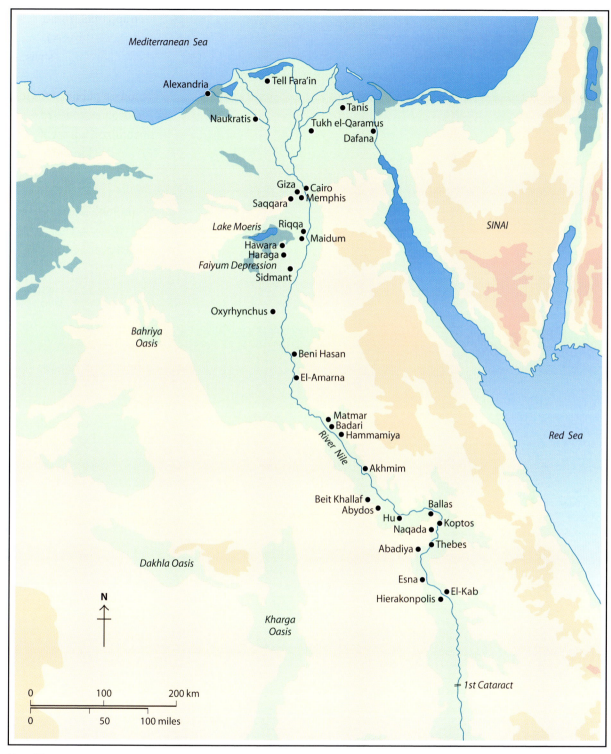

Map of Egypt, showing sites mentioned in this book

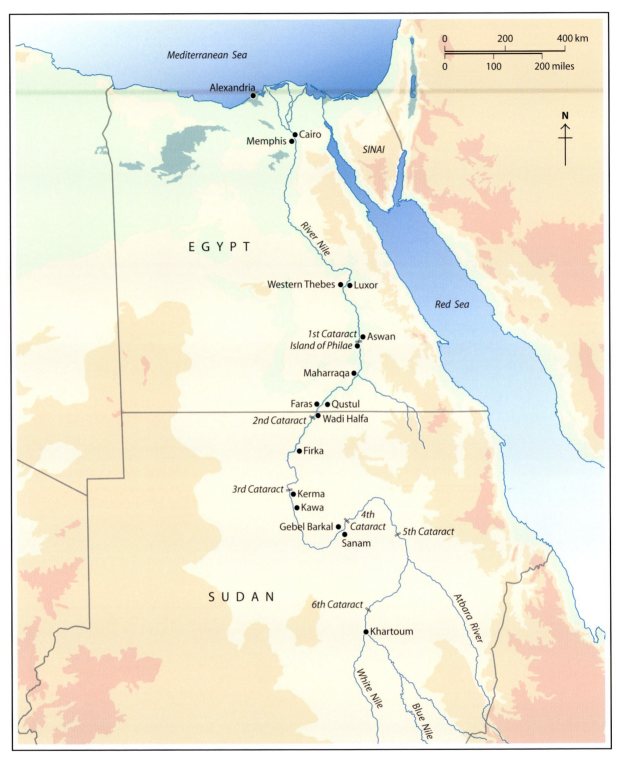

Map of Egypt and Sudan, showing Nubian sites mentioned in this book

The Predynastic and Early Dynastic Periods

Chronological outline

The Predynastic (prehistoric) Period

Approximate dates	Lower Egyptian cultures	Upper Egyptian cultures	Significant developments
5300–4400	Faiyum Neolithic		Earliest evidence of agriculture and animal herding
4400–3900	Merimde	Badarian	Settlements at the cliff edge of the Nile Valley; the first copper artefacts
3900–3600	Maadi	Naqada I (Amratian)	Growing social complexity; improved technology
3600–3300	Buto, Maadi	Naqada II A–D (Gerzean)	Development of fortified urban settlements and a ruling elite; increased foreign contacts

Early Dynastic

Dynasty/Naqada phase	Approximate dates	Rulers	Significant events
Dynasty 0, Naqada III A–B	3300–3100	Local rulers	Upper Egyptian rulers including the 'Scorpion King' and Narmer (Dynasty 0)
1st Dynasty, Naqada III C	3100–2890	Rulers of united Egypt, beginning with Hor-Aha (the 'King Menes' of later records?)	Foundation of Memphis; kings buried at Abydos in Upper Egypt; Djer the third in line and Anedjib the seventh
2nd Dynasty, Naqada III D	2890–2686	Rulers of a divided Egypt, of whom Khasekhem is the last	Reunification of Egypt by Khasekhem/Khasekhemwy
3rd Dynasty	2686–2575	Five rulers, including Djoser	Construction of the Step Pyramid at Saqqara, Djoser's funerary monument

1. Human images

The earliest representations of men and women were modelled in clay, or carved in stone, bone, or ivory. Amongst these a distinctive group have been dubbed 'tags'; the category includes representations of animals and birds, as well as humans. They are grooved at the lower end, and may also be pierced with holes. Found in Predynastic burials as groups lying along the forearm of the body, some show traces of leather tied at either end, and remnants of thongs in the holes and grooves, suggesting an association with leather artefacts such as clothing or bags. Sometimes a thong connects the group, as though they were

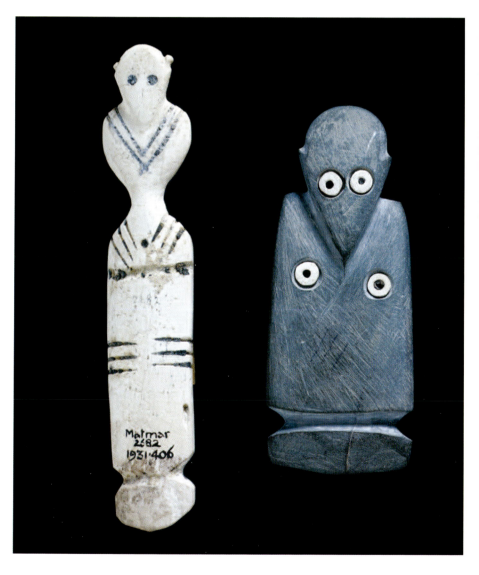

Carved bone figure, incised details filled with black paste; ht. 10.6 cm. From Matmar, grave 2682: Naqada I, *c.* 3900–3600 BC
1931.406: British Museum excavations (Brunton)
Carved siltstone figure inlaid with shell ring-beads: ht. 8.2 cm. From Naqada, grave 271: Naqada IIb, *c.* 3600–3500 BC
1895.132: gift of J. Haworth and H.M. Kennard, from Petrie's excavations

The Predynastic and Early Dynastic Periods

strung together for wearing. The function of these figures, however, remains unknown: they might be human or divine, indicators of status, or protective amulets. Equally ambiguous is their sex: their faces terminate in sharp points, suggesting a beard, but this could also be a stylized rendering of the chin. Small, high-set ears project from smoothly rounded heads which could be interpreted as shaven, close-cropped, or covered with a cap. The narrow waist and wide hips of the bone 'tag' illustrated here suggest a female (though the incised 'necklaces' could belong to either sex). She was found with three others in the grave of a man, where they had apparently been deposited in a wooden box. The inlaid nipples or breasts of the siltstone figure are not so definitive. It was found in a basket, together with some malachite, in a well-equipped burial which also included peg-like ivory statuettes set upright in a row.

2. Decorated pottery vessels

The first pottery with painted decoration to be made in prehistoric Egypt was dubbed 'cross-lined ware' by Flinders Petrie, in the pottery typology he devised to elucidate the chronology of the Predynastic Period. Some of the patterns used to decorate it recall basketwork: the association is particularly strong in one of the pieces illustrated here, shaped like a small basket with a handle, and painted with rows of chevrons. The decoration on 'C-ware' was executed in a light-coloured paint which fired creamy-white to pink and contrasted well with the glossy red surfaces of the pots; analysis of some examples has shown that

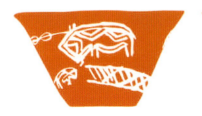
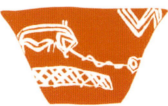
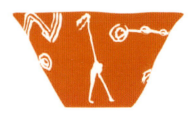

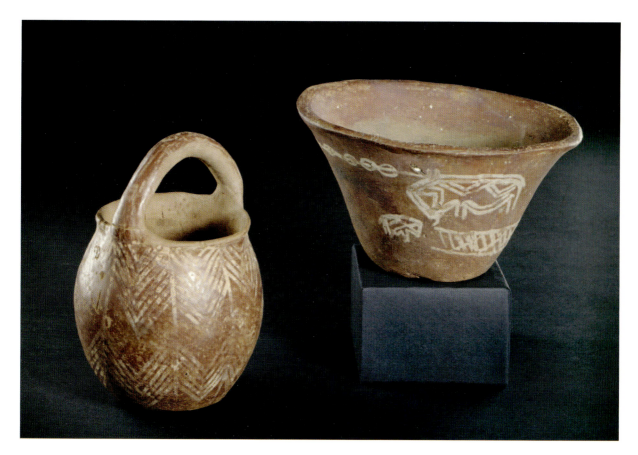

it contained calciferous clay or pale iron oxide.

Linear designs are the most typical decoration of these 'C-ware' vessels, but some carry the earliest figure and landscape scenes surviving from Egypt, apart from those found in rock art. The bowl shows a long-haired man, most likely a hunter, standing between two hippopotami, one accompanied by a calf. Attached to both the adult animals are lines, straight and looping or knotted, ending in concentric circles; they may represent harpoon shafts attached to coiled rope. The cross-hatched area below the animals may indicate water, and the zigzags above, vegetation or hill country.

Jar with handle, ht. 12.8 cm. From Abadiya, grave B107
1896-1908 E.2777: EEF excavations of 1898–9 (Petrie)
Bowl, ht. 8.3 cm. From Abydos, grave B5
1909.1026: EEF excavations (Ayrton and Loat)
Both vessels hand-made of clay coated with haematite, burnished and decorated before firing; Naqada Ic, *c.* 3600 BC

The Predynastic and Early Dynastic Periods

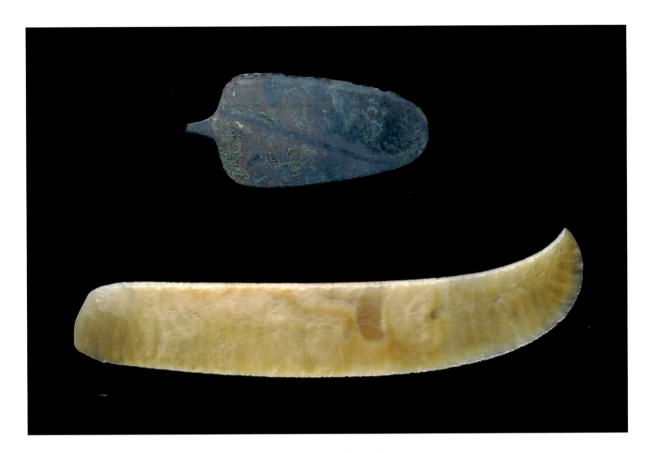

Flint blade, with fine denticulation along the convex cutting edge; length 21.5 cm. From Naqada, grave 162: Naqada IId1, c. 3400–3300 BC
1895.1021: gift of J. Haworth and H.M. Kennard, from Petrie's excavations
Copper knife-blade, cast and hammered; length 10.3 cm. From Naqada, grave 807: Naqada IIc, c. 3500–3400 BC
1895.970: gift of J. Haworth and H.M. Kennard, from Petrie's excavations

3. Flint and copper blades

Flint was the first material used to produce tools and weapons with cutting edges or sharp points. A form of quartz or chalcedony which is often found as nodules in limestone, it is readily available along the Nile Valley. It is sometimes defined as 'chert' when it is light in colour. The technology required to produce satisfactory implements evolved into the highest craft, and the beautiful 'ripple-flaked' knife-blades made at the end of the Predynastic Period were objects indicative of status, made for display or special use. Even after the widespread adoption of metal tools, flint remained the preferred material for implements to be used in religious rituals, and flint knives are represented in the hands of divine or magical beings who can avert evil. Recent study of stone-working techniques has suggested that flint also remained the choice for certain specialized craft activities.

Copper objects began to appear in Egypt during the Badarian Period (about 4400–3900 BC), but the first

sophisticated artefacts occur a few centuries later in the Naqada IIb phase. They were produced by casting, and hammering while hot or cold, using metal-working techniques which had been developed in Mesopotamia. Copper ore was available from many sources in the eastern desert of Egypt and the Sinai peninsula. The knife-blade illustrated here has one sharp edge, and a projecting tang that could be fitted into a wooden handle.

4. Mace

The weapon *par excellence* in prehistoric Egypt was the mace. It generally survives only in the form of the detached stone head: this is one of the few examples found complete, and it provides rare evidence for a functional type of handle – a tapering shaft of horn (probably from the Arabian *Oryx leucoryx*), bound with strips of leather to give a good grip. From the same grave at Abadiya came fragments of a non-functional ivory mace-handle; handles of clay and wood have been found at other sites. These maces were probably buried as indicators of the status of their owners, as well as weapons for use in the next life. As found, the stone disk of this one was fixed to the handle with a clay-like substance, not a practical means of attachment: for actual use, some system of binding

Disk mace-head of limestone with calcite veins, diameter 8.8.cm, fitted with a handle of oryx horn with traces of leather binding; total length 33.5 cm. From Abadiya, grave B86: probably Naqada I, *c.* 3900–3600 BC
1896–1908 E.3142: EEF excavations of 1898–9 (Petrie)

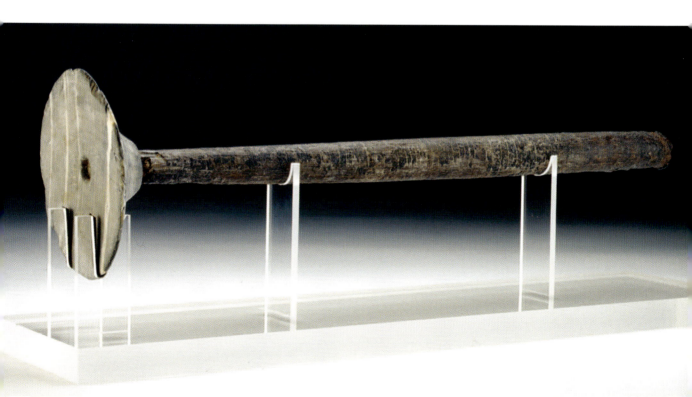

along the length of the handle, finishing with a tied knob protruding from the top of the mace-head, is likely. The disk-shaped stone is the earlier type of head, found in southern Egypt and Nubia. It was superseded by the pear-shaped form found in Lower Egypt before 4000 BC, but also common throughout the Near East. The shape is typified by the colossal ceremonial examples found at Hierakonpolis (**12**).

Even before the end of prehistory, the mace had ceased to be a functional weapon. It remained current, however, in Egyptian art until the Roman Period: in the archetypal scene where the pharaoh strikes his enemies, the weapon he uses is the mace with a pear-shaped head.

5. Decorated ostrich egg

Ostriches are represented in prehistoric rock carvings and also figure amongst the hunted creatures carved on the decorated palettes produced at the end of the Predynastic Period (**15**); hunters are sometimes depicted wearing ostrich-feathers on their heads. Although their flesh is edible, it seems that these flightless but fast-moving birds were valued chiefly for their fine plumage. In Dynastic times, when the ostrich also acquired solar associations, ostrich-feather fans were used to shade both kings and divine images.

Their eggs, which are laid in clutches in the ground, would have been a valuable food-source. The desert traveller Ralph Bagnold reported that the contents of a single egg, blown via a pipe into a cooking pot and scrambled, provided 'a good meal for eight people'. Once emptied, the thick-walled shell makes a useful container, especially for liquids; the drilled blow-hole can be fitted with a stopper. Not all surviving Predynastic examples of ostrich-egg vessels are decorated, but this one has an incised design of two bovids, possibly gazelle or hartebeest, the zig-zag markings on their bodies probably a convention to indicate animal hide. They seem to be fleeing as though from hunters. A tradition of ostrich-egg containers with black-filled incised decoration

Reconstructed shell with incised drawings filled with black paste, ht. 15 cm, diam. of blow-hole 1.2 cm. From Naqada, grave 1480: Naqada IIa, *c.* 3600 BC
1895.990: gift of J. Haworth and H.M. Kennard, from Petrie's excavations

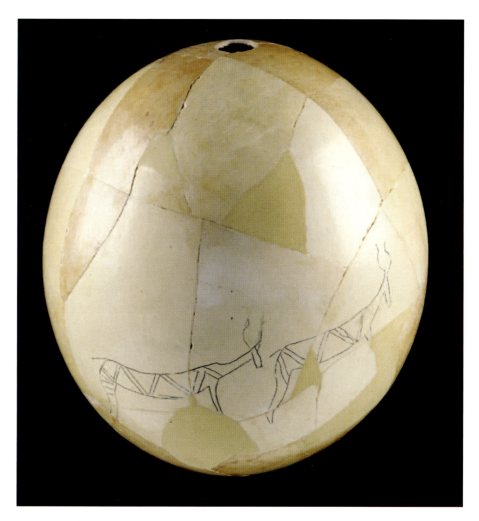

continued further south in Africa until the twentieth century.

This shell, found in pieces, had been significantly positioned to replace the missing head of the body in a grave at Naqada.

6. Pottery hippopotamus

This lively model shows a hippopotamus in a typical pose, standing four-square on its short legs, with jaws threateningly agape. The body is hollow; the coarse clay (Nile silt) has fired to a rich red-brown colour appropriate to the animal, and the broken lower jaw shows the darker interior typical of this clay when fired.

Hunted in Predynastic times, the hippo was the source of ivory tusks (actually its teeth – incisors and

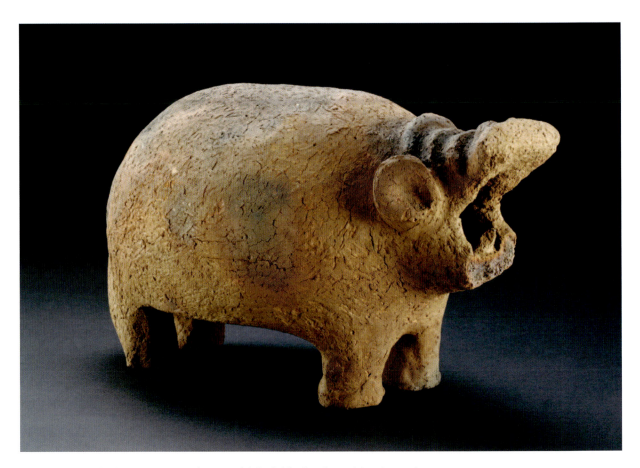

Hand-made model, fired chaff-tempered clay, length 27.3 cm. From Hu, grave R 134: Naqada IIb, *c.* 3600–3500 BC
1896–1908 E.3267: EEF excavations of 1898–9 (Petrie)

canines – which yield a harder, whiter ivory than elephant tusks). Its gradual retreat along the course of the Nile southwards into Africa reflects the pressure of hunting in Egypt, though small numbers remained in the Nile Delta until at least the seventeenth century AD. Foraging on land at night, the hippo is known for the damage it inflicts on crops. In pharaonic times, it was associated with the god Seth and his destructive works, and the hippopotamus hunt was conceived as a ritual enactment of the overcoming of evil. The female, however, a vigorous defender of her young, attained the status of a beneficent goddess, Taweret (**54**). Whether any such association was made in Predynastic times is unknown. Model hippopotami of various sizes in stone and clay, stone vessels in hippo shape, and also harpoons, were quite frequently placed in burials, along with many artefacts made of hippopotamus ivory. They may have been intended to give the deceased continued power and success in hunting the animal in the next life.

7. Black-topped pottery

Of all the types of pottery made during the Predynastic Period, 'Black-topped ware' (B-ware in Petrie's initial classification of Predynastic pottery) is the most prominent. It was already being produced in the fifth millennium, and is especially typical of the periods Naqada I and early II. It finally disappeared from the potter's repertoire in Egypt early in Dynastic times, when the fine, mostly hand-made, vessels of prehistory gave way to a more mundane level of wheel-made pottery.

The ware acquired its name from its most distinctive visual feature: a band of black, of a lustrous, almost metallic appearance, over the upper surface of the vessel. The blackening, which often extends over the interior and through the thickness of the clay, was produced by two factors – carbon absorption, and firing in a reduced atmosphere. This was achieved by setting the vessels upside-down in a bonfire: those areas deprived of oxygen and smoked by the burning fuel would turn black in firing, while the rest of the surface became a glossy red. The colour and sheen were the result of a coat of ground haematite (iron ore), applied in liquid form to the leather-hard clay and burnished before the pots were fired. All-red or all-black vessels were also produced by this surface treatment, and variations in the firing method. Recent experiments in replicating the firing process have produced the best results when the bonfire containing the pots is covered with clay.

Black-topped vessels were made in a wide range of forms, with the occasional addition of relief decoration. This was modelled separately, then applied to the surface before it was coated and burnished. The small number of vessels thus decorated seem to have been of special significance. On the beaker illustrated here, a human face on a pole is flanked by bovid horns; below, a pair of arms stretch around the vessel to hold small breasts. The significance of this decoration is unknown, but it is echoed in the special jars of much rougher ware produced in pharaonic times, decorated with miniature breasts

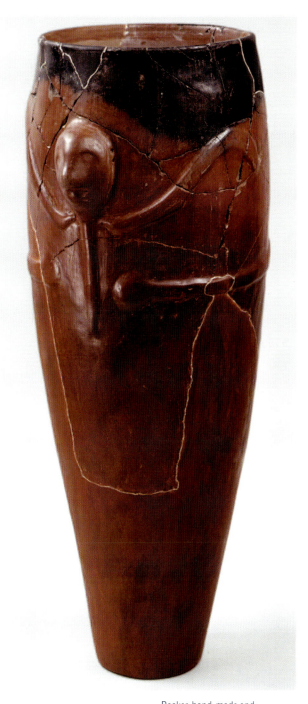

Beaker, hand-made and decorated in relief, ht. 42.8 cm. From Naqada, grave 1449: Naqada IIa, c. 3600 BC
1895.1220: gift of J. Haworth and H.M. Kennard, from Petrie's excavations

The Predynastic and Early Dynastic Periods 11

and the head of the goddess Hathor, who was associated with the cow.

Amongst the decorated pieces of B-ware in the Ashmolean is a sherd from quite a large jar (below, left), with applied decoration depicting in outline the form later known as the Red Crown of Lower Egypt. Its distinctive flaring profile, rising high at the back and fitted with a curling addition like a springing tendril that faces inwards, is clear; but the presence of this symbol in Upper Egypt at this time is unexpected and so far unique, and we do not know whether it already represents a ruler's headgear.

Black-topped ware, like other types of hand-made pottery, continued to be produced in Nubia long after such technically accomplished vessels had disappeared from Egypt. It reached its peak in the 'Kerma ware' of c. 1800 to 1650 BC, typically in the form of thin-walled vessels where the black zone gradually passes to clear red through a band of intermediate colours. This decorative effect, the result of interaction between the clay and the mineral coating, was evidently deliberately sought by these potters who were masters of the shaping and firing of clay.

Fragment of jar, ht. 25 cm. From Naqada, grave 1610: Naqada IIa, c. 3600 BC
1895.795: gift of J. Haworth and H.M. Kennard, from Petrie's excavations

A Kerma-ware beaker, one of 11 found in a burial-shaft at Abydos (North cemetery, O4: 2nd Intermediate Period, c. 1640–1540 BC); ht. 11 cm.
1910.692: EEF excavations (Peet)

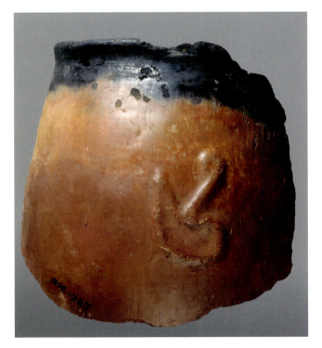
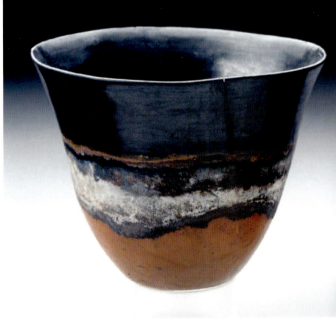

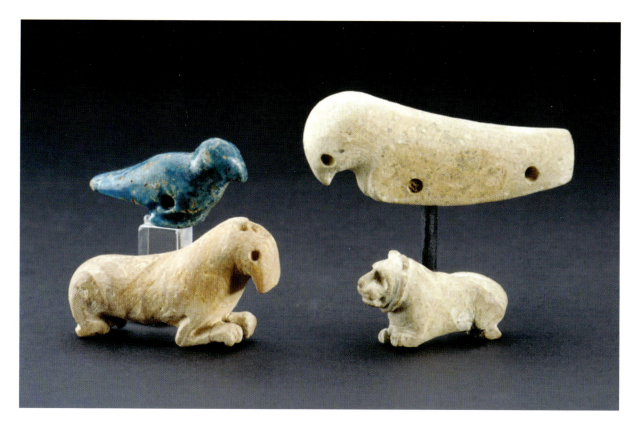

8. Model birds and animals

By the end of the prehistoric period, animals and birds figured amongst the symbols used to denote territorial divisions or social groupings, such as the images on the standards carved around the top of the 'Scorpion Mace-head' (**12**). The elephant ensigns depicted on a late Predynastic pot (**10**) may have a similar meaning. The significance of the model creatures found in other Predynastic contexts, however, is unclear. In later times, particular creatures were associated with specific gods – the falcon, for example, was identified with sky or solar gods, especially Horus. In the absence of written evidence, such associations cannot be confirmed for prehistoric times, although the connection of certain major divinities with significant early sites suggests that they were already represented in some form there.

The small animals illustrated here have been made for attachment to supports: the glazed falcon has a hole pierced through the body, the others have a single hole underneath. The additional holes on the

Blue-glazed falcon with a core of sandstone or sandy ceramic medium, length 3 cm. From Naqada, grave 1774: Naqada I, *c.* 3900–3600 BC
1895.142
Limestone falcon, 'Seth-animal', lion; lengths 5.5, 4.3, 3.3 cm. From Naqada, grave 721: Naqada IIc, *c.* 3500–3400 BC
1895.136, 138, 144a:
Gift of J. Haworth and
H.M. Kennard, from Petrie's
excavations

limestone falcon probably served to secure the bird-shaped casing of lead which was found in the same grave. The three stone models have eyes hollowed to take inlays, and the seated quadruped at the left also has holes for fitting ears and a tail. Its muzzle resembles the curving snout later shown on the 'Seth-animal', a fabulous beast with tall ears, clawed feet, and an upright tail. In historic times, this animal was uniquely associated with the god Seth; revered in some parts of Egypt, including the area around Naqada, he was more generally seen as a negative force who brought chaos and disorder.

9. Miniature 'Serpent game' board

One of the earliest surviving artefacts connected with the 'Serpent game' (Egyptian *mehen*), this is a miniature version of the board used to play this race game. Other surviving boards are about 30 cm in diameter, and

Carved limestone model; diam. 10 cm. From Ballas, grave Q19 : Naqada II, *c.* 3600–3300 BC
1895.997: ERA excavations (Quibell)

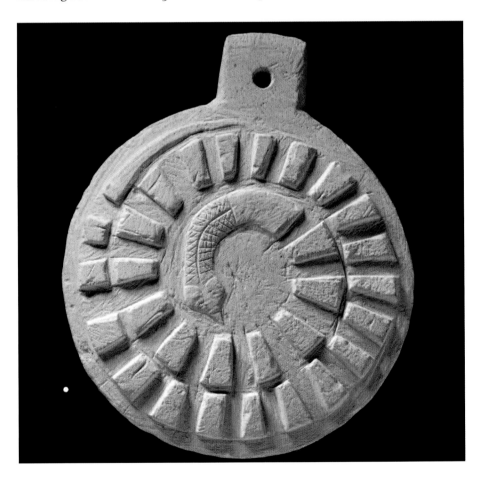

14 Ancient Egypt and Nubia

have a projecting tab like the one carved here. The associated gaming-pieces, as depicted in tomb scenes and also found in sets (although none has yet been found with a board), comprised three lions, three lionesses, and 36 marbles, plus a set of rods, apparently for use as throwsticks. It seems that the pieces were moved around the segmented coils of the snake, according to the players' throws. The precise method of play is not known; the tab could have been used to shake the board, or serve as a parking-place for the pieces not in play. *Mehen* is the earliest known member of the family of 'race games': the most familiar to us is 'Snakes and Ladders', played on a square board, but there are earlier spiral games akin to *mehen*, such as the sixteenth-century 'Game of Goose'.

This miniature board had been used as the lid of a pot in a grave. Several other burials in the Predynastic cemeteries of Ballas and Naqada were equipped with games, however, and that was probably the intention here. Its size, and the hole for a suspension-cord, give it the appearance of a portable version. It may also have been thought to have magical properties helpful to the deceased: games of hazard came to have a special significance in later Egyptian religion, reflecting the chancy nature of the dead person's progress through the trials of the Underworld.

10. River scene on a pottery jar

The decorated pottery of the late Predynastic Period is the best evidence we have for pictorial art at this time; only a few examples of painting have survived on walls or textiles, and comparable scenes in rock art are not securely datable. Boats, as on this jar, are a frequent subject, and the two with curving hulls depicted here display a typical form, probably made of wood. They have numerous oars grouped fore and aft, and steering oars at the stern. At the prow of each boat is a branch with fronds curving inwards, and at the centre cabins, with an elephant ensign at the rear of each. The surrounding terrain seems defined by the line of solidly-coloured triangular 'hills' around the top; below these are large birds (flamingos), and hatched

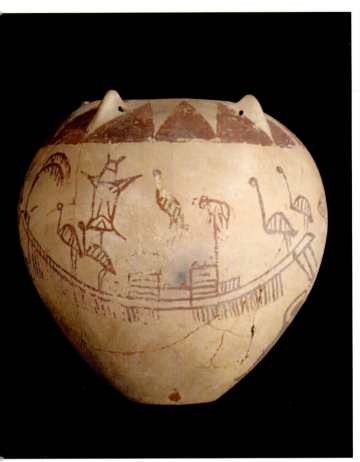
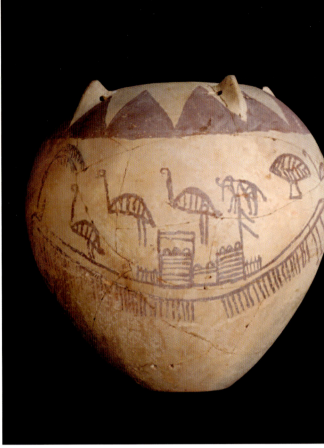

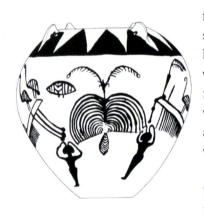

fan-like objects. An unusual detail here is the animal-skin (?) shown above one of the boats. Between the boats (see drawing) is a large stylized flowering plant which has been identified as an aloe. Below and flanking this stand two figures, slender-waisted and with arms raised to touch their heads: their figures and gesture are paralleled in Predynastic figures of women modelled in clay.

The complex detail of such scenes involving river traffic suggests a narrative or commemorative purpose. Similar content, but in a much expanded form, with a greater variety of incident including combats and hunting, is seen in the paintings discovered in the Predynastic tomb of an important local ruler at Hierakonpolis (tomb 100, dating to about 3400–3200 BC).

The production of these decorated pots was the preserve of a small number of specialized workshops,

Jar with painted decoration applied before firing; ht. 25 cm.
From Naqada, grave 454: Naqada IId1, c. 3400–3300 BC
1895.584: gift of J. Haworth and H.M. Kennard, from Petrie's excavations

and their use seems to have been almost exclusively funerary. Their shapes often imitate stone vessels, complete with the perforated lug-handles typical of these. Sometimes their painted decoration consists merely of spirals, random splashes, or lines to suggest the patterns occurring in hard stones. The clay used to make them – desert marl, with a high calcium carbonate content – produced a harder, more uniform ware than the rougher Nile mud. When fired, the surface would become a suitably light-coloured background, ranging from off-white to warm pink, for the decoration. This was applied before firing with a wash containing iron oxides which fired reddish-brown. The incised lines with which the painter roughed out the design can be seen on this jar, around the prows of the boats and under the aloe plant.

11. Basalt statuette of a man

This unique figure has been the object of controversy since it first came to the notice of scholars at the end of the nineteenth century. It was then in the fine collection of Egyptian antiquities belonging to the Revd William MacGregor (1848–1937), of Bolehall Manor, Tamworth. He had acquired it together with a number of ivory statuettes, the whole group allegedly having been found at a site in the vicinity of Naqada. At that time there was little with which the figure could be compared: it shows a man, naked save for a penis-sheath suspended from a belt. He has a long, pointed beard, the lines of which merge with stylized hair or a cap on his head, beyond which project neat, almost circular ears. His features are emphatically rendered – eyebrows and nose carved as a unity, large eyes outlined in raised relief, and a receding chin below a mouth with overhanging upper lip. The figure is basically cylindrical, but flattens at the shoulders, from which the rather shapeless arms extend, flipper-like, some way down the body, ending in hands with carefully detailed fingernails. The lower legs are lost.

Some of the individual features shown by 'MacGregor Man' can be paralleled on the ivory statuettes of men wearing penis-sheaths, discovered

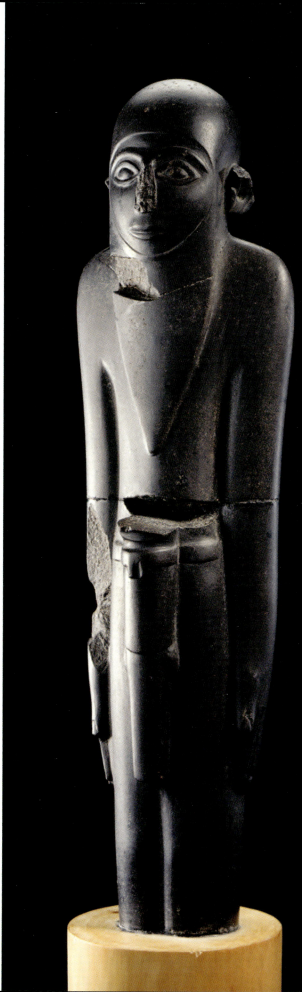

(previous page)
Basalt figure, carved and polished, ears drilled; repaired breaks at neck and waist, with some stone missing; lower part of legs lost, surface damage to ears, nose, right forearm; ht. 39.5 cm. Said to have been found at 'Saoniyeh', near Naqada: Late Predynastic– Early Dynastic? 1922.70: acquired from the MacGregor collection

at Hierakonpolis in 1897–9; two of the ivory male figures acquired with him also show similarities with these. At the time of the group's acquisition, however, only the Min statues excavated at Koptos (pp.xv–xvii) could have served as comparable early stone sculpture of male figures, and the rough quality of these colossal limestone works is far from the surprisingly accomplished and stylized carving of the basalt statuette. Doubts as to its authenticity have been expressed on many grounds – style, iconography, quality and technique of the carving, and the breaks and surface abrasions, which have been seen by some to be more consistent with the deliberate 'antiquating' of a forgery than credible damage sustained over time.

The MacGregor collection was dispersed at a London auction in 1922. The sale catalogue noted of lot 1624, 'this very remarkable figure has caused a great deal of discussion…'; undeterred by this, the Ashmolean acquired the statuette with the aid of funding from a number of leading archaeologists. Given the absence of detailed information about its source and the circumstances of its entry into the MacGregor collection, the figure will always remain problematic. The recent discovery at Hierakonpolis of shattered stone sculpture which predates the Min colossi, and the male statuettes of gold newly found at Tell el-Farkha in Lower Egypt, add new aspects to the arguments for and against 'MacGregor Man'.

Three of the ivory figures 'found at Saoniyeh' and sold as part of lots 710 and 711 in the MacGregor sale: now in the Birmingham Museums and Art Gallery (photo courtesy of BMAG)

12. The 'Scorpion Mace-head'

In the winter of 1897 British archaeologists began excavating at Kom el-Ahmar in Upper Egypt, the place named Nekhen in Egyptian but more commonly known by its Greek name, Hierakonpolis ('Falcon City'). The site of the dynastic town lay north of an extensive range of prehistoric settlements and cemeteries. Within the area of the town was an enclosure which from at least the time of Thutmose III was the site of a temple of the falcon god Horus. Earlier structures within the enclosure are not so clearly defined, though it was evidently a place of considerable ritual importance.

Hierakonpolis figured prominently in the mythology of Egyptian kingship. Every Egyptian king was 'the living Horus' on earth, incarnation of the divine ruler of Egypt who avenged and succeeded his murdered father Osiris. Mythological figures called 'The Souls of Nekhen', depicted with jackal heads on men's bodies, might be derived from the early rulers of this area. At the end of the Predynastic Period, the rulers associated with Abydos and Hierakonpolis became the dominant power in Upper Egypt, leading to the unification of Upper and Lower Egypt under a single king. Current excavations at Hierakonpolis have revealed large tombs of the late Predynastic Period, where the human deceased were accompanied by animal burials (in one instance, a young elephant) and post-and-matting structures had been built above ground, most likely for the performance of funerary rituals.

The early excavations at Hierakonpolis directed by James Quibell and Frederick Green revealed within the temple enclosure the most important assemblage yet discovered of objects dating to the time around Egypt's unification, as well as a number of artefacts associated with King Khasekhem of the 2nd Dynasty (**20**), and later material. Many of these objects were found grouped within an area about 8 x 8 m, where they had been deliberately buried; the excavators termed this the 'Main Deposit'. It included several over-life-size representations of objects associated

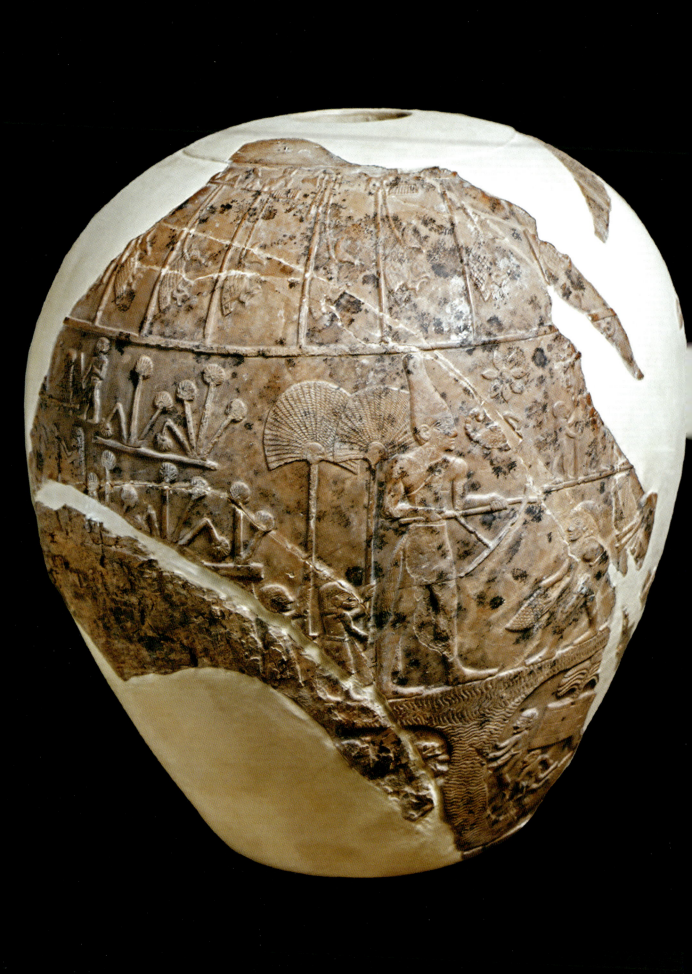

Limestone mace-head, carved in low relief, the surface marked with manganese dendrites; restored from fragments; ht. as restored 31.5 cm; max. diameter 30 cm. From the 'Main Deposit', Hierakonpolis: Dynasty 0, c. 3100–3000 BC
1896–1908 E.3632: ERA excavations of 1897–9 (Quibell and Green)

with power and domination: giant flint knives, ceremonial palettes (**15**), and decorated mace-heads – enlarged versions of the pear-shaped stone head which, fitted with a handle, was the weapon with which the king was shown smiting his captive enemies in depictions throughout Egyptian history. Only one of these mace-heads was intact, that depicting, and carrying the name of, King Narmer (now in Oxford). Fragments of three others were recovered, however, along with numerous other mace-heads of functional size but apparently ceremonial use, as indicated by the elaborate shapes and prestigious material of some.

The largest of the oversized, decorated mace-heads was found in fragments amounting to only about a third of its original surface, but for the quality of its carving and the interest of its scenes, the 'Scorpion Mace-head' has attracted particular attention. Roughly five times the size of a functional mace-head, it takes its name from the central figure in the preserved scene: he wears the tall crown of Upper Egypt and, over a short tunic, a belt with a bull's tail at the back, subsequently a standard feature of royal dress. Unlike Narmer, shown similarly crowned and dressed on the ceremonial palette from Hierakonpolis in Cairo, the 'Scorpion King' is apparently beardless, though traces of a line parallel to his jaw recall the strap holding the royal false beard. He is performing the ceremonial cutting of a trench for irrigation or a building foundation, and a functionary in front of him stands ready with a basket to take the soil removed by his hoe. Further right, a partly-preserved figure holds a bound, brush-like arrangement of plant elements, possibly corn heads.

The rosette and scorpion symbol carved in front of the ruler's face have been taken to indicate his identity as a 'King Scorpion', thought to be a predecessor or (less likely) a successor of Narmer in 'Dynasty Zero', the group of rulers immediately preceding the kings of the historic 1st Dynasty. Inscribed labels of ivory and bone found in recent excavations at Abydos have suggested the possibility of a series of early rulers' names written with signs such as scorpion, lion, and

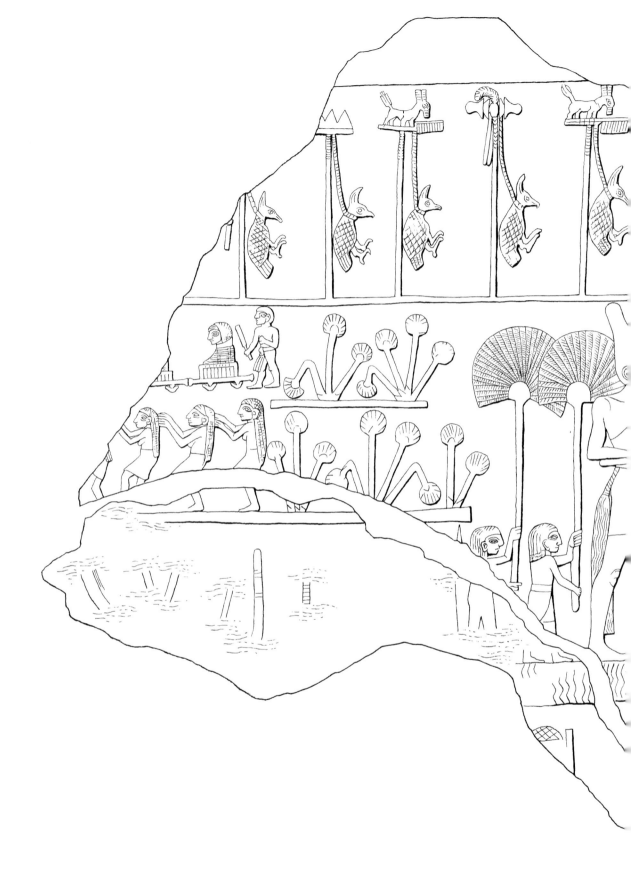

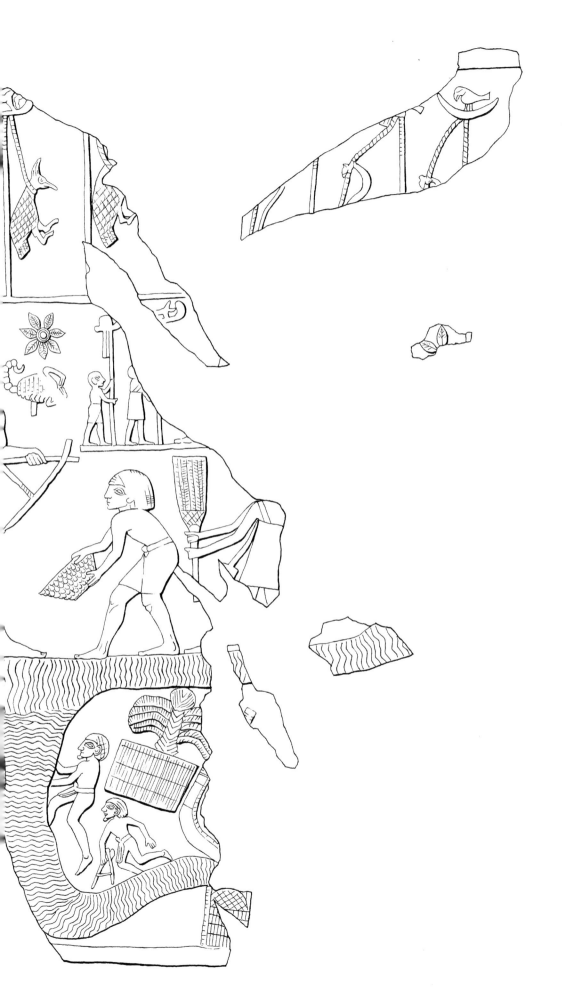

elephant, but the reading of these as personal names is not proven. The seven-petalled rosette, not found amongst later hieroglyphs, has been interpreted in various ways, as a symbol of rank or territory, or a phonogram with the reading *Ḥr* (used in the writing of 'Horus'). The small peg projecting from the body of the scorpion shows that it is not a depiction of the creature *per se*, but an emblem, possibly a component for an ensign which might indicate a group affiliation rather than an individual.

The scenes preserved on the fragments of the 'Scorpion Mace-head' are set out in horizontal registers, with additional groundlines supplied for further figures or elements within the register; the defining line of the principal scene as preserved is the waterway. Horizontal registers are the standard compositional scheme in later relief sculpture and painting, and their early use here and on the Narmer palette and mace-head have been seen as portraying order, as distinct from the 'chaos' of battle and hunting scenes (**15**).

Also typical of later representational conventions are the relationship between size and status in the depiction of figures, and the significant direction in which they face. Thus, the central group with the 'Scorpion King' includes his fan-bearers (behind), the two functionaries in front of him, and the royal standard-bearers preceding him on their own groundline. These standard-bearers are usually four in number (as shown on the Narmer palette and mace-head), but directly in front of the two here are traces of carving (a foot and possibly a knee) suggesting a larger figure facing them.

Behind the fan-bearers, two rows of plants denote the location of a separate scene directed perhaps towards another large figure of the ruler. There would be room within the missing part of the mace-head for at least one more such figure, if not two, and the small, unlocated fragment with two petals of the rosette sign (shown at the right in the drawing, pp. 22–3) could belong to one of these. Facing this way are long-haired dancing women, and at least two carrying-chairs under the supervision of a functionary with a baton.

The swathed figure in the fully-preserved chair might be female, though the hair or wig style is similar to that of the man with a basket. In the lowest part of the mace-head, bearded men work on a branch channel of the horizontal watercourse. The prow of a boat appears at the right, beside a palm tree within a fence, and there are parts of two post-and-matting structures of the same form as the shrine shown on the Narmer mace-head, the shape particularly associated with the *pr-nw* shrine of Buto in the Delta. Further left, in the poorly-preserved area below the long-haired women, are traces of other boats and structures.

The most orderly register is the topmost, with a rhythmical composition created by a row of standards from which are suspended lapwings (later a hieroglyph used in writing the word for 'subject people'). The symbols on top show a row of hills, the Seth-animal (twice), the symbol of the god Min (see p.xvi), and a jackal divinity. They face in the same direction as the 'Scorpion King' but they did not continue around the entire upper circumference – another, unlocated, fragment from the top (shown at right in the drawing) shows part of three standards facing in the opposite direction. Bows are attached to these, and the image of a falcon atop a crescent facing left (see p. 23) is preserved on one.

Despite their size, the giant mace-heads were drilled vertically with central perforations, like functional ones, and could have been fitted with oversized 'handles', perhaps serving as supporting poles to display them upright in some ritual context. The preserved pictorial content of the 'Scorpion Mace-head' has suggested to some scholars that it was made for the celebration of a royal jubilee, and reflected the ruler's successful campaigns and territorial gains. In the absence of so much of its original decorated surface, however, this remains an open question.

13. Scorpions

Serpentine scorpion, l. 10.3cm; rock crystal tail, l. 7.4 cm; scorpion of malachite in iron-rich sandstone (?), l. 8.3 cm. From the 'Main Deposit', Hierakonpolis: Early Dynastic, *c.* 3300–3000 BC 1896–1908 E.194, 205, 204; ERA excavations of 1897–9 (Quibell and Green)

In addition to the fragmentary mace-head of the 'Scorpion King' (**12**), the buried deposits at Hierakonpolis included a number of model scorpions, as well as relief carvings of the creature amongst other animals on stone vases and ivories. More recently, model scorpions have also been found in tombs at Hierakonpolis which predate these deposits. In Egyptian religion, the scorpion was associated with a goddess, Selkis, who is attested from the 1st Dynasty onwards, and early in Dynastic times it also begins to feature amongst the symbols connected with the ruler's renewal of power at his jubilee. The Hierakonpolis scorpions, however, have no explicit relationship to the goddess; in this early context, perhaps it was the creature's own power that gave it significance.

In daily life, the scorpion's poisonous sting, delivered from its upraised tail, was an ever-present threat, a potentially fatal injury against which magic spells were used. The rock-crystal tail in this group was made for attachment to a body possibly made in another material, so that the lucent, raised tail would aptly symbolize the swift flash of its sting.

Ancient Egypt and Nubia

14. Model animals

The ceramic medium generally called 'faience' is one of the most typical productions of Ancient Egypt, used for small sculpture, vessels, and jewellery from earliest dynastic times until the Roman Period. Made of the same raw materials as glass – silica (in the form of sand or crushed quartz), plus lime and soda – it was prepared as a paste which could be moulded or modelled. The surface was glazed by a variety of techniques, using a range of colorants, but the most popular colour by far was blue-green, obtained by the addition of copper. Extra details could be painted or drawn in black (manganese) before firing.

Many faience models of creatures, as well as objects, were found in the Hierakonpolis deposits. Their significance here may in some cases relate to the performance of rituals including animal sacrifice and the presentation of food, rather than the divine association later attributed to certain animals. Amongst those shown here, the oryx and the hippopotamus were hunted; the quadruped wearing a collar may be a domesticated hound, man's assistant in the hunt; the pelican, a winter visitor to Egypt, was a seasonal food

Blue-glazed faience, modelled: dog(?) with a collar (E.5), l.9.8 cm; pelican (E.7), ht. 8.2cm; hippopotamus (E.3), l. 6.6 cm; baboon (E.191), ht. 7.7 cm; Beisa oryx (E.1), l. 9.1 cm. From the 'Main Deposit', Hierakonpolis: Early Dynastic, *c.* 3100–2800 BC
1896–1908 E. 5, 7, 3, 191, 1: ERA excavations of 1897–9 (Quibell and Green)

The Predynastic and Early Dynastic Periods

source. The many model baboons found at Hierakonpolis may anticipate the animal's later connection with the sun and moon (it 'greets' the dawning sun with a chattering noise), but the typical organization of baboon packs, in which a dominant male is 'ruler', may also have contributed to its early symbolism and the later association of baboons with the royal jubilee.

15. Ceremonial palette ('The Two Dog Palette')

Siltstone palettes, often in the shape of fish, birds, or animals, were used for the preparation of cosmetic paint, and were included amongst the grave goods in Predynastic burials. Sometimes the raw pigments – lumps of copper or lead ore – and a pebble for grinding them were placed with these palettes. Their surfaces often show signs of repeated use, with a sunken, abraded central area. In historic times, eye-liner was a standard cosmetic enhancement for both men and women; members of the elite are invariably shown made-up in this way, though the use of eyepaint seems in fact to have been quite widespread throughout Egyptian society. In prehistory, cosmetic paint may have been applied more extensively to the body, but was also probably more restricted in use, as the preserve of those with a particular role or social standing. A series of large, elaborately decorated palettes from the late Predynastic and Early Dynastic Periods shows their transition from practical equipment to objects with ritual significance.

Amongst the objects found at Hierakonpolis were the two best-known of these large, decorated palettes: the 'Narmer Palette' (Cairo Museum: ht. 63 cm), and the 'Two Dog Palette', the name conferred by Petrie on the example now in Oxford. Both have reservoirs for grinding paint, but their surfaces are smooth and carry no traces of use. The Cairo palette shows the triumphant King Narmer in scenes organized and divided horizontally, the linear format in which relief sculpture was composed throughout Egyptian history. By contrast, the 'Two Dog Palette' depicts the frenzy of

the animal world, where beasts pursue and attack, a kind of chaos compared with the 'subdued' world of Narmer. Into this seemingly wild environment, however, mythical beasts and the collared hunting-dogs of man have intruded.

The Oxford palette is framed by two hyena dogs (*Lycaon pictus*, Cape hunting dog) set like heraldic beasts, their forepaws touching. They define the area at the centre of which is the circular grinding-reservoir, flanked by the snaking reptilian necks of a pair of fabulous beasts with the heads and bodies of leopards (serpopards). Within this area move other hyena dogs – aggressive hunters which live and work in packs, they would have been native to Egypt at this period. The tongues of the serpopards work at the flesh of a fallen gazelle, and a bird (ostrich?) flutters its wings nearby. Below this carefully-ordered composition, three saluki hounds wearing collars harry a diverse troop of animals on the move – gazelle, ibex, Beisa oryx, and hartebeest.

This free style of composition is also seen over most of the reverse side of the palette, but at the top the heraldic pose of the hyena dogs is echoed on a smaller scale by a pair of long-maned lions attacking gazelles. Below them are various predators and victims – a serpopard biting an oryx, a leopard attacking a Barbary goat, with a hyena dog looking on, while a hartebeest flees; below, a winged griffin is about to assail a wildebeest. At the base, however, the scene becomes mysteriously different: a standing man wearing an animal (jackal?) mask and tail plays an end-blown flute, while a giraffe below steps calmly forward, and an ibex prances from the opposite direction, either fleeing from the action above or attracted by the flute-playing decoy.

The device of the 'heraldic' animals framing the palette is seen on others in this group, including one with four dogs encompassing the whole outline. On these other examples, however, the mass of stone between the animals' heads and forelegs has not been cut away. The clearing of this space on the Oxford palette is a distinctive feature. It probably contributed to the loss of one of the dog heads, broken away at the

(*next pages*) Siltstone palette, carved in low relief; head of one dog missing, repaired in antiquity; modern repairs to upper part of other dog – restored break at base of neck, reattached flakes on shoulder, foreleg, ribs; ht. 42.5 cm. From the 'Main Deposit', Hierakonpolis: late Predynastic–Early Dynastic, *c.* 3300–3100 BC
1896–1908 E.3924: ERA excavations of 1897–9 (Quibell and Green)

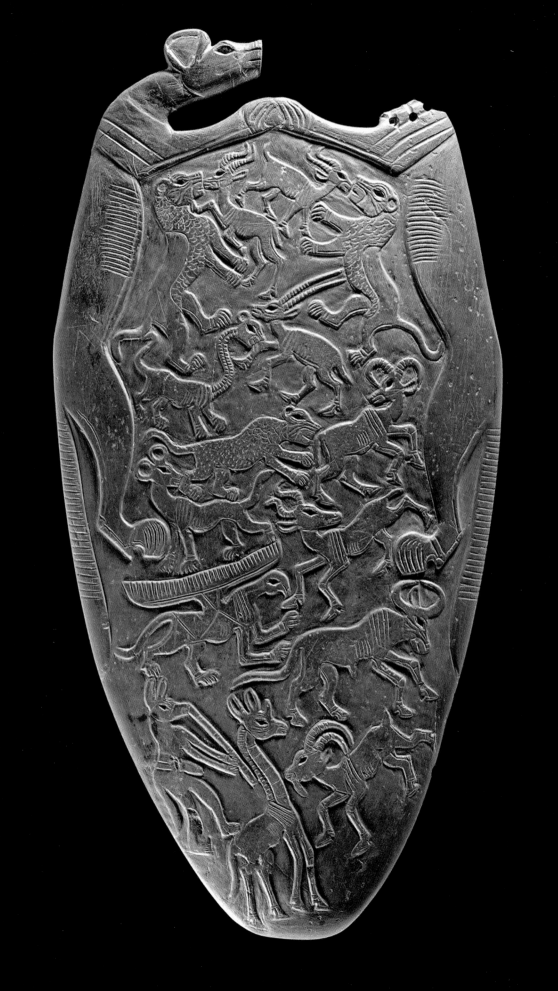

base of the neck. The stone was repaired here in antiquity: holes were bored on either side of the irregular break, and a groove was cut along the upper edge of the palette. Reattaching broken fragments by lashing them with copper wire threaded through drilled holes is a method which can be seen on surviving ancient repairs of stone or ivory artefacts, sometimes in conjunction with the use of adhesives.

The break could have occurred in the course of manufacture, or during the palette's use as a ritual object; there are also patches of flaking on the other dog's body and lower down on the same side, perhaps because this edge was exposed when the rest of the palette lay buried. In other respects, the surface is well-preserved and the exceptional quality of the carving, ranging from subtle relief modelling to the deep cutting of the animals' eyes, perhaps to contain inlays, is clear to see. The nature of the palette's ritual function is unknown: the common theme of these large palettes seems to be successful aggression – the overcoming of human foes, men hunting animals, or the power of predatory beasts over other animals. The palettes might have been created to procure or to commemorate a successful action.

16. Ivory statuette of a woman

Enveloped in a kind of mantle, this woman is one of several such figures recovered from the large deposit of carved ivories which formed a particular feature of the 'Main Deposit' at Hierakonpolis. They included statuettes of men, women, children, and captives; model boats, animals, spoons, vessels, sceptres, cylinders, knife handles; and rectangular and cylindrical pieces with tenons, slots, or holes which suggest that they were furniture components.

Like several of the other female figures, this woman has an elaborate hairstyle or wig with two distinct features: a bouffant upper part composed of parallel locks divided by a central parting, and below this, visible at the back, a descending mass of braids. Amongst other ivory figures from Hierakonpolis shown with this hairstyle are two nude female dwarfs.

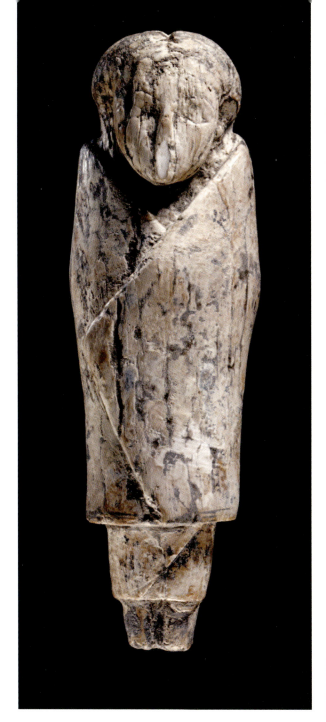

Carved hippopotamus ivory; ht. 18.5 cm. From the 'ivory trench' of the 'Main Deposit', Hierakonpolis: Early Dynastic, c. 3100–2800 BC
1896–1908 E.326: ERA excavations of 1898–9 (Quibell and Green)

The mantle in which this woman is wrapped is reminiscent of the robe assumed by the king during his jubilee celebration (20), but here another wrapped garment with a lower hemline is visible below it. Although the hairstyle bears some similarity to that later associated with the goddess Hathor, the identity of the woman – royal, divine, or the participant in some ritual – is unknown.

The Predynastic and Early Dynastic Periods

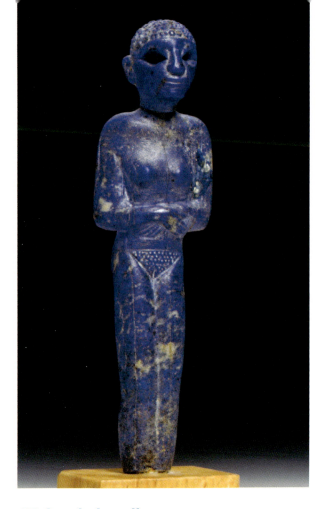

Lapis lazuli, the head and body carved separately and pegged together, modern repair to left arm; ht. 8.9 cm. From the temple enclosure, Hierakonpolis: Early Dynastic, c. 3300–3000 BC
1896–1908 E.1057 (body): ERA excavations of 1898 (Quibell and Green); 1057a (head): gift of Harold Jones, from the University of Liverpool excavations of 1906 (Garstang and Jones)

17. Lapis lazuli woman

Lapis lazuli was esteemed above all other precious stones in Ancient Egypt, and blue was the most favoured colour: the bodies of the gods were described as being made of lapis lazuli, and even in Predynastic times, sizeable pieces of this stone were being imported for the creation of prestigious objects. They must have travelled along a complicated trade route: Egypt's closest known source of true lapis lazuli is Afghanistan.

This figure has an archaeological history as extraordinary as its form is unique. In antiquity, it was made of two separate pieces: the head, carved from a more deeply blue piece of lapis lazuli, had been attached to the body at the neck by means of a wooden peg fitted into drilled cavities. The body was found in the 1898 season's work at Hierakonpolis; eight years later, the head was recovered during a different campaign.

Many of the carved ivory women from the 'Main

Ancient Egypt and Nubia

Deposit' are shown nude, standing with legs together, right arm at their sides, left folded under their breasts; they have flowing, wavy hair that extends far down their backs. The short, tightly-curled hair of the lapis lazuli woman is unparalleled, and the pose of her hands and arms is not found amongst other female figures from this site (but see the arms of the ivory female figure on p.18). Her face is dominated by the large eyes, deeply cut for inlaying; the details of her body are summarily indicated, save for the detailed carving of the pubis. The legs end in a straight edge at ankle-level, and on the underside of this is another drilled cavity. This may have served to peg her to a base, or attach separately-made feet; it has also been suggested that the figure was the terminal of a spoon-handle.

The lapis lazuli woman's unique features have led to the suggestion that she is not Egyptian but was carved, in part or whole, somewhere along the trade route between Iran and Egypt. There are no strong parallels from this area to support this idea, however, and she remains a beautiful enigma.

18. Fragment of an inscribed stone bowl

The tombs of the first kings of Egypt at Abydos were filled with goods, providing them with a virtual household for eternity. Built of mud-brick and containing many storerooms as well as a burial chamber, these tombs were stocked with sealed and labelled packages of foodstuffs and cloth, jars of wine, oil, food, and unguents, utensils, furniture, and vessels of stone and copper inscribed with the royal name. Despite the reverence with which the site was regarded, the tombs did not remain intact: over time they were pillaged and burnt, so that most of the beautifully-crafted goods which these kings had taken into eternity survive only as smashed and scattered remnants.

This fragment comes from a shallow bowl incised with the name of King Anedjib of the 1st Dynasty. It is written within the *serekh* symbolizing the palace, the

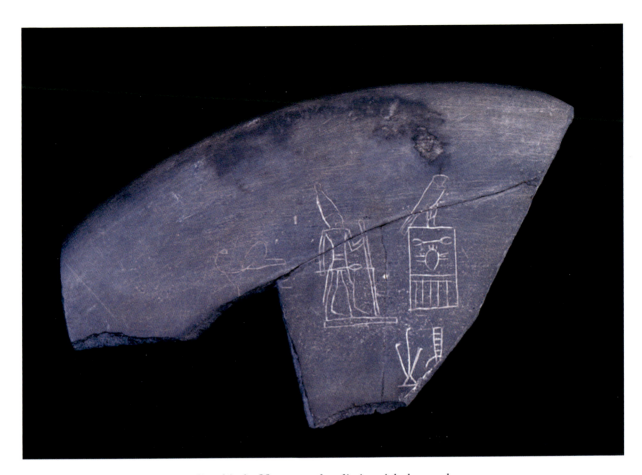

Part of a carved siltstone vessel, reconstructed from three fragments; max. w. 20.5 cm. From Abydos: *c.* 3285 BC 1896–1908 E.137: acquired in 1904 at the sale of objects from Amélineau's excavations of 1895–6

earliest kind of frame used to distinguish the royal name. Atop sits the falcon of the god Horus, of whom the king was the living embodiment on earth, and underneath in hieroglyphs (incomplete) is written the royal epithet 'uniter of Upper and Lower Egypt'. Left of the *serekh* stands an image of the king as ruler of Upper Egypt (cf. the 'Scorpion King', **12**), holding a staff and mace. Further left, another incomplete inscription begins with the hieroglyph depicting feline hindquarters, for which several phonetic readings are possible.

19. Fragment from a piece of royal furniture

Carved to resemble bound stalks of reed or rush, as in matting or basketwork, this fragment comes from a piece of royal furniture. It was probably part of the top of a chair, although its total width (both outer edges are preserved) is not of functional size. On one side it

is decorated within the 'matting' border with square panels filled with triangular inlays of glazed faience (blue, green, and black) alternating with wood. On the other side, a central panel is carved in low relief to show a *ka*-sign (pair of arms) embracing a royal *serekh* surmounted by a falcon; flanking this are compound *ankh*-signs and *was*-sceptres ('life and power'). There is no legible name within the *serekh*. The surface of the carving in and around the panel is covered with very fine linen, probably the foundation for a covering of gold (see **38**).

Although its size and delicate workmanship suggest that this was not part of a functional piece of furniture, it might have been made expressly for use after death by the royal tomb-owner's *ka*, the spirit that required a dwelling and sustenance for eternity. A furniture fragment of similarly inlaid wood was found in tomb 3504 at Saqqara, dated to the 1st Dynasty, and full-sized chairs carved with mat-pattern decoration were buried at Giza with Queen Hetepheres, of the 4th Dynasty (about 2570–2550 BC).

Furniture fragment carved from softwood, inlaid with pieces of faience and lighter-coloured wood bedded in plaster; assembled from two pieces, inlays restored; max. w. 27.1 cm. From Abydos: *c.* 2800 BC 1896–1908. E.138: acquired in 1904 at the sale of objects from Amélineau's excavations of 1895–6 + E.1255: EEF excavations of 1900 (Petrie)

The Predynastic and Early Dynastic Periods 37

The two pieces of which this fragment is composed came from different excavations at Abydos: the larger was recovered by Amélineau in 1895, while the small piece which makes a perfect join at the upper left edge of the inlaid side was found five years later by Petrie in the tomb of King Semerkhet (tomb 'U'), of the 1st Dynasty.

20. King Khasekhem

Khasekhem was the last king of the 2nd Dynasty; it seems that in the course of his reign he waged a military campaign to reassert control over the north of Egypt, significantly changing his name thereafter to Khasekhemwy ('The Two Powers shine forth'), with the dual version (ending in -*wy*) of the word for 'power' (*sekhem*). A number of objects inscribed with his earlier name were found at Hierakonpolis, suggesting that this was his base in southern Egypt until the successful reunification of the land. It was also the site of a large mud-brick ceremonial enclosure built by him and possibly used as the location of a festival connected with the renewal of his power over Upper and Lower Egypt.

This statue, found within the temple enclosure at Hierakonpolis, shows Khasekhem seated on a low-backed throne, wrapped in the cloak-like garment associated with the royal jubilee celebration, and wearing the White Crown. His right hand is hollowed to take an added object such as a flail or sceptre. The limestone of which the statue is made is creamy-white shading to pink in places, and now marked with black dendritic stains. A matching statue, 56 cm high and carved in dark siltstone, was found in a different part of the site (see **25**) and is now in the Cairo Museum.

On both statues the dais of the king's throne is carved with the prostrate and contorted bodies of slain

Limestone, the surface marked with manganese dendrites; reassembled from fragments, with the left shoulder and torso above the waist restored; ht. 62.4 cm. From Hierakonpolis, temple enclosure; 2nd Dynasty, *c.* 2700–2650 BC
1896–1908 E.517; EES excavations of 1897–9 (Quibell and Green)

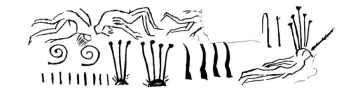

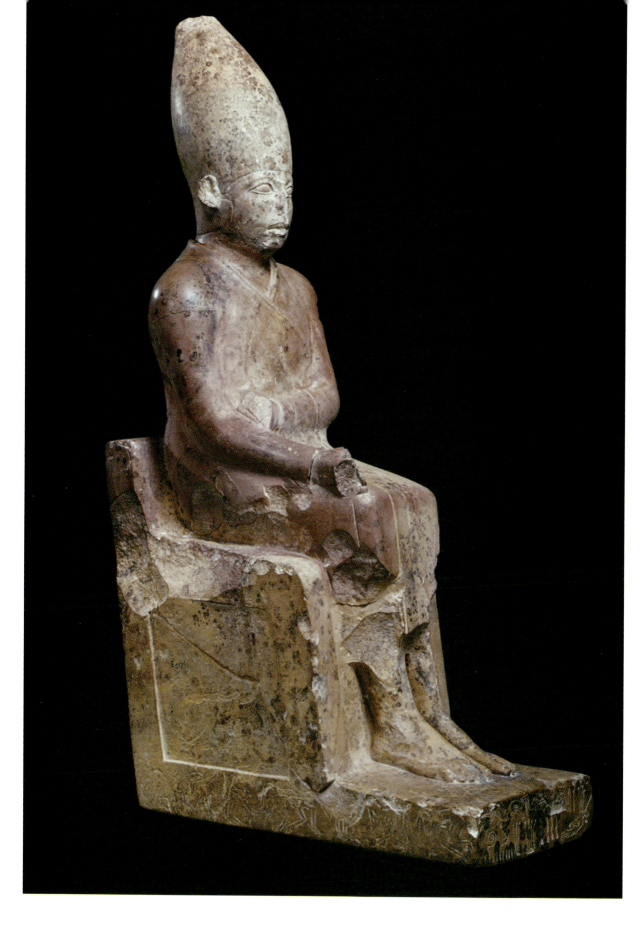

enemies, with their total number given on the front – 47,209 on the Oxford base, which identifies them as 'rebellious inhabitants of the Delta', symbolized at the right by a clump of papyrus springing from the head of a bound figure who is apparently being struck by a mace. The Cairo statue records 48,205 dead. Incised in a less emphatic way on the upper surface, facing towards his royal person, is the king's name in its earlier form.

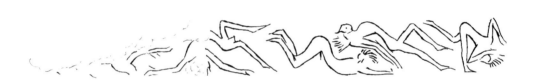

The slain enemies on the sides and back of the dais

The depiction and enumeration of the slain rebels refers to the 'Year of the War against the northern enemies', as it appears in the records – the crucial period which consolidated Khasekhem's power and led to his re-emergence as Khasekhemwy. The reason for the duality of the figures found at Hierakonpolis, and the light/dark contrast of their stones is not known. Amongst various dual images prominent in Egyptian thinking, those of day/night or Upper/Lower Egypt might be relevant here, though in both sculptures the crown he wears is that of Upper Egypt. They are the earliest surviving inscribed royal sculptures from Egypt.

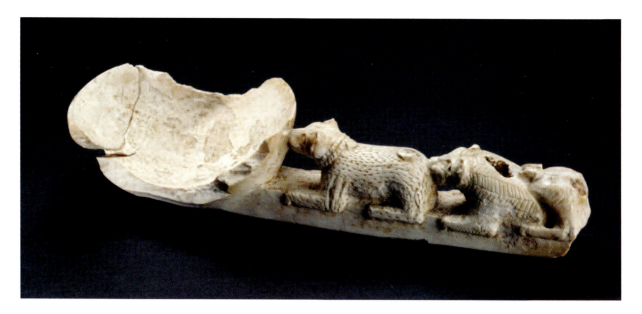

21. Carved ivory spoon

Small spoons of bone or ivory were placed in Predynastic graves along with palettes, grinders, jars, and the materials for cosmetic paint. Larger and more elaborate spoons continued to be included amongst grave goods during the transition to the Early Dynastic Period. Their size suggests that they were used for some more substantial preparation, like ointment, but their decoration, as in this case, sometimes recalls the imagery seen on earlier cosmetic equipment – birds, fish, animals, and hunting scenes.

On the handle of this spoon a lion bites the rump of a hunting dog whose muzzle is pressed to the bowl; behind the lion the handle is broken, so it is uncertain whether there was another animal behind the lion. The dog wears a collar, and its lop ears, speckled coat, and heavy build suggest that it is a mastiff, represented in hunting scenes of this period. The hair of the lion's mane is depicted in bands of hatching which distinguish it from the rest of the body. Despite the implicit ferocity of the decorative theme, both animals sit with their legs neatly aligned along the shaft of the handle. Although it was discovered at the site of one of the most important early cemeteries in Upper Egypt, the spoon was not excavated but found accidentally by someone digging for salt.

Carved hippopotamus ivory; l. 13.5 cm (incomplete). From Ballas: Early Dynastic, c. 3100–2900 BC
1895.902: gift of W.M.F. Petrie and the ERA

Carved siltstone; w. 11.3 cm. From Abydos; Early Dynastic, c. 3000–2800 BC
1896–1908 E.139: acquired in 1904 at the sale of objects from Amélineau's excavations of 1895–6

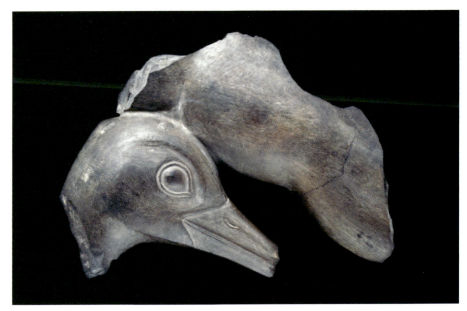

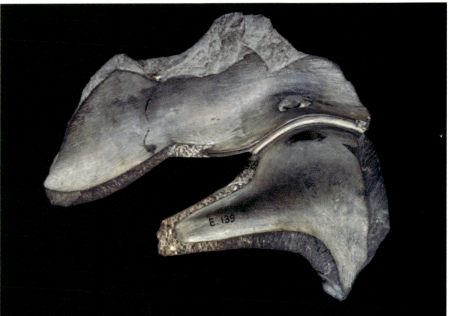

22. Fragment of a carved dish

Carved in hard siltstone, this fragment from a much larger vessel or lid of complicated shape shows the head of a waterfowl, probably a duck. The curving form adjacent to it is the upper part of an arm, one of a pair in the shape of the hieroglyph ka ⊔, which would have been holding the bird. The reverse side is divided into compartments following the outlines of the duck head and the arm; the thin wall separating them is

pierced with a hole. Such perforations usually served as the means of attaching something else to the object with a pin or wire; if this fragment was part of a vessel, however, it would have enabled anything small or liquid placed in these cavities to flow from one to the other.

Numerous fragments of such stone vessels were recovered, like this one, from the early royal tombs at Abydos; complete examples have been found at Saqqara and elsewhere. They demonstrate the virtuosity of the stonecarvers who made these luxurious items, as well as the diversity of shapes they created, such as baskets, a vine leaf, and compound forms like this one where the assembled images may have expressed a concept. An unprovenanced vessel in New York shows the *ka*-sign holding between its hands the *ankh*-sign for 'life', carved in such a way that water could have been poured from it. The duck depicted on this fragment could likewise refer to the sustaining food and drink required by a person's *ka*, the spirit that received offerings after death.

23. Stone bowl

The handle of this siltstone vessel is carved in the shape of a gazelle leg doubled-back and bound with rope. It is one of a small group of dishes or shallow bowls with this distinctive style of handle; they were probably used as containers for unguent. The fact that the leg is bound implies that the animal to which it belonged was destined for slaughter. In later Egyptian religious practice, the sacrifice of an antelope or gazelle was a royal prerogative, but there is no evidence for such a ritual in the period to which these dishes belong. Their form and material indicate that they belong to the category of luxury stone vessels produced in Early Dynastic times, and placed in the burials of both royal persons and members of the elite.

The most recent addition to this group was discovered in an Early Dynastic burial at Manshiat Ezzat in the Nile Delta, together with a large decorated siltstone palette; this confirms the dating and likely context of the others, none of which has an

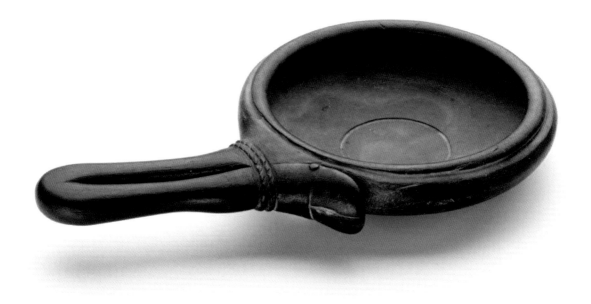

Carved siltstone, l. 17.8 cm.
From Saqqara; Early Dynastic,
c. 3000–2800 BC
1887.2428: Thomas Shaw
collection, transferred from the
Bodleian Library

archaeological provenance. We do, however, know that the Ashmolean bowl was bought at Saqqara in July 1721 by Thomas Shaw, who subsequently published it in his *Travels or Observations relating to several parts of Barbary and the Levant* (Oxford, 1738). It had most likely come from one of the many cemeteries scattered throughout the desert to the north and south of Saqqara.

24. Lotus jar

The elegant form represented by this stone jar is the chalice-like flower of the blue lotus, *Nymphaea caerulea*, which opens at sunrise and blooms through the morning until midday. Its tapering petals are individual pieces of travertine set in plaster around a conical jar; the pointed sepals are made of dark green argillite, forming an outer cup of four adjoining pieces.

In Egyptian religion, the blue lotus was a symbol of the eternal renewal of life. It became associated with

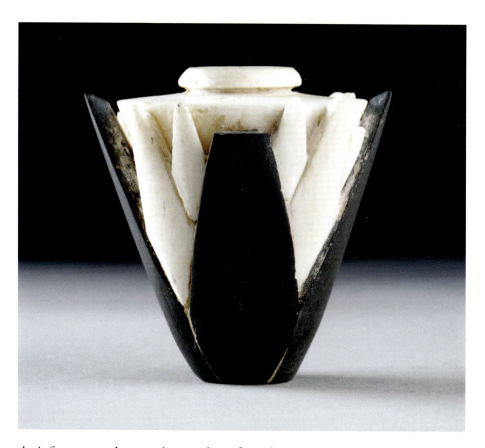

the infant sun-god, appearing on a lotus from the waters of chaos on the first day of creation, just as the lotus rose every morning from the surface of the water when the chaos of night was dispelled by the light of a new day. In addition, the beauty and fragrance of the lotus, and perhaps also its narcotic properties, gave it erotic connotations in Ancient Egypt, and the flower was thus especially appropriate for the shape or decoration of cosmetic vessels. This jar was found in the burial of a woman, whose grave-goods also included a wig, beads, and cloth. It is one of a small number of this date placed in tombs, where its suggestion of renewed life and physical attraction would have been very apposite.

Composite vessel of travertine, argillite, and plaster, repaired, one sepal restored; ht. 6.3 cm. From Lahun, grave 743; Early Dynastic, *c.* 2800 BC
1921.1343: BSAE excavations (Petrie)

Dynastic Egypt, from the 4th to the 25th Dynasty

Chronological outline

Dynasty	Approximate dates	Rulers	Significant events
The Old Kingdom			
4th Dynasty	2575–2450	Eight rulers, beginning with Snofru	Construction of the great pyramids at Giza; founding of a settlement at Buhen in Lower Nubia
5th Dynasty	2450–2325	Nine rulers, beginning with Userkaf	The 'Pyramid Texts', to help the king in the underworld, inscribed in the pyramid of Wenis, last of the dynasty
6th Dynasty	2325–2175	Six rulers, including Pepy I and Pepy II	Egyptian power declines during the long reign of Pepy II (2246–2152)
1st Intermediate Period			
9th, 10th (northern) and 11th (southern) Dynasties	2125–1975	Contemporaneous rulers in the north and south	Recorded in later literature as a period of disorder
The Middle Kingdom			
11th Dynasty	1975–1940	Three rulers of a reunified Egypt, beginning with Mentuhotep II	Mentuhotep II builds a funerary complex in Western Thebes
12th Dynasty	1940–1755	Eight rulers, beginning with Amenemhet I and including Senwosret I, Amenemhet III	Amenemhet I, vizier at the end of the 11th Dynasty, moves the royal residence from Thebes to Memphis; building of forts in Lower Nubia, where Senwosret III extends the frontier to the Second Cataract. The 'classical' period of Egyptian literature; use of bronze becomes common
13th and 14th Dynasties	1755–1640	About 70 rulers, those of the 14th Dynasty contemporary with the 13th or 15th Dynasties	Central authority weakens; increasing presence of Western Asiatics in Lower Egypt

Chronological outline (cont.)

Dynasty	Approximate dates	Rulers	Significant events
2nd Intermediate Period			
15th and 16th Dynasties (Lower Egypt)	1640–1540	Hyksos (Asiatic) rulers, based at Avaris in the Delta	Introduction of the horse and chariot, the composite bow, and new technology
17th Dynasty (Upper Egypt)	1640–1540	Numerous rulers based at Thebes, including Kamose	Campaigns against the Hyksos in the north, and their Nubian allies
The New Kingdom			
18th Dynasty	1540–1292	Fourteen rulers, beginning with Ahmose and including Thutmose III, Amenhotep III, Akhenaten, and Tutankhamun	Reunification of Egypt with Thebes the royal capital and cult-centre of Amun-Re; extension of Egypt's power – Thutmose I campaigns as far as the Euphrates to the north, and the Fourth Cataract in Nubia. After the female 'king' Hatshepsut, Thutmose III and his successors continue military campaigns. Akhenaten introduces a new solar religion with one divinity, the Aten. Return to orthodoxy under Tutankhamun
19th Dynasty	1292–1190	Eight rulers, including Ramesses II	Conflict with the Hittites in North Syria; the Battle of Qadesh, indecisive but commemorated in the monuments of Ramesses II, greatest builder of all, as a victory. Invasion of the 'Sea Peoples' in the time of Merneptah (*c.* 1213–1204)

Dynastic Egypt, from the 4th to the 25th Dynasty

Chronological outline (cont.)

Dynasty	Approximate dates	Rulers	Significant events
20th Dynasty	1190–1075	Ten rulers, nine of them named Ramesses	Wives of Ramesses III con conspire over successsion to throne; increased land-holding enhances the power of the temple of Amun at Thebes; weakening of central authority
3rd Intermediate Period			
21st Dynasty	1075–715	Seven rulers based at Tanis in the Delta	High Priests of Amun wield effective power in Thebes
22nd–24th Dynasties	945–750	Partly contemporaneous lines of rulers in different parts of Egypt	Palestinian campaign, including the sacking of Jerusalem, by Shoshenq I (945–925), first ruler of the 'Libyan' 22nd Dynasty
25th Dynasty	770–715	Kushite rulers Kashta and Piye (Piankhy)	Kushite dominion over Nubia and the Theban area

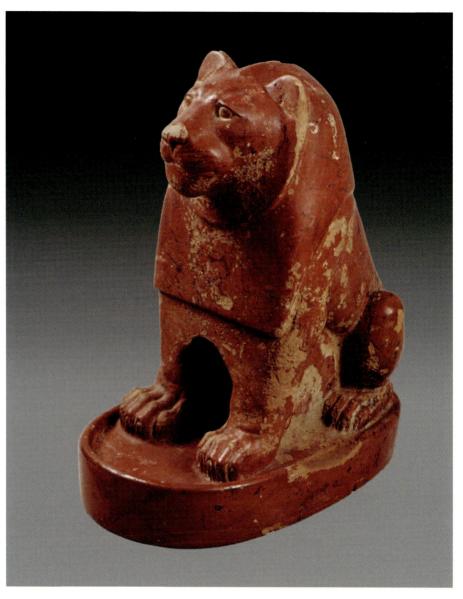

25. Pottery lion

This watchful lion is a rare surviving example of Egyptian sculpture in clay; the modelling and firing of large pieces in this medium pose considerable artistic and technical challenges. The lion is depicted with a mixture of realism and stylization. Its face, muscular body, and paws – the toes curled in repose yet promising powerful action with their claws – are shown with graphic naturalness. Its mane, however, is rendered rather geometrically, the ruff around the face forming a circle continuous with the ears, and the fall of hair on the chest shown as a bib-like square. The

Modelled in Nile silt, coated with haematite wash and polished before firing, patches of surface lost; ht. 42.4 cm. From Hierakonpolis, temple enclosure, 'Citadel': probably 6th Dynasty, c. 2325–2175 BC
1896–1908 E.189: ERA excavations of 1897–9 (Quibell and Green)

body is proportionately small for the head (probably because of the technical limitations of the medium), yet the overall impression is one of dignity and strength. The oval base with a rim may have been added for technical as well as functional reasons.

The lion was found in a cache of objects in the temple enclosure at Hierakonpolis which included the siltstone statue of King Khasekhem, pair to the limestone figure in Oxford (**20**), and the copper statue of Pepy I (Cairo Museum), over the legs of which it was lying. Within this context of objects dating from the 2nd Dynasty to the 6th, the lion is probably to be placed, for stylistic reasons, at the latter end, with King Pepy.

In Egyptian mythology, paired lions often served as the guardians of entrances, and sculpted lions performed the same function in temples. This pottery figure may have had a companion – the excavators reported the discovery of pieces of another pottery lion in a different part of the site; the two may have served as guards within the precinct.

The lion as found, lying upside-down over the legs of the copper statue; drawing by Annie Quibell (née Pirie). The moist soil in which it lay caused the mottling and flaking on its surface

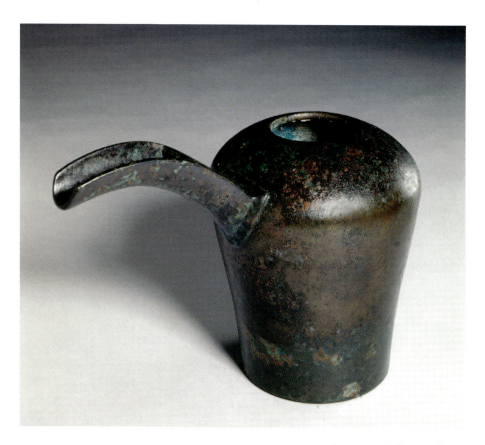

26. Copper ewer

Early in Dynastic times, a new item began to feature in funerary scenes which showed the deceased seated at a table laden with food offerings: an ewer and basin for washing the hands. Such cleansing would have been considered appropriate before eating, and also before performing religious rituals. Like the other vessels and food depicted in tomb scenes, these washing sets were included in reality amongst the grave goods. Ideally made of metal or stone, they were also more cheaply produced in pottery; sometimes models served as substitutes.

 This ewer, which would have formed a set with a splay-sided bowl, is a complex piece of metalworking involving two different processes, raising and casting. The body was raised by beating a copper sheet: copper is a more brittle medium than bronze (which did not come into general use in Egypt until the Middle Kingdom), and requires skilful handling. Normally vessels are raised from bottom to top, but it would be difficult to shape this kind of narrow-mouthed ewer by

Copper vessel with a raised body and cast spout, broken area to left of the spout; ht. 15.2 cm, diam. of mouth 5 cm., max. diam. of body 14cm. From el-Kab, mastaba A: 4th Dynasty, c. 2571–2450 BC
1896–1908 E.407: ERA excavations of 1897 (Quibell)

that method. A few vessels of this type have apparently been raised upside-down, with the mouth subsequently cut out of the top, the spout inserted, and the bottom sealed with a sheet of copper; it is not clear whether this ewer was made in that way, but it seems likely. The cast spout with a flange is fixed to the body via a hole cut to shape; the outer margin of the flange is angled under the cut edges and was probably cold-hammered in place on the inside.

The washing set to which the ewer belonged was found in a brick-built mastaba tomb, with the body of a man identified by fragments of inscribed limestone as the priest Kaimenu. With it was a model granary of pottery, stone vessels, and model tools.

The priest Sheri and his wife Khenteyetka, with funerary offerings. Each is provided with a washing set, shown in the space in front of them: the ewer with a beak-like spout is shown above the bowl. This limestone block carved in low relief is one of the inscribed pieces given to Oxford University in 1683 by Robert Huntington. Like the coffin board (**58**), it came from Saqqara, where it originally formed the cornice of the false door (the place where the deceased received food offerings) of Sheri's tomb.
1836.479, carved limestone, 44 x 106 cm: 4th Dynasty

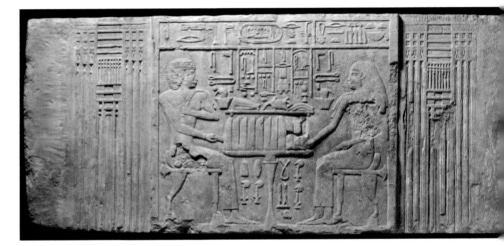

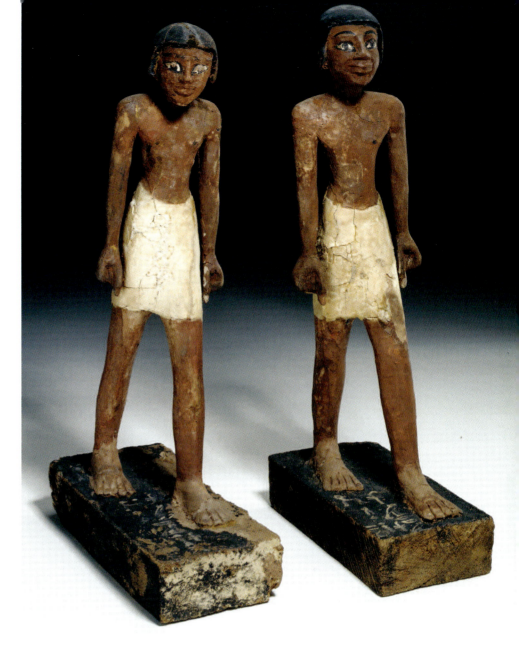

27. Funerary statuettes

In these twin images the tomb-owner Nebem-henennesu strides forward confidently into eternity. His name and titles – 'royal noble, overseer of craftsmen' – are painted on the statue-bases, and he is depicted according to a set of conventions for representing male figures established in Egyptian art at the beginning of Dynastic times: left foot forward, arms at the sides, or one hand extended and holding a staff, and (in all painted representations) red-brown skin. He wears a short wig and short kilt. The shaping of the figures is somewhat rudimentary with no attempt to

Sycamore wood, plastered and painted, with some restorations, especially to the ankles and feet; ht. 38.2 and 37.9 cm. From Sidmant, Maiyana cemetery, shaft-grave 604: 6th Dynasty, c. 2325–2175 BC
1921.1418, 1419: BSAE excavations (Brunton)

show musculature, their most conspicuous feature being the broad shoulders set off by narrow waists.

Nebemhenennesu's statuettes were intended to provide a physical image for his continuing existence in the afterlife. Both the mummification of the body and the provision of sculpted representations of the deceased were directed to this end. The dead person's *ka* – the essence of their vital being that remained in the tomb and required sustenance – could occupy these images. The food and drink which the dead needed was also represented in model form, in addition to its provision in reality as offerings and its magical recreation in funerary texts. Nebemhenennesu's well-equipped burial included servant models showing various stages in the manufacture of bread and beer.

Wooden models and sculpture were equivalent in function to the scenes carved in relief or painted on the walls of tombs, and have survived relatively well in some burial contexts. In general, wood was undoubtedly much more widely used as a medium for sculpture of all sizes, and in many different locations, than the surviving quantity of statues and statuettes would suggest.

Woman grinding corn on a saddle quern: one of the painted wooden models from Nebemhenennesu's grave. *1921.1423; L. 34 cm*

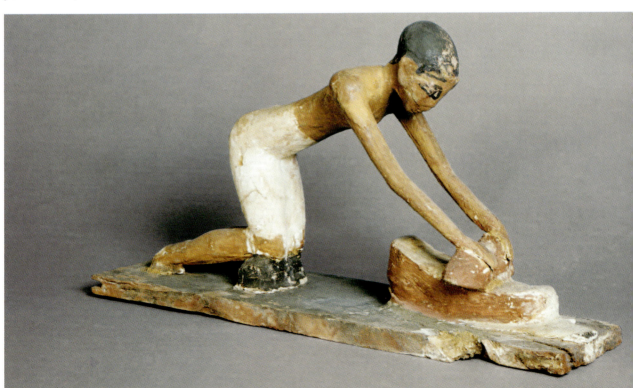

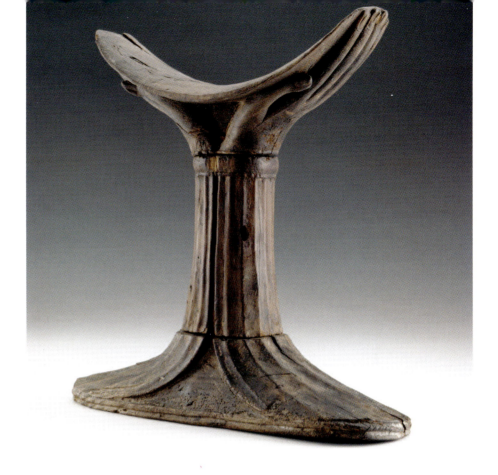

28. Wooden headrest

Egyptian beds consisted of a wooden frame with strapping to take a mattress; the sleeper's head was supported on a headrest made as a separate item. A great number of these have survived in tombs, sometimes with clear traces of lifetime use; they include portable folding models. Wood was the most common and practical material used to make headrests, though there are also examples in stone, ivory, and faience; the curving rest at the top could be padded for extra comfort. In addition to regulating the sleeper's posture (ancient Egyptians apparently slept on their sides), a headrest would keep the head cooler in hot weather; they are still used in some parts of Africa.

Headrests figure prominently among the items provided in burials of the Old Kingdom, and this beautifully-carved example is of a style first seen then, and continuing in production until the Middle Kingdom. The support is conceived as a pair of human

Carved in softwood (from a legume), in three parts secured with mortise and tenon joints, with a decorative round dowel through the upper joint; ht. 12.2 cm. From Haraga, grave 86; 1st Intermediate Period, c. 2125–1975 BC
1914.673: BSAE excavations

hands, carved in relief on the underside of the curving rest. On some examples, this imagery is continued with the shaping of the supporting column as a pair of arms wearing bracelets; and on a few of these, the base of the headrest is carved as a pair of human feet, standing firm. There may be an allusion here to a specific mythological supporter in human form, but no surviving text or representation identifies such a being.

These 'hand headrests' typify the subtle ability of Egyptian craftsmen to introduce the unexpected into the established forms of artefacts. The elegant hands of this one are carved in high relief, the elongated fingers reaching the very edges of the curved rest, the nails carefully detailed. A single bracelet-like band unites them at wrist level; below that the columnar element has a fluted surface but retains a central division corresponding to the separate hands, and as it expands downwards, it divides, like feet, over the base. The whole object thus has a beautiful curving symmetry and a combination of textures which evoke different possibilities – the fluting echoes the linear pattern formed by the fingers but is also reminiscent of plant forms, and their replication in architecture.

This exceptionally fine headrest had been placed in the burial of a child which was subsequently plundered, so its original location therein is unknown. A headrest has sometimes been found under the head of a mummy, emphasizing the particular importance of headrests for the afterlife, in an extension of their mundane service: they would assist the deceased to raise his or her head in resurrected life, but also prevent its being severed from the body. Spell 166 of the Book of the Dead asks that the sleeper's head shall be awakened at the horizon, and no enemy shall harm it: 'You are Horus, son of Hathor ... Your head shall not be taken from you ...' From the 18th Dynasty onwards, a model headrest was included amongst funerary amulets. The earliest, exclusively royal, models were made of meteoric iron, and this preference for special material continued in the choice of dark stones, especially haematite, for these amulets.

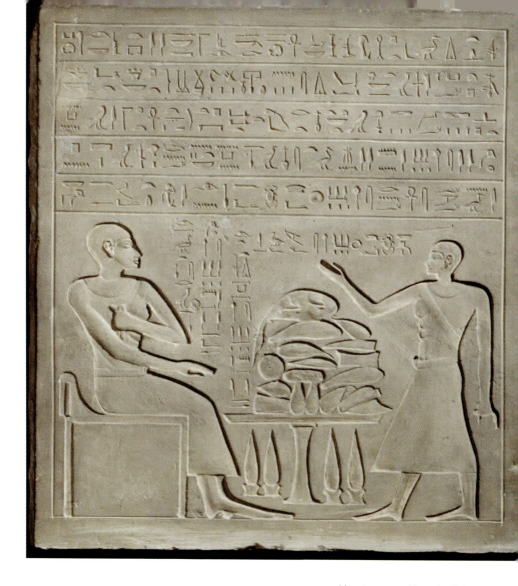

29. Stela of the Inspector of Fields, Imeny

A stela (the Latin form of the Greek stele) is a slab of stone or other material, inscribed or decorated for documentary or commemorative purposes. Often thought of as primarily funerary monuments, akin to gravestones, their function was in fact much more diverse: in the world of the living, they were used to record important events, decrees, legal or oracular decisions (47), and religious donations. In this aspect, they would be set up in temples or at sacred sites. Individuals could also dedicate small stelae with personal expressions of piety in such places (48).

In Ancient Egypt, stelae had an important funerary function, when inscribed with the texts which ensured

Limestone, carved in sunk relief, with traces of red paint; 49.5 x 45.7 cm. From Abydos, cemetery east of the Osiris temple; 12th Dynasty, c. 1940–1735 BC
1926.213; EES excavations (Frankfort)

Dynastic Egypt, from the 4th to the 25th Dynasty

the supply of everything which would sustain an Egyptian in death as in life. Placed in a tomb chapel or on the exterior of a tomb, they were to be read by the living (especially the priest employed to serve the dead person's funerary cult), and the commodities enumerated in the inscriptions would thus be magically recreated for the dead.

On this well-carved stela from Abydos, the confident figure of the tomb-owner Imeny is depicted in sunk relief, as he sits before a laden table, with sealed beverage jars on stands shown below. His jewellery and clothing, the cloth in his hand, and the comfortable rolls of flesh on his chest denote his status. His son Khakheperre stands making a gesture of offering, and the sustenance provided for his father and family is depicted on the table: loaves, joints of meat, vegetables, and a fowl. Although his body, and especially his head, are decorously shown at a smaller scale than his father's, Khakheperre carries the same outer signs of prosperity; he, too, was an Inspector of Fields. The hieroglyphic text invokes the provision of 'bread and beer, cattle and fowl, linen, all vegetables and all gifts, food-offerings, a thousand of all good pure things which the heaven gives and the earth brings forth' via the agency of the gods Geb, Ptah, Sokaris, Osiris, and Anubis.

Imeny's stela was found with several others in drift sand, and it is unlikely that he was actually buried at Abydos. Revered as the location of the tombs of the first kings of Egypt (**18**, **19**), Abydos subsequently became the chief Upper Egyptian cult site of Osiris, god of the underworld. The tomb of King Djer of the 1st Dynasty was identified as the god's, and the death and resurrection of Osiris were celebrated annually in a great festival. Burial in this most sacred place was an aspiration not just for the local population, but for all persons of rank. Many officials of the Middle Kingdom placed themselves eternally in the god's vicinity by having memorial chapels, where they were commemorated by stelae and statues, constructed in the area adjacent to the temple of Osiris, from which the annual procession set forth to his tomb .

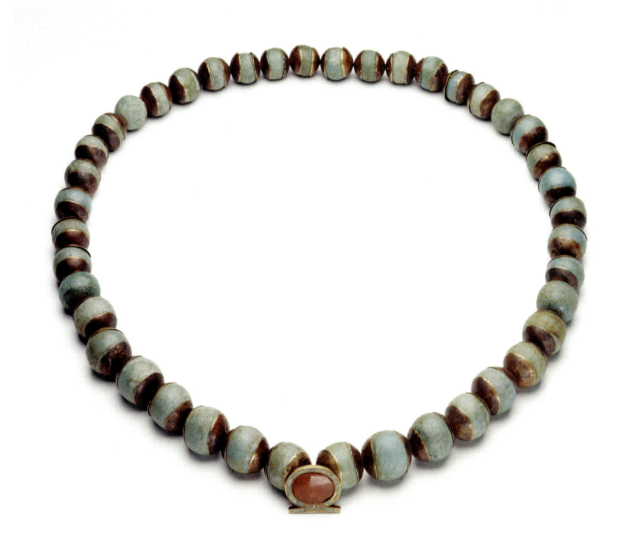

30. Necklace with a *shen*-sign

From the Old Kingdom onwards, the most important name of an Egyptian king – the one he assumed at the beginning of his reign – was written in a rectangular frame with rounded corners (a cartouche). The same frame was later used also for his name as the 'Son of Re', the sun-god, one of the five names carried by an Egyptian king in the fully-developed sequence of royal titles. The cartouche was depicted as being made of rope, the ends tied at the bottom. In origin the rope cartouche sign was circular; its Egyptian name, *shen*, relates it to the verb 'to encircle', and it represented that which is encircled by the sun – in Egyptian eyes, the land of Egypt. When associated with the king's

Necklace of 42 beads and a pendant, faience, electrum, carnelian, and turquoise; length 52.5 cm as restrung. From Abydos, grave E 105: late 12th Dynasty, *c.* 1800–1755 BC
1896–1908 EE.472: ERA excavations of 1900 (Garstang)

name, it evoked his supreme controlling power; as a sign in its own right, a cartouche enclosing the sun's disk was considered to be a powerful amulet.

This necklace is composed of the large spherical beads typical of Middle Kingdom jewellery, made here of glazed faience enhanced with caps of electrum. The centrepiece is a *shen*-sign made of electrum in cloisonné technique: thin vertical strips of metal have been fused on to a shaped backplate to create compartments for inlays of carnelian and turquoise. A single piece of carnelian forms the sun-disk at the centre, and a loop is fused on to the back of the plate. The beads and pendant were found with other fine objects removed from their tomb context but seemingly belonging to a single individual's burial: they included a funerary statuette inscribed for an official named Nakht, Overseer of the Delta.

31. Birds and fish

These amulets were found lying on the chest of a mummy, hidden under sand which had fallen on to the body when the burial was disturbed. The largest is a falcon wearing the Double Crown – a representation of the god Horus, with whom the king of Egypt was identified. Two smaller falcons are shown without crowns, and two pairs of birds, perhaps geese, stand beak-to-beak on a bar like a groundline. The birds have apparently been made by hammering sheet-metal over a core modelled as a positive image, then attaching a flat back-plate, and chasing the linear details on the front with a fine chisel. The cores (made of a dull white material) are still in place inside the metal, and a hole has been pierced widthways through each amulet so that it could be threaded, or perhaps sewn on to a textile. The method of manufacture is unusual: metal relief images were more commonly made by the repoussé technique, where sheet metal is hammered from the back as a negative image, then fitted with a back-plate.

The fish (an amulet thought to protect the wearer from drowning) is modelled in the round but similarly core-formed. The body is in two halves, with a central

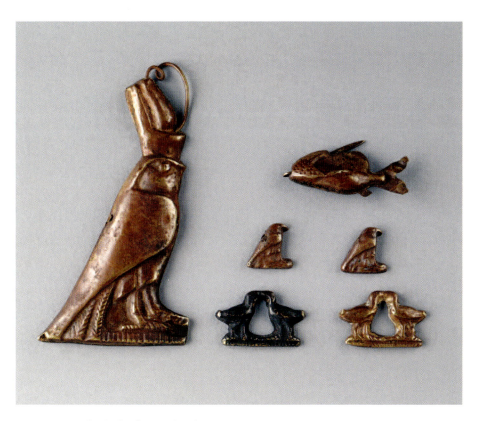

'seam' into which the fins and tail, cut as separate pieces, have been slotted. The head has been speckled with a pointed tool, and a suspension loop of thin tubing has been inserted into the fish's mouth. Despite their rich colouring, most of these pieces are made of gold containing such a high percentage of silver that it is more correctly identified as the naturally-occurring alloy electrum – harder than pure gold.

Crowned falcon: electrum, detail of crown added in wire, ht. 6.7 cm; single falcons: electrum, ht 1.1 cm; paired birds: gold and electrum, width 2 cm; fish: electrum, l. 3 cm. From Abydos, tomb E 30: 12th Dynasty, c. 1940–1755 BC
1896–1908 E.4238, 4243–4, 4241–2 and 4240: ERA excavations (Garstang)

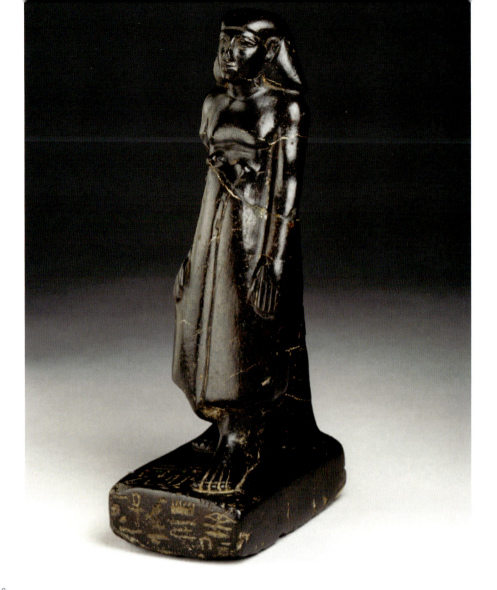

Statuette of igneous rock, ht. 22.6 cm. Probably from Thebes: early 13th Dynasty, *c.* 1755–1700 BC
1888.1457: ex Chambers Hall collection

32. The steward Senwosret-senbebu

Small sculptures of private individuals, as single figures or groups, became widespread in the Middle Kingdom. By means of these images, the people depicted could retain a physical presence in the tomb or present themselves within a god's temple; in both locations the goal was to ensure the reception of funerary offerings. Such sculptures were often carved in dark stones which could be given an attractive surface polish, and clearly inscribed with the name and titles which conferred personal identity on the figure. The choice of colour may also have reflected the association of the colour black with Osiris, the mythical archetype of death and resurrection.

The man shown here has the comfortable appearance of someone who has done well in life, his figure and his status emphasized by the long wrap-around kilt pulled tight around his midriff and knotted. He wears a full wig or head-cover, and, in the conventional manner of male statues, he strides forward with the left foot. Any sense of real movement is cancelled, however, by the supporting back pillar. This typical feature of Egyptian stone sculpture provided stability and also a convenient surface on which to write. The hieroglyphic inscriptions on this statuette begin with the invocation of funerary offerings on the back pillar, and end over the base with Senwosret-senbebu's name and official rank (steward), together with the name of his mother, Ankhti-en-Mentu.

The statuette's origin is unknown, but it is likely to be Theban. The man's name is compounded with one of the most celebrated royal names of the Middle Kingdom, Senwosret, borne by three rulers of the 12th Dynasty, while his mother's includes the name of the Theban war-god Mentu. The statuette came to the Ashmolean from the collection of Chambers Hall (1786–1855); a collector of antiquities as well as fine art, he is best known for his donation to the University Galleries, shortly before his death, of a fine assemblage of prints and drawings.

33. Wrestlers

Despite the limitations of the carving, this statuette presents an amusing and lively image of the grunting effort of a wrestling match. The addition of brightly coloured paint supplements the rudimentary cutting of the figures, who are blocked forever in mid-bout by a mass of uncut stone. The combatants are somewhat elaborately dressed for this activity – short, striped kilts, collar-like necklaces, and even bracelets. One stands with feet braced, gripping the arms of his opponent, who bends his knees in a strenuous attempt to topple his rival; chins thrust forward and large eyes gazing upwards, they seem to be locked in a contest of equal strengths.

Carved and painted limestone, l. 10.4 cm. From Abydos, tomb 416: late 12th Dynasty–13th Dynasty, *c.* 1800–1700 BC
1896–1908 E.3297: University of Liverpool excavations of 1907 (Garstang)

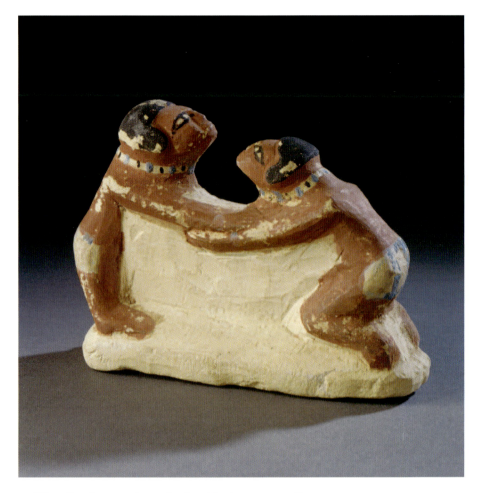

Wrestling is sometimes depicted in the context of sports or warfare in tomb paintings, but the presence of this statuette in a tomb with six burials is somewhat puzzling. It was part of a rich array of objects which included a Minoan vase, as well as other figures (lion, baboon, and hedgehog of glazed faience) possibly placed there to extend magical protection over the dead. The wrestlers, too, may have had some further meaning drawn from the kind of combat between two opponents which figures in Egyptian mythology and magic.

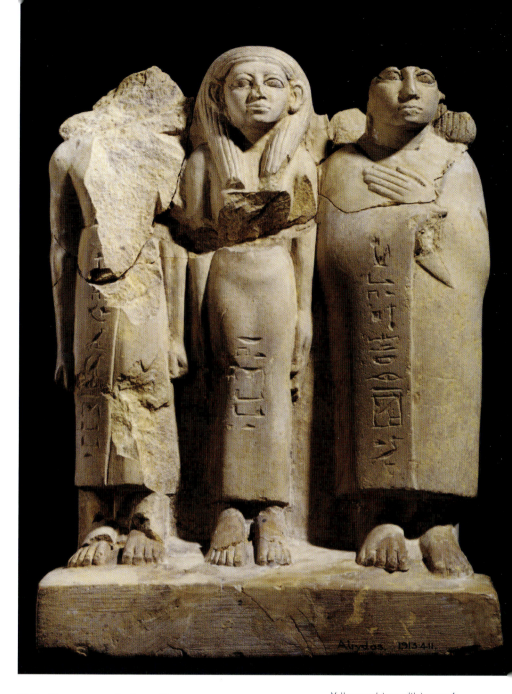

34. Group statuette

When Egyptian sculptors depicted two or more figures in a single carving, they often expressed their relationship by showing them in physical contact, with gestures such as an arm placed around the companion figure's shoulder or waist, or a hand resting on a limb. The husband and wife 'pair statue' is the most familiar of this type, and to our eyes, at least, these conventional gestures of contact seem to carry also an expression of affection.

Yellow sandstone with traces of red and black paint, ht. 18.6 cm as reassembled from fragments, incomplete. From Abydos, mastaba D 109–11: late 12th or early 13th Dynasty, c. 1800–1700 BC
1913.411: EEF excavations (Peet and Loat)

The three people depicted in this funerary statuette, however, stand in rigid independence, gazing outwards from their private space without any physical reference to each other. The hieroglyphic inscriptions incised down the front of their garments identify them as Dedetnub (the central woman), her son, the attendant Kemau (the man in a long kilt at the left), and the attendant Neferpesed, son of Sit-Hathor (at the right), who is shrouded in a wrap which he holds in place, his right hand gripping a corner of the cloth. The only unifying feature is the plinth on which the figures stand, which rises to form a solid vertical support at the back. This format, typical of small 'family group' sculptures of the 12th and 13th Dynasties, could be used for as many as five figures standing in line.

With the addition of their ample wigs, of which fragments only remain, the two men in this group would have stood slightly taller than the lady Dedetnub. The statuette was found in pieces in the sand filling a brick-built mastaba tomb which seems to have served as a family burial place. A niche in the west wall of the tomb probably once held a stela which was found lying near the ruined mastaba. The inscription on this again names Dedetnub, this time plus her husband Siamun, apparently as relatives of the two men (not those shown in this group) for whom the stela was dedicated.

35. Child in a shroud

This statuette has the shaven head and side-lock of hair customary for both male and female children before puberty. The figure represented here seems to be a young boy, although there is at least one instance of an adult male, depicted in a stone sculpture slightly later than this figure, wearing a side-lock. The boy's flat-topped head is rather large for the rest of his body, which is shown mummiform and standing on a small plinth. He bears some resemblance to the later shabti-figures, though lacking the details which are distinctive to these surrogate workers for the dead (52). The earliest mummiform funerary statuettes

from which shabtis were developed were made in the same period that this figure was modelled, but this boy is most unusual in being shown enveloped in a shroud, from which only his fists emerge, clutching the edges of the covering. Although the modelling of the figure is rather rough, the face, with its emphatically large eyes detailed in blue-black, is most expressive.

The details of the shroud drawn in blue-black show a network which in reality would have been made of alternating cylindrical and spherical beads (most likely of blue-glazed faience, like this figure), with a single bead-like dot at the centre of each diamond thus formed. The bead net could have been sewn on to a backing or laid over another garment. Although a network pattern is often shown in representations of clothing (especially women's), it is particularly associated with the dead, on whom it seems to have conferred some protective effect. Actual bead networks have survived on mummified bodies of the Late Period, and depictions of Osiris, god of the underworld, show his mummiform body covered thus (**63**).

36. Fragmentary wallpainting from 'The Tomb of the Dancers'

This lively scene shows girls who are probably performing a festive dance in honour of the goddess Hathor, divine patron of music, dancing, and love. It was recovered by Flinders Petrie from the tomb of an unknown person at Qurna, and was the only substantial surviving painting therein, although the rock-cut chamber and central pillar had originally been extensively decorated.

Hathor was not only associated with music and dancing, but also played an important funerary role as 'The Lady of the West' – the region of the dead. The portrayal of a dance for Hathor in a tomb thus had a double significance, especially in Western Thebes, where she was venerated as guardian of the cemeteries. The scene reflects actual dances performed in temples, at festivals, and also at

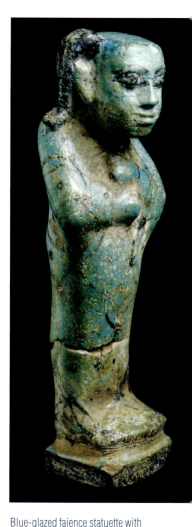

Blue-glazed faience statuette with details in black, repaired break; ht. 12 cm. From el-Kab, burial 1: 12th Dynasty, *c.* 1940–1755 BC
1896–1908 E.3788: ERA excavations of 1897 (Quibell)

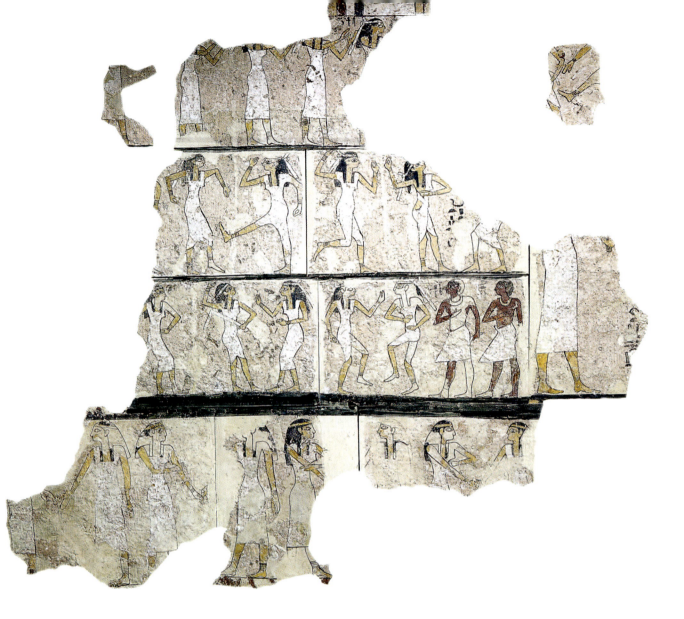

Painted plaster, 122 x 137 cm as restored. From Abd el-Qurna, Western Thebes, Theban tomb A.2: 17th Dynasty, *c.* 1640–1540 BC
1958.145: BSAE excavations of 1909 (Petrie)

funerals. There may have been a caption identifying the specific dance or occasion, now lost. The remaining hieroglyphic inscriptions name the two men in the third row (Wadjy and Mery) and identify the group they are supervising as 'the girls' chorus'; and the girls in the top row are said to be 'making gladness'. They are clapping the rhythm of the dance, while the energetic dancers are snapping their fingers, the usual percussive accompaniment for this kind of women's dance; there may also have been a vocalist.

The girls' dresses and headbands are probably special to this occasion; depicting the skirts of those whose legs are in vigorous movement seems to have defeated the artist, who has painted them like

trousers. The partly-preserved larger figure at the right belongs to a girl making an offering. An early photograph of the painting *in situ* shows further details at the far left – fragmentary scenes of men butchering animals – which had already been lost when Petrie investigated the tomb.

Naive but expressive, this painting was executed in Western Thebes at the end of a period of provincial decline; within a short time, the political transformation which established the 18th Dynasty at Thebes would make it the centre of the most sophisticated artistic productions, including the elegant paintings in the rock-tombs of Western Thebes (p.xxii).

37. Bronze blade of Kamose

This blade was the most famous Egyptian item in the private museum created by the Scottish antiquary John Sturrock (1832–1888). At the Sturrock sale of 1889 it was purchased by John Evans (1823–1908), businessman, geologist, antiquary, numismatist, and a founding father of the study of prehistory. Evans's particular interest in Egypt was in the context of his systematic collections of tools and weapons of various ancient cultures. Amongst the Egyptian specimens he added to these collections, this blade, and the inscribed axe-head of the same period, were outstanding: they carry the names of two key members of the Theban family which reunified Egypt at the end of

Cast bronze blade with incised inscription; tapering bronze socket, hammered, butt-jointed, and moulded on to the blade, fitted with black bronze ring, incised and inlaid with gold; max. length 59.5 cm. Probably from a tomb at Dra Abu el-Naga, W. Thebes, ?from Mariette's excavations of 1857–8: end of the 17th Dynasty, *c.* 1545–1539 BC
1927.4622: gift of Arthur Evans, ex John Evans collection

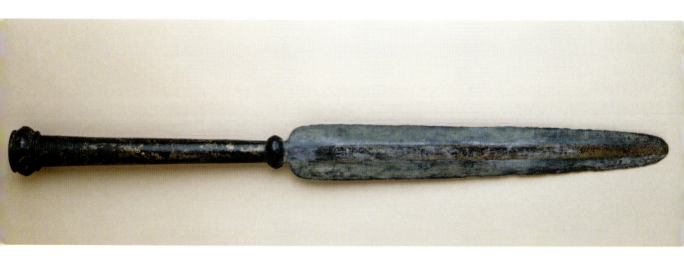

Dynastic Egypt, from the 4th to the 25th Dynasty

the 2nd Intermediate Period and initiated the 18th Dynasty.

The hieroglyphic inscription incised down the midrib of the blade names '... the good god, lord of offerings, Wadjkheperre, beloved of Iah ... the son of Re, Kamose, victorious in eternity'. Kamose (ruling c. 1545–1540 BC) was the last ruler of the 17th Dynasty, and waged military campaigns to the north and south of Thebes. He thus began the expulsion of the Hyksos rulers of Lower Egypt and their Nubian allies. The process was completed by his brother Ahmose (ruling c. 1539–1514 BC), first king of the 18th Dynasty. Ahmose's name is inscribed on the axe-head that Evans acquired, and both weapons may have been placed in the tomb of a loyal Theban courtier of the 17th Dynasty.

The solid-cast blade is fitted with a long, hollow socket into which a wooden grip or shaft would have been fastened. Around the end of the socket is a decorated ring, held in place by a pin which would have passed through the wood. The ring is inlaid with gold and carries the cartouche of Kamose within a band of fleur-de-lis and zigzags, a design more reminiscent of Minoan than Egyptian decorative art. Although the blade and socket have been described as the components of a two-handed sword, their length, and the manner of their construction, would have made them more suitable for use as a lance.

The inscribed blade and axehead came to the museum in 1927 with the rest of John Evans's collection of tools and weapons, the gift of his son Arthur, who was Keeper of the Ashmolean from 1884 to 1908.

Detail of the ring with Kamose's cartouche: the surface of the bronze has apparently been patinated black to enhance the contrast with the inlaid gold

38. Fragment of a royal wig sculpted in wood

This beautifully-carved fragment comes from the back of a lifesize, bewigged head; the headband with falling streamers indicates that the head was that of a royal person wearing the 'boatman's circlet', headgear that was exclusive to the pharaoh. Its fragmentary condition reveals some of the technical processes used by craftsmen working for the highest level of patronage in Ancient Egypt.

The wig is carved of dark wood, probably acacia, in a serried mass of corkscrew curls typical of a short wig, over which the headband lies. At the centre of the band, corresponding to the back of the head, a recess has been cut to accommodate the central feature, a sun-disk flanked by papyrus-umbels, carved in lighter-coloured elm wood. The headband and streamers are carved to contain inlays, and were originally gilded: a piece of gold leaf can be seen just above the break in the streamers. There are substantial remains of plaster, especially over the streamers, and in places a fine linen substrate can be seen. This seems to have been part of the surface preparation for the plaster, which was probably gesso, made of gypsum with the addition of an organic binder. The inlays, orange-red carnelian and two shades of blue-glazed faience, are set in a typical pattern of alternating bars and blocks; where the carnelian is missing, the plaster bedding which held it in place is tinted yellow, probably to enhance the colour of the stone. The traces of yellow-tinted plaster in the central sun-disk show that this, too, originally contained a piece of carnelian.

A complex arrangement of slots on the interior of the fragment, one of them still containing rawhide strips and plaster, shows that the wig was attached to an inner core. The fragment was originally identified as part of a royal coffin, as would befit its alleged provenance – the cache of royal mummies from a rock-cut shaft at Deir el-Bahri, revealed in 1881. The detailed depiction of the back of the head, however, plus the fixing system and the nature of the headdress, suggest that the wig was more likely made as part of a

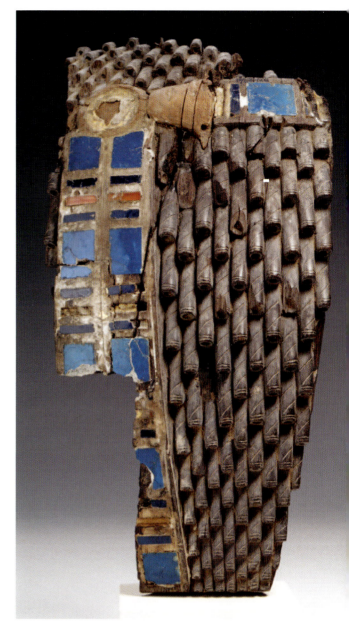

Carved wood (elm and a legume, probably acacia), with gilding, plaster, and inlays of glazed faience and carnelian; max. ht. 24cm. From Western Thebes, said to have come from the cache in Tomb 320 at Deir el-Bahri in 1881: 18th or 19th Dynasty, c. 1539–1239 BC
1933.618: A.H. Sayce bequest

Dynastic Egypt, from the 4th to the 25th Dynasty

royal statue, possibly one assembled from different components, with a variety of costly surface finishes. Two further fragments of this wig survive, in the Burrell Collection, Glasgow, and the British Museum.

39. Chariot wheel hub

The Hyksos occupation of the Nile Delta (c.1640–1540 BC) introduced to Egypt the horses and chariots already known in Western Asia. These became essentials for warfare and hunting, aiding the military expansion of Egypt once the Hyksos were driven out, and also serving as a favourite means of royal display. Actual chariots were placed in the tombs of kings and high-ranking courtiers; much of our knowledge of these vehicles is derived from the six found in the tomb of Tutankhamun.

Seven years before Lord Carnarvon and Howard Carter made this, their most celebrated, discovery, they had investigated the tomb of Amenhotep III, where they found pieces of a royal chariot within a deep shaft. Amongst them was this remnant of a

Elm and tamarisk wood, with remains of plaster and rawhide binding; max. preserved l. 29 cm. From the tomb of Amenhotep III, Western Valley no. 22, Western Thebes; 18th Dynasty, c. 1391–1353 BC.
1923.663: gift of Almina, Countess of Carnarvon

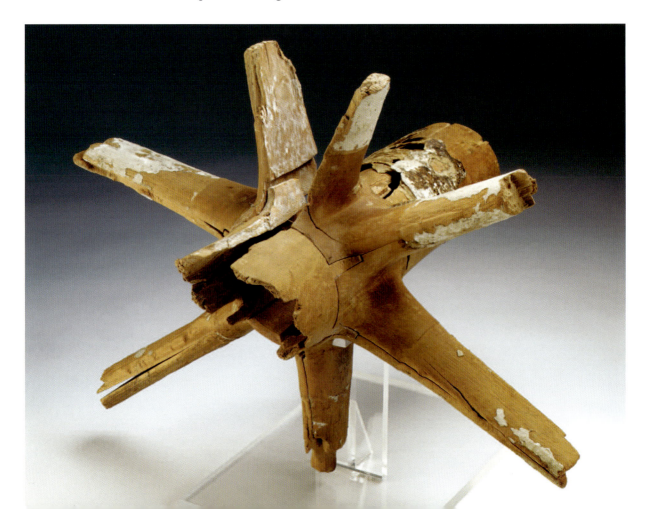

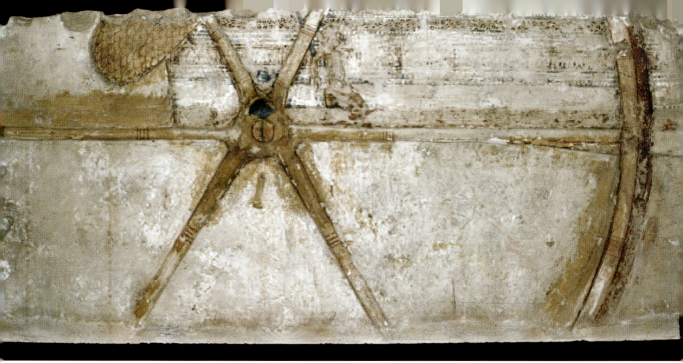

wheel hub. Its fragmentary nature and the loss of most of its surface decoration make it of particular interest, since it shows details not observable on intact specimens: it demonstrates the sophisticated engineering used for these high-performance vehicles of the fourteenth century BC.

The fragment comes from the centre of a six-spoke wheel. The spokes are elliptical in section and composite in construction, formed of V-shaped pieces of elm wood, glued together on their flat sides, then bound with rawhide; one of the spokes is now split, revealing the flat surfaces and traces of adhesive. This system would have formed a very strong and effective joint, contributing to the chariot's load-bearing capacity and stress tolerance. The V-shapes also form the central section of the nave, which is extended on either side with cylindrical bearings formed of hollowed-out billets of tamarisk wood, attached by mortise and tenon joints.

The axle carrying the wheel would have been located at the back of the chariot body, constructed and fitted in a way that provided the vehicle with an effective suspension system, though transmitting more weight to the horses than a central axle would. Two horses were harnessed to such chariots, and two persons rode in them: when hunting or fighting, one would be armed with a bow and arrows.

Six-spoke wheel of a royal chariot, depicted on a limestone block from the Great Temple at el-Amarna. A tyre of rawhide is indicated by the red zone around the outside of the felloes. The decorated body of the chariot can be seen in the upper half, with the end of a bow-case seen slantwise at the left. The linch-pin through the axle is decorated with a papyrus-head, painted blue; to the right of it is a model of a kneeling, bound captive.
1927.4087, carved and painted limestone, 24 x 50 cm: EES excavations (Frankfort and Pendlebury)

40. Pharaoh Akhenaten holding an offering-table

The reign of Amenhotep III marked the peak of Egypt's material prosperity. His successor, Akhenaten (initially reigning as Amenhotep IV), created a religious revolution with his introduction of the monotheistic cult of the Aten, the sun-disk. With his new religion came new art forms. This was both ideologically and practically necessary: religion was the basis of all formal art in Ancient Egypt, and sweeping aside its many gods and goddesses removed a large part of artistic subject-matter. Akhenaten's new cult offered only a restricted range of subjects – the offering of food, flowers, and jars of wine, heaped on altars or stands in the open air, and the royal family's presentation to the Aten of bouquets, vessels containing perfume and ointment, or images of themselves and their names. The repertoire was expanded by showing the royal family in their private life, too, in scenes of an intimacy that was extraordinary by comparison with conventional Egyptian art (p. xv).

As exclusive mediators between humanity and the Aten, the royal family were worshipped in their own right. Private houses in the new capital city of Akhetaten ('Horizon of the Aten', the site now known by the modern place-name el-Amarna) had garden shrines where they were depicted in sculpture or on stelae. This statue came from one such, where its companion was a figure of Akhenaten's chief queen, Nefertiti (now in the British Museum). The king is shown holding an offering-table; depictions of the temple of the Aten show a quantity of such statues. His body, visible beneath his diaphanous linen garments, displays the distinctive physiological traits which typify representations of him – long, thin neck, pronounced collarbones, heavy breasts, large abdomen, and wide thighs. No single medical condition has been identified to account for these physical features, if they existed in reality, and they may in part at least have had an ideological basis, endowing Akhenaten with an androgynous quality

Carved and painted figure of sandstone, set in a sandstone block, head missing, some repairs; ht. 90 cm, incl. plinth. From el-Amarna, found in the area of house L.50.12 but probably originally placed in the garden shrine of L.50.9: 18th Dynasty, c. 1345–1335 BC
1924.162: EES excavations (Newton and Griffith)

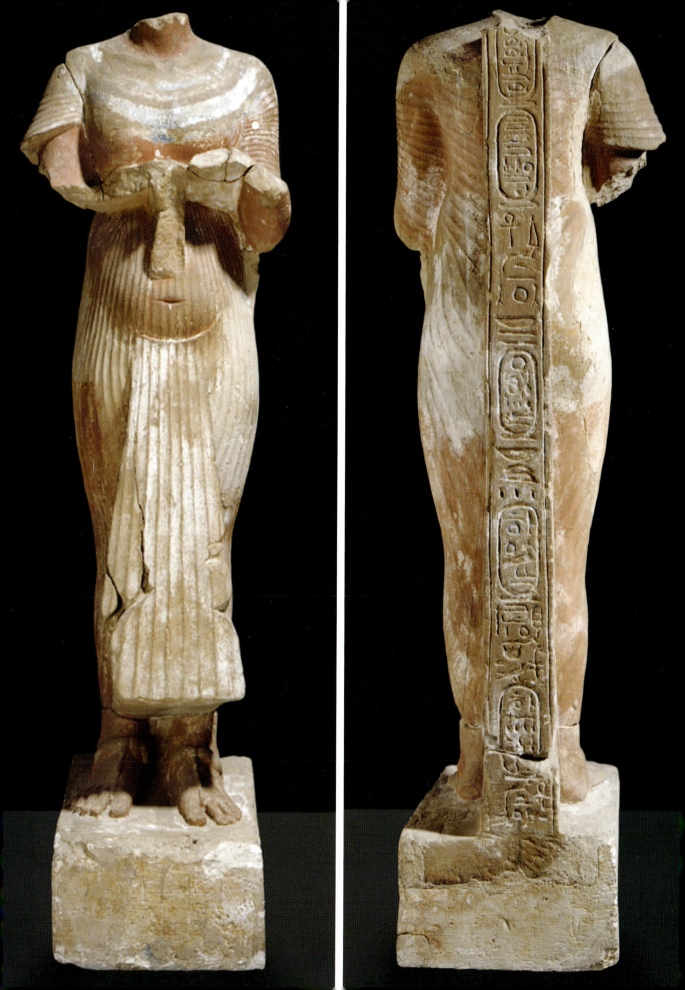

which assimilated him to the Aten, who embodied both male and female creative powers.

The germ of the ideas embodied in Akhenaten's radical interpretation of solar theology was already present in the time of Amenhotep III, but the full-blown cult marked an abrupt break with traditional religion and its accompanying artistic expression. The counter-revolution that followed the end of Akhenaten's reign was equally decisive, and with the return to orthodoxy, the royal family of Akhetaten were consigned to non-existence by the hacking-out of their names from inscriptions, and the destruction of their images and monuments. Akhetaten was abandoned, and the court returned to Thebes. Although the loss of this statue's head may be ascribed to that phase, the inscription on the back pillar preserves the cartouches containing the names of the Aten (uniquely accorded this royal privilege), Akhenaten, and Nefertiti. The statue was found, together with Nefertiti's, in a rubbish-filled chamber to which it had been removed from the garden shrine where they had stood. The inscriptions had perhaps remained safely out of sight.

41. Queen Nefertiti offering a bouquet to the Aten

This fragment carved in sunk relief comes from a limestone column erected in a building at Akhetaten, possibly the royal family's official residence, the 'Great Palace'. The figure of the queen shares many of the physiological traits displayed in images of Akhenaten, but they are more appropriate to this undoubtedly female form. The elongated line of her head is emphasized by her headgear, the tall cap-crown which is her particular royal attribute, surmounted here by ram's horns, sun-disk, and feathers. These are unusual additions to the queen's headgear and seem to equate her with Akhenaten, whose prerogative they were.

As she lifts a bouquet towards the rays of the Aten, one of the hands in which his rays end stretches out to touch the royal cobra on the front of her crown. She is

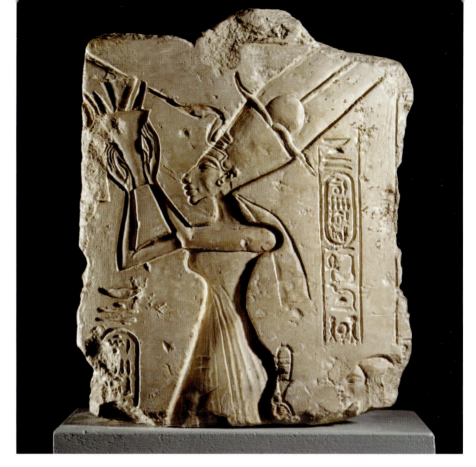

accompanied by one of her daughters, Meretaten, of whom only the head, with the child's sidelock of hair, and right hand, shaking a sistrum, remain. The column of hieroglyphs to the right gives Nefertiti's name prefaced by her queenly title, 'The Lady of the Two Lands'. An oddity of this relief is the presence of two navels on Nefertiti's body, both cut in the wide, crescentic form distinctive to representations of the royal family of Akhetaten. This shape may have been adopted for ideological reasons: the navel on the corpulent bodies of the so-called fertility figures or Nile gods shown on earlier reliefs is depicted in similar crescent form. When shown on the body of Akhenaten, the navel is set low, and it seems that the sculptor of this column forgot which royal figure he was carving. The mistake was later corrected and the 'wrong' navel plastered over and painted; the plaster fill is now lost. Despite this flaw, the depiction of Nefertiti, carved in the style typical of the early years at Akhetaten, presents a powerfully sensual image of the royal lady.

Limestone fragment from a column, with traces of red and blue paint; ht. 34 cm. From el-Amarna, possibly from the Great Palace; 18th Dynasty, c. 1345 BC
1893.1–41 (71): gift of H.M. Kennard, from Petrie's excavations

Limestone carved in sunk relief; 23 x 26 cm. From the Great Palace, el-Amarna: 18th Dynasty, c. 1345–1335 BC

1893.1–41 (116): gift of H.M. Kennard, from Petrie's excavations

42. Sleepy servant in the palace

Amongst the standard categories of representation in Amarna art are schematic depictions of buildings – temple, palace, or house – with their significant exterior features plus their interior layout, contents, and sometimes their working staff or other occupants. A key element in depictions of the palace is the public view of the royal family at their balcony-like 'Window of Appearances', from which they hand out material rewards to courtiers. Within the palace, floors are swept, cooks prepare food, scribes make inventories, and in the women's quarters, girls play musical instruments; servants are shown on duty but also lounging and chatting. The best-preserved of these scenes are found in the tombs of courtiers at el-Amarna.

The representation of people asleep, in a variety of poses and situations, is one of several types of depiction which are seen to denote a more 'natural' quality in Amarna art: in other periods, such details would be mostly confined to artists' informal sketches. This rather corpulent servant who has nodded off may be a doorkeeper, who was probably seated on a cushion. Similar figures, wide awake or somnolent, are shown seated on duty in the corridors between different parts of the palace. A doorway might have been represented in the area behind him,

where it would have been depicted in frontal view; but the block-like feature to the right, reminiscent of the stands on which food and other items are shown stacked, suggests that this is not the usual type of corridor location.

43. Blue-painted jar

This is the largest example known of the colourful style of decorated pottery which began to appear in the reign of Amenhotep III (c. 1390–1353 BC). Egypt's material prosperity at that time, when her power extended far outside her borders, is reflected in imported luxury goods, as well as new materials and manufacturing processes, and a greater receptivity to foreigners.

Blue-painted ware testifies to this material well-being, and the technical innovations introduced in the course of the 18th Dynasty. The 'true blue' colour which has given this type of pottery its name was obtained by using cobalt as a pigment in the painted decoration applied before firing (the other colorants were iron oxides for the various browns, and manganese for black). Cobalt also became widely used as a colorant in faience and glass in the later 18th Dynasty. The raw material itself was thought to be a foreign import until analytical work on faience glazes in the 1980s identified a source within Egypt's borders – alum deposits in the oases of the Western Desert, which contain veins of dull white cobalt.

The pots themselves were made of Nile silt, the surface improved with a slip. This particular vessel is too big to have been made on the potter's wheel, but was assembled from hand-made sections, with the addition of a wheel-turned neck. The decoration of blue-painted ware most often features petal designs, reminiscent of the actual floral collars placed on festive wine-jars, and many blue-painted jars were probably destined for use as wine receptacles. Sherds of blue-painted ware have been found in abundance on palace sites occupied by Amenhotep III, at Malqata (W. Thebes) and his successor Akhenaten, at el-Amarna.

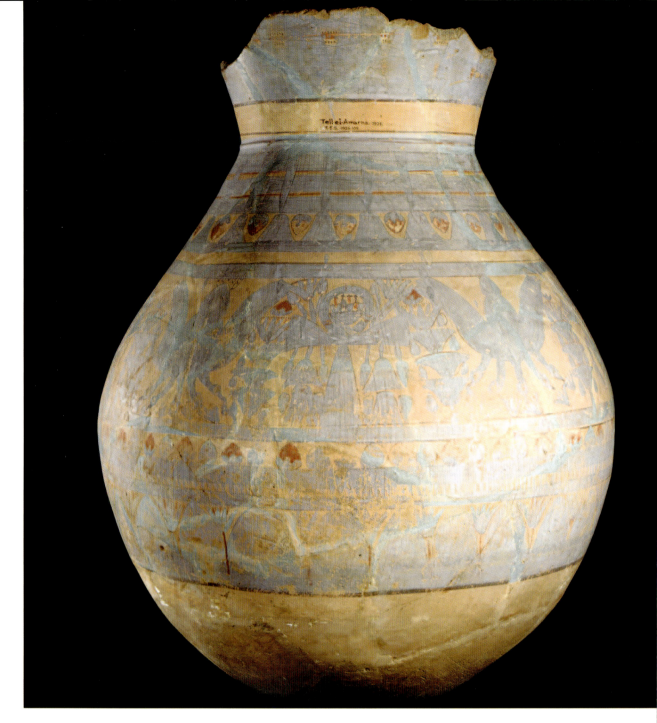

Hand- and wheel-made jar with painted decoration applied before firing, reassembled from fragments, with some restoration; ht. 93 cm. From el-Amarna; 18th Dynasty, c. 1345–1335 BC
1926.109: EES excavations (Newton and Griffith)

This vessel was restored from fragments found at el-Amarna, and its exuberant decoration includes the marsh plants and waterfowl which were favourite motifs in Amarna art, interspersed with *ankh*-signs signifying 'life'. This kind of pottery was not, however, the luxury preserve of the highest members of society – blue-painted ware has also been found in private tombs and domestic settings. It continued in production into the 20th Dynasty.

44. Pottery vase in the shape of a woman

Fashionably bewigged and wearing large disk earrings, this woman is a miniature work of sculpture but also a functional item of pottery, destined to contain liquid. She belongs to a group of vessels in the form of seated or kneeling women; sometimes they are shown nursing a child. It is thought that the liquid they were made to contain was of pharmaceutical value – possibly human milk, an ingredient listed in medical preparations intended to help a child sleep, or determine a woman's fertility.

Polished red ware, figure formed of two moulded pieces, with added arms and spout, details painted in red; ht. 13.5 cm. From Abydos, grave W1: 18th Dynasty, c. 1500–1350 BC
1896–1908 E.2432: EEF excavations of 1904 (Ayrton, Currelly, and Weigall)

Moulded glass fish, with some repaired breaks, l. 5.9 cm. Provenance unknown: late 18th Dynasty, *c.* 1400–1320 BC
1989.85: acquired with the aid of the Friends of the Ashmolean

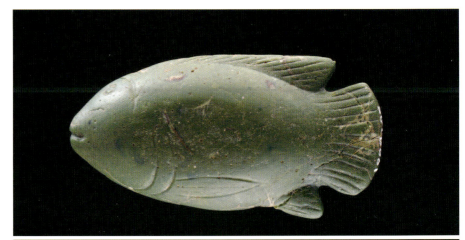

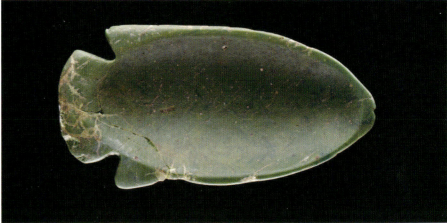

The woman's attractive appearance has been enhanced with details painted in red, though these are difficult to see on the polished red surface of the pottery: a necklace, a double outline under her breasts, and a girdle around her hips. When found, she was wearing a string of beads. This emphasis on female sexuality relates her to contemporary pottery figures of nude women lying on beds; they are likewise depicted with elaborate wigs and jewellery, and sometimes a baby lies nearby. Commonly called 'fertility figures', these have been found in houses, but also in the burials of both men and women. The grave in which this vase was found was that of a young girl.

45. Green glass fish

Amongst the many kinds of freshwater fish eaten by the inhabitants of Egypt past and present is the *tilapia* or Nile perch (modern Arabic *bulti*). For ancient

consumers, however, the *tilapia* was also a symbol of fertility and rebirth. This was probably due to its distinctive breeding habit – its eggs are hatched in the mother's mouth, from which shoals of tiny new fish are seen to emerge.

This small scoop or cosmetic dish in the shape of a *tilapia* is made of an opaque, apple-green glass, a distinctive shade found in objects made of glass and glazed faience from the later 18th Dynasty to the 20th. Chemical analysis has shown that the colour here was produced with a mixture of lead, copper, and antimony, and the latter, together with calcium, was also the agent that made the glass opaque. The fish's body is of a crumbly consistency, probably because it was prepared from ground glass put into a mould and then fired at a low temperature.

Glass-working was introduced into Egypt in the 18th Dynasty. Moulding was a standard production technique, but the more common method of manufacture was to form decorated vessels by applying heated glass over a core. There are several surviving fish-shaped bottles which have been made in this way, but amongst the many *tilapia*-shaped cosmetic dishes and scoops produced from the New Kingdom onwards, this one is so far unique in being made of glass. The fresh green colour, redolent of health and new life, would have been appropriate to the *tilapia*'s symbolic role.

46. Metal flask with a lid

A new type of pottery vessel appeared in Egypt during the 18th Dynasty: a flask with a lentil-shaped body and a narrow neck flanked by a pair of handles. Now known as 'pilgrim flasks', these containers for liquid were produced in a variety of materials, styles, and sizes until the Byzantine Period in Egypt. It was from their use then that their name is derived: visitors to the Christian sites of Egypt and the Eastern Mediterranean would not only have carried their drinking water in such flasks, but also acquired holy water or oil in miniature flasks as souvenirs of their pilgrimage.

This vessel is a unique example from the New

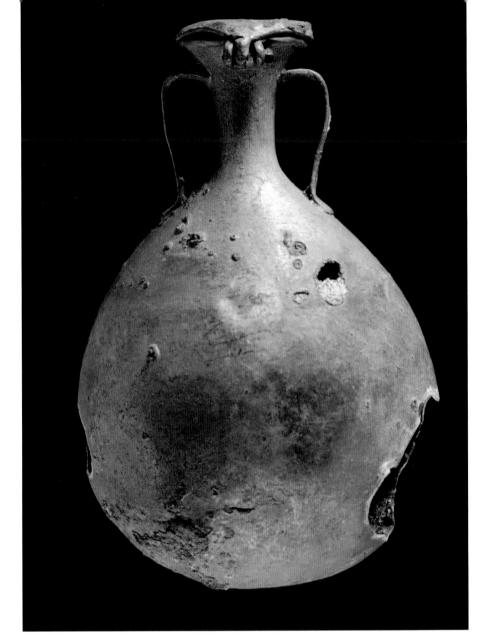

Flask of tin-lead alloy (tin with 4.7–6.00% lead and small amounts of copper, iron, and silicon); ht. 18.7 cm. From Abydos, grave G 70: 18th Dynasty, *c.* 1490–1390 BC
1896–1908 E.2442: EEF excavations of 1902 (Petrie)

Kingdom of a such a flask made of metal and fitted with a hinged lid. The metal from which it is made would now be identified as a low-lead pewter, and it is the only example of this alloy to have survived from Ancient Egypt. The mixture may have been accidental, and the method by which the flask was made is somewhat mysterious. A pottery flask would have been made by forming the body of two moulded halves and adding a wheel-made neck, plus handles formed of strips of clay. There are no signs of a seam around the circumference of this metal flask, but two horizontal seamlines are apparent across the upper part of the body, suggesting that the lower part was

beaten and raised, and the neck and shoulders cast, then the two parts were joined with a strip, the lid and handles being added separately. The hinged lid is secured with a piece of wire inserted through three rings, a pair attached to the rim of the flask and one attached to the lid. The flask was recovered from the grave of a woman buried with shabtis, jewellery, cosmetic accessories, and also a smaller pottery 'pilgrim flask'.

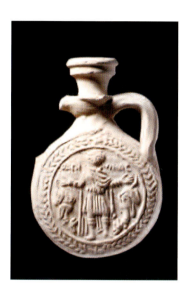

A pottery pilgrim flask of the 5th to 7th century AD, associated with the shrine of St Menas at Abu Mina, south-west of Alexandria. Flasks from this important site of early Christian pilgrimage have been found far outside Egypt. Most of them, like this one, were decorated with the figure of the soldier-martyr flanked by the camels said to have carried his body to the site.
*1933.717, ht. 15.3 cm:
A.H. Sayce bequest*

47. Ramesses II offering incense to Isis

At the great religious festivals celebrated in Ancient Egypt, statues of the gods were carried in procession outside the sacred area of their temples. These were the only occasions on which ordinary people would have some degree of contact with the gods. Even so, they could not see them: the statues were placed inside shrines which were carried on model boats, the gods thus making a 'voyage' – the most typical kind of Egyptian journey. These processions were also occasions on which people could present a written request for an oracle from the god, formulated so as to receive a 'yes' or 'no' answer. The question could concern any kind of personal, professional, or legal problem; it was read to the god, whose boat then moved in a direction indicating the reply, which was further interpreted by the priests.

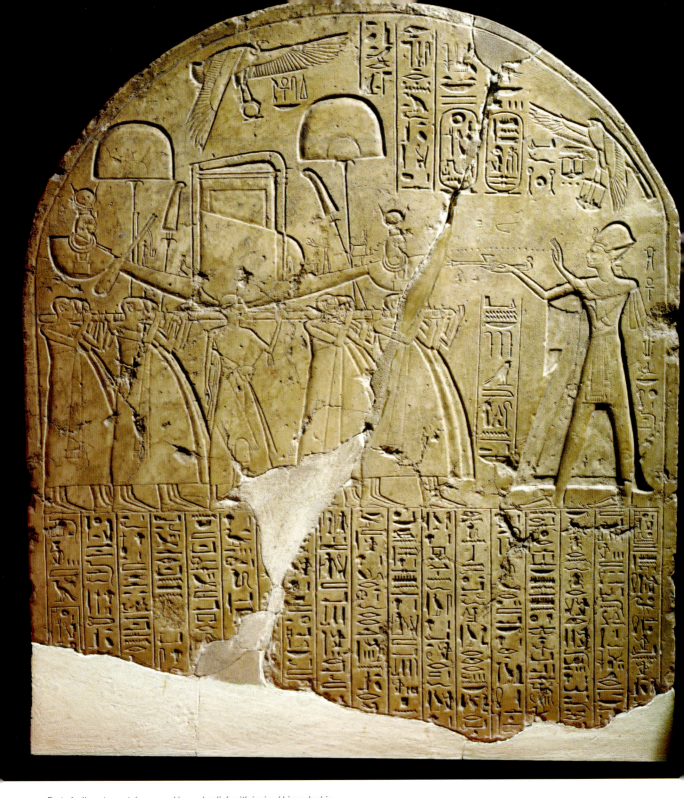

Part of a limestone stela, carved in sunk relief, with incised hieroglyphic inscriptions, restored from fragments; w. 87 cm. From the temple of Min at Qift (ancient Koptos); 19th Dynasty, c. 1279–1213 BC
1894.106d: gift of J. Haworth and H.M. Kennard, from Petrie's excavations

This fragment comes from a large stela found in the temple of Min at Koptos. It was probably dedicated by a man named Penre, to record a clearly affirmative answer given to him on the occasion of a procession. The scene at the top concerns the goddess Isis, who was associated with Min at Koptos in the role of his mother (as she is identified in the inscription here). She is making her processional voyage in a boat carried by twelve priests, in ranks of three; a further, single, priest at the centre is distinguished by his garments – a fringed sash and panther-skin – and raises an arm in the gesture of adoration. The shrine containing the statue of Isis is wrapped with cloth and shaded by fans placed fore and aft. At the prow and stern is a protective image of the goddess herself, an 'aegis' consisting of her crowned head shown above a wide collar hung with necklaces. Within the boat are other divine images, and figures of the king offering to the goddess. The vulture-goddess Mut hovers protectively above.

At the other side of the scene, a falcon holding the sign symbolic of the royal jubilee hovers over the figure who is honouring the goddess, tossing pellets of incense into the hand-shaped receptacle of an incense-burner – he is Ramesses II, wearing the Blue Crown. The text of the stela records the answer given to a question posed by an Overseer of Works, who has been identified as the official named Penre. His name is not preserved on this fragmentary stela, but occurs in other inscriptions relating to a certain Penre who carries all the titles listed here. The question seems to have concerned promotion to a post he was seeking, but the details are missing with the lower part of the text. The satisfactory nature of the answer is clear, however, in the praises heaped on Isis, whose oracular decision was unassailable, for 'her action cannot be opposed'. The material record of the decision provided by the stela would have been seen as a guarantee of this process, as well as defining Penre's good standing with the goddess and the reigning king.

Limestone, painted and inscribed in black over red draft lines: ht. 21 cm. From Deir el-Medina: 19th Dynasty, *c.* 1292–1190 BC
1961.232: ex Armytage collection

48. Worshipping the divine cats of Re and Atum

In addition to serving as funerary monuments and formal temple dedications, stelae in smaller form were also used to carry the prayers and wishes of private individuals. A number of personal stelae of this kind have survived from the tomb-workers' community at Deir el-Medina, where the scribal and craft skills required to make them were readily available; some of them were dedicated in the chapels and sacred places surrounding the village.

The unnamed couple on this small stela are shown, as described in the opening of the inscription, 'Offering prayers to The Two Great Cats'. The Egyptian language contained several onomatopoeic words, and one of them is 'cat' (*miw*, with an added 't'

Initially envisaged as a raging lioness, Bastet became especially prominent in the Late Period as a more peaceable cat-goddess. Quantities of votive bronze figures of the divine feline have survived, sometimes enhanced, like this one, with earrings or amuletic collars – ornaments which were apparently tolerated by living cats of the time. Equally numerous are the mummified cats, elaborately wrapped and buried in temple cemeteries at her chief cult site, Bubastis, and other places.
1933.1694, ht. 13 cm, Late Period: A.H. Sayce bequest

for the female) – it would have sounded something like 'mew'. The word is defined by the cowhide sign indicating the name of a mammal. The cats themselves, depicted at the top of the stela, are rather leonine in form, apart from their distinctly cat-like ears. They are designated 'The Cat of the god Re' (on the right), and 'The Great Cat, the peaceful one, in his perfect name of Atum' – two aspects of the same solar divinity. The man and his wife are shown wearing the elaborate wigs and pleated linen clothing typical of the 19th Dynasty. The depiction is quite generic, and the stela was probably ready-made for the dedicators to have their names added upon purchase, and the prayers thus personalized.

Remains of the wild cat (*Felis silvestris*) have been found in prehistoric contexts in Egypt; the domesticated cat (*Felis catus*) seems to have become an established pet and helper by the Middle Kingdom. The animal was associated with a number of divinities, the most prominent of them Bastet, daughter of Re. In its direct association with Re, it was also an important actor in the nightly journey of the sun through the underworld (cf. **56**): illustrations to funerary texts show a wild cat decapitating the wicked underworld snake, Apophis, who would prevent the rebirth of the sun.

49. Writing-board with lines from 'The Hymn to the Nile Flood'

Potsherds and pieces of limestone (both termed 'ostraca') were the most common material employed as writing surfaces in Ancient Egypt, but coated wooden boards which could be cleaned and used again were also used. A number of these have survived, inscribed with some of the texts which formed the school curriculum. This is one of two which preserve parts of a much-copied hymn celebrating the inundation of the Nile during the months of summer. No complete single version of this text has survived, but the greater part is preserved on a papyrus in Turin, and the lines missing at the beginning of this can be supplied from one of the many copies on ostraca. The text is a poem, probably written in the Middle Kingdom or early New Kingdom, divided into 14 verses each consisting of two lines. Both sides of this writing-board carry the opening lines of the hymn, punctuated with red dots which mark the ends of lines of verse. The side shown here also carries three unrelated columns of vocabulary, and some sketches: the head of a divine falcon with a solar disk, a bee, and a detail of the bee's head.

Until the nineteenth century, the sources of the Nile and the reason for its annual flood (seasonal rain in the Ethiopian highlands boosting the volume of water flowing from Lake Victoria) were not known. The Egyptians had no name for the Nile itself (they termed it simply 'the river', *itrw*), but they identified the flood which ensured the agricultural richness of their country as a divinity, Hapy. He was envisaged as controlling the floodwaters from his cavern at the southern end of the country, where the rocks of the First Cataract break up the flow of the river. Hapy's name was also conferred upon the red, silt-laden waters of the flood, which brought rich, fertile soil as well as moisture to the cultivated ground.

We owe much of our knowledge of Ancient Egyptian literature to what has survived in the excerpts copied by generations of apprentice scribes. Schooling was a privilege reserved for boys destined

Wood coated with plaster, painted, and inscribed in ink with hieratic texts and drawings; 13.7 x 23 cm. From Qurna, Western Thebes: 19th Dynasty, c. 1292–1190 BC
1948.91: gift of Sir Alan Gardiner

Hail to you, Hapy!
who emerges from the earth, and comes to make Egypt live,
who hides his form, a darkness during the day,
whose followers have sung his praises, who floods the meadows,
whom Re has created to make live all the young cattle,
who satisfies the hill-country that is far from water:
what falls from the sky is his dew.

for this profession, into which sons regularly followed their fathers. It was the key to a comfortable life as a bureaucrat, courtier, high-ranking craftsman, or temple functionary – a respected member of society upon whose skill many depended. Very few others were literate.

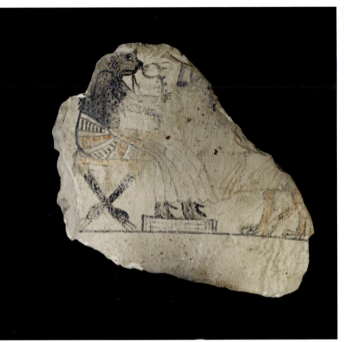

Limestone ostraca with sketches in black and red ink; [left] 9.3 x 8.5cm; [right] 8.1 x 8.5cm. From Western Thebes, probably Deir el-Medina: New Kingdom, probably 19th Dynasty, c. 1292–1190 BC
1942.53, 54: gift of Nina Davies, ex Norman de Garis Davies collection

50. Humorous drawings on ostraca

The artists who decorated the tombs cut into the cliffs on the western side of the Nile at Thebes often made preliminary drawings for their work on limestone ostraca; they used rush pens, the fibrous ends of which were slightly splayed by chewing, so as to give a brush-like stroke. The pigments used for writing and drawing were carbon black, and minerals such as red or brown iron oxide.

 These artists also on occasion made humorous sketches on ostraca, including scenes in which animals replace the usual human protagonists. The sketches often parodied incidents of daily life, and the artists sometimes transferred the tomb scenes which were their habitual work into the animal realm. On these two ostraca, the draughtsmen have sketched the conventional offering scene, where a well-to-do tomb owner is shown receiving the good things of this life which he or she hoped would continue into the next. Here, however, the elegant lady seated on a chair has become a cat, sniffing a lotus blossom while receiving offerings from a dog standing on his hind legs and

wearing a long linen kilt (only his paws, the tip of his tail, and the hem of his kilt remain). On the second ostracon, another dog extends offerings to a banqueter who is drinking through a double straw: he is a hyena.

The clarity of the writing or drawings has often been lost from the surface of ostraca over time. The possibility of manipulating images using computer software can be a useful tool in summoning pictures and writing back to life: the ostracon illustrated at the right here, almost illegible in reality, has been resurrected by enhancing a digital image.

51. The goddess Renenutet suckling a child

We know more about the community of workmen who lived in the village now known as Deir el-Medina than the inhabitants of any other settlement in Ancient Egypt. In addition to the remains of housing, the site has yielded thousands of documents, mostly in the form of limestone and pottery ostraca, relating to every facet of their daily life. Yet it was not a typical community: these were specialized – and quite privileged – masons, craftsmen, and artists, working on the construction and decoration of the royal tombs in the Valley of the Kings. The village itself, set high amongst the arid cliffs of Western Thebes, was not typical in its situation: Egyptian settlements were usually constructed within reach of the Nile, on the edge of the cultivated land and clear of the floodplain, and their remains have rarely survived for archaeological investigation.

The tomb workers especially revered the cobra goddess Meretseger, whose image they saw in the profile of the highest rock formation towering over the Valley of the Kings, of which she was the guardian. This ostracon shows another cobra divinity who was assimilated to her, the harvest-goddess Renenutet, associated with crops, the threshing-floor, and the granary, but also revered as a divine nursemaid and protector of the king. Renenutet is shown seated on a block throne, peacefully suckling her child. She has a

Limestone ostracon inscribed in black ink; 20.8 x 17 cm. From Deir el-Medina; New Kingdom, probably 19th Dynasty, c. 1292–1190 BC
Ashmolean HO 49: A.H. Gardiner bequest

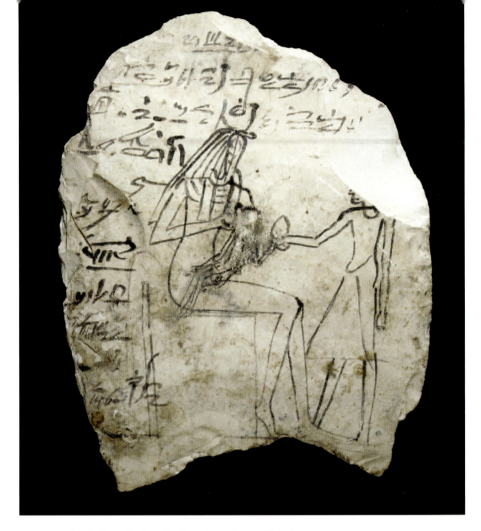

woman's body, but the head of a cobra, framed by the full wig proper to a goddess. The fragmentary text written above and behind her may contain a prayer or wish being made by the unknown man shown extending a loaf of bread to her. It includes mention of 'The Great Peak', the rocky eminence associated with Meretseger.

52. Inscribed vessel and shabti figure of Amenemopet

The rich blue glaze of these two objects is typical of the faience produced during the 21st Dynasty, a period which saw the rulers of Egypt installed at Tanis in the Delta, and the high priests of Amun at Thebes in Upper Egypt exercising considerable power. Both objects once belonged to the collector Charles Fortnum, who acquired a small number of Egyptian items of exceptional quality to complement his major

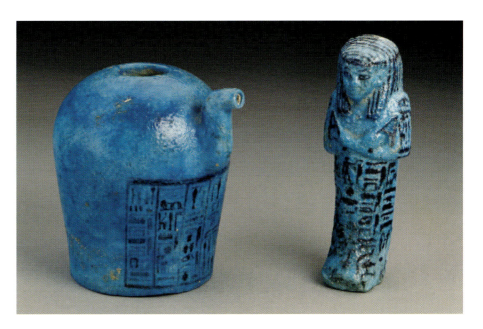

Moulded shabti and spouted vessel of faience with applied blue glaze, inscribed in black; ht. of shabti 10.7 cm, vase 9 cm. From Thebes, Dra Abu el-Naga, tomb of Amenemopet (A.18): 21st Dynasty, c. 1075–945 BC
1964.705, shabti; C.2, vase: Fortnum bequest; objects acquired in Thebes in 1867

holdings of European ceramics, metalwork, and decorative art.

Both pieces are inscribed with the name of a man who held priestly office at Thebes: Amenemopet, 'Priest of Amun-Re ... Secretary, Chief Draughtsman of the Temple of Amun'; they would have formed part of his funerary equipment. The shabti has the squat form and rather rough modelling typical of its time, when quantity rather than finesse was the aim. Unusually, instead of the regular 'shabti spell' (Book of the Dead spell 6, intended to activate the figure to work in place of the deceased), it is inscribed with a version of the preceding spell, no.5. This is a text to assure the deceased's magical survival, and it was associated with Hermopolis, the chief cult site of the god Thoth, who was scribe of the gods and patron of all scribes. The vessel is the *nemset*-vase typically used for pouring libations; the body of the vase seems to have been shaped over a form, with the small spout and flat base added. The inscription, arranged symmetrically in two facing texts of three columns each, gives Amenemopet's titles and name and prescribes libations 'coming from the table of Amun' (right, centre) and 'libations of wine and milk' (left).

Blue-glazed faience, restored from fragments; ht. 16.6 cm. From Maidum, southern tombs: late New Kingdom – 22nd Dynasty, *c.* 1100–800 BC
1910.576: BSAE excavations (Petrie)

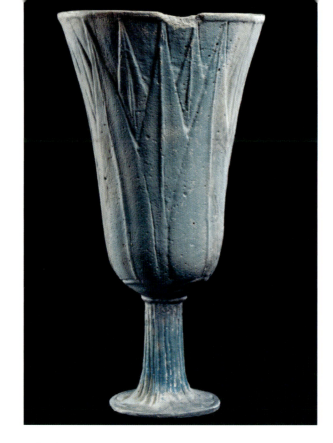

53. Lotus chalice

Elegant vessels like this one in the shape of the blue lotus, *Nymphaea caerulea*, first appeared in the New Kingdom, when they were made of metal, pottery, glass, or – as in this case – glazed faience. Similar chalices in the more rounded form of the night-blooming white lotus (*Nymphaea lotus*) are shown in use as special drinking vessels; the blue lotus chalices, however, seem to have been exclusively for ritual use and were apparently of particular funerary significance. This connection would be appropriate to the flower's association with rebirth: rising a little way above the water to open at sunrise each day, it was the mythical bloom on which the infant sun-god appeared out of the waters of chaos on the first day of creation.

 The cup of this chalice seems to have been moulded, with the outline of the lotus's tapering sepals and petals partly enhanced with incised lines. The stem and foot, decorated with incised ribbing, were made separately, then joined to the cup before firing by means of a slurry of faience paste with water. The chalice was found in fragments, incomplete and without a specific burial context.

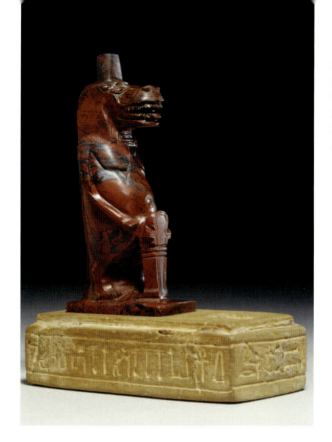

Statuette carved of red jasper, on an inscribed limestone base; ht. incl. base 10.6 cm. Provenance unknown; late New Kingdom – 3rd Intermediate Period, c. 1100–700 BC
1923.662: gift of Almina, Countess of Carnarvon

54. The goddess Taweret

Protector of mothers and children, Taweret, 'The Great One', is customarily shown as a hippopotamus standing on her hind legs, with pendant breasts and a heavy belly, taken to indicate pregnancy. She wears the wig of a goddess, but has the additional animal attributes of leonine paws, and a crocodile tail down her back. Her apotropaic function is made clear by the amuletic sign *sa*, 'protection', standing between her paws. The projection on the head of this statuette could have served to secure a headdress. Around the sides of the base on which it stands is carved a dedicatory inscription in hieroglyphs, naming the goddess as Semset – her aspect as one of twelve manifestations of the hippopotamus goddess, one for each month of the year. The inscription is poorly written, and the name of the male dedicator is unclear.

The stone chosen for this statuette is a fine piece of red jasper, which contrasts with the yellowish limestone base. The qualities attributed to the colour red in Ancient Egypt were ambivalent – it was related in a positive way to the sun and the perpetual rebirth of the dead via the solar cycle, but in its association with

the desert, the god Seth, and hence violence and aggression, it was perceived in a negative way, and in its destructive aspects the hippopotamus was a Sethian animal. Taweret's assumption of red was perhaps on a par with her attributes borrowed from other ferocious creatures – lion and crocodile – as an enhancement of her power, magically harnessing ferocity to provide protection.

Terrifying in their bulk, hippopotamuses are aggressive in defence of their young. A mother hippopotamus will deal swiftly with an intrusive predator: the marsh scenes carved on the walls of Old Kingdom tombs sometimes show the dispatch of a crocodile who has moved too close to the hippo calves, gripped in the jaws of their mother who bites it in half. As a powerful defender, Taweret figured among the images carved on the ivory 'wands' which were apparently used in magic rituals to protect mother and child.

Moulded vase of blue-glazed faience in the shape of Taweret, her wig detailed in black. Her breasts are pierced to allow liquid to flow out. Such vessels are thought to have been made as containers for medical or magical preparations, possibly including human breast milk
1913.789, ht. 18.5 cm. From Riqqa, cemetery B (BSAE exavations): 25th Dynasty, c. 715–657 BC

From the Late Period to the Arab Conquest

Chronological outline

Dynasty	Dates*	Rulers	Significant events
The Late Period			
25th Dynasty	715–657	Nubian rulers of Egypt, including Taharqa and Tantamani	Conflict with the Assyrians, who are driven back twice but eventually sack Thebes
26th Dynasty	664–525	Saite dynasty of six rulers, beginning with Psamtik I	The Assyrians plunder Egypt, Tantamani flees to Nubia. Greek trading post established at Naukratis in the Delta; use of iron becomes widespread; coinage comes into use
27th Dynasty	525–404	Five Persian kings, beginning with Cambyses	After Cambyses' invasion, his successor Darius I pursues a more conciliatory policy; Greek defeat of the Persians at Marathon (490) fosters growing resistance in Egypt
28th to 30th Dynasties	404–343	Amyrtaios and four Saite rulers, followed by the last native Egyptian dynasty, beginning with Nectanebo I	Amyrtaios of Sais frees the Delta of the Persians, then the rest of Egypt; Greek mercenaries assist. Nectanebo I, an usurper, initiates a period of prosperity and much building activity
2nd Persian Period			
[31st Dynasty]	343–332	Three Persian rulers	Invasion of Artaxerxes III Ochus initiates a decade of oppression

* Dates before 664 BC are approximate

Chronological outline (cont.)

Dynasty	Dates	Rulers	Significant events
Greek, Roman, and Byzantine Periods			
Macedonian Dynasty	332–305	Alexander the Great and two successors	Foundation of Alexandria
Ptolemaic Dynasty	305–30	Twenty-two male and female rulers, beginning with Ptolemy I Soter I and ending with Cleopatra VII and her son Ptolemy XV Caesar	Alexandria becomes the foremost Greek city. Arrival of settlers, especially in areas of land reclamation, such as the Faiyum; temples constructed by the new rulers in traditional style. Octavian (subsequently the Emperor Augustus) defeats Cleopatra VII and Mark Antony at the Battle of Actium, 31 BC
Roman and Byzantine emperors	30 BC–AD 641	From the reign of Augustus on, Egypt ruled from Rome as a province, then after the division of AD 395, from Constantinople as part of the Eastern Empire	Visits to Egypt of the emperors Hadrian (130–131), Septimius Severus (199–200). Under Diocletian, AD 284, beginning of the 'Era of Martyrs' for the Christian church in Egypt; pagan worship ended by decree of the Emperor Justinian, AD 535–8
Arab domination	639–641	Amr ibn el-As as governor, on behalf of the Caliph Omar	Capitulation of Alexandria, 641; foundation of Fustat (nucleus of later Cairo)

55. Amulets from The Queen's College collection

The beads, pendants, and model objects which were credited with magical powers in Ancient Egypt are amongst the most numerous and typical survivors of its culture. They are usually made of stone, metal, glass, or faience. Other models and amulets which were made of perishable materials for some immediate protective or magical purpose have not survived, but their existence is known from the texts which prescribe them. Many of the amulets which were deemed particularly efficacious for the dead are described and named in compilations such as the Book of the Dead, in conjunction with the magic spells which would activate them. Their functions were various – protecting the mummy and ensuring that it remained intact, effecting the deceased's successful negotiation of the initial judgement process and subsequent cyclical events in the underworld, and magically recreating the objects that would be needed there. The specific colour and material of some amulets was also considered important in ensuring their efficacy. The headrest, for instance, should be made of hard, dark stone, the tyet-knot associated with the goddess Isis (and perhaps also with blood) of red jasper.

From earliest times, amulets were also worn or carried by the living, to avert everyday misfortunes and protect or heal those parts of the body whose shape they copied. Virtually all Egyptian jewellery features at least some amuletic items. From the Late Period (beginning with the 26th Dynasty) onwards, there was an upsurge in the production of amulets of glazed faience, mostly coloured blue-green. To Egyptian eyes this was a very positive colour, the name of which – wadj – was also the word for a papyrus stalk. These faience amulets would presumably have had lifetime use, but large quantities were bestowed on mummies, either threaded as jewellery or coverings, or simply placed within the enveloping bandages; contemporary funerary texts illustrate the particular order in which they should be laid out on the body.

In the shape of individual gods or divine families of

From left to right, top to bottom: *Queen's College loan 421*: Horus in his manifestation as Haroeris ('the elder Horus'), glazed faience; *431*, Harpocrates ('the child Horus') with his mother Isis and her sister Nephthys, glazed faience; *387*, the primal god Shu (air), glazed faience; *576*, heart, carnelian; *562, wedjat*-eye, glazed faience; *640*, headrest, haematite; *604*, papyrus-column (*wadj*), glazed faience; *613, djed*-pillar, glazed faience; *626*, knot of Isis, gilded wood; *334*, Ptah-Pataikos, glazed faience; *516*, crocodile, glazed faience; *327*, Bes, glazed faience. All Late Period (*c.* 715–332 BC) with the exception of Bes (Roman); ht. of largest (*djed*-pillar) 7 cm

three (mother, father, infant god), amulets secured the power of those divinities for one person's benefit. Some of the most popular gods represented in amulets were not major divinities but those considered particularly influential in daily life – such as the dwarf-gods Bes, protector of children and mothers giving birth, and Ptah-Pataikos, a manifestation of the creator god Ptah in a form akin to a child's. Some amulets are

From the Late Period to the Arab Conquest

related to the myths and attributes of the gods: the *djed*-sign, denoting lasting stability, was associated with a pillar raised in the ritual of Osiris' resurrection, the *wedjat*, 'the one made sound', is the left eye of the falcon-god Horus (hence the falcon markings under it), torn into pieces when he fought his wicked uncle Seth, but magically restored by Thoth; *wedja* is also one of the Egyptian words for amulet.

56. Amuletic disk (hypocephalus) made for Tasheritenkhonsu

An amulet consisting of an inscribed circle of metal or cartonnage was sometimes placed beneath a mummy's head (hence the Greek designation, 'under the head'), to kindle solar heat there and ensure the reawakening of the deceased. The use of these amuletic disks was restricted in time and place; they have been found in burials at important religious centres such as Thebes and Abydos in Upper Egypt, and their use extends from the 25th Dynasty to the Ptolemaic Period.

This one was made for a girl named Tasheritenkhonsu, daughter of Khonsardais. Both her name, 'The little one belongs to Khonsu', and her father's refer to the Theban moon-god Khonsu, revered as the son of Amun and Mut and worshipped in a temple at Karnak next to the great temple of Amun. The fact that her parents' names are recorded but she herself is not given the title 'lady of the house' (i.e. she was not a married woman), suggest that she died young.

The inscriptions contain the necessary formula for kindling heat in the afterlife, as set out in spell 162 in the Book of the Dead. This also prescribes the placing of '… a drawing of [an i*het*-cow] on a new papyrus scroll … under [the deceased's] head. A great quantity of flames will envelop him/her completely like one who is on earth'. The divine cow shown in the uppermost register here recalls this prescription, but also the important funerary role of the cow goddess *par excellence*, Hathor, 'Mistress of the West'. Other scenes drawn on the disk relate to the twelve-hour

Cartonnage of linen and plaster, inscribed in ink; diam. 20 cm. Probably from Western Thebes; 26th Dynasty, 664–525 BC
1982.1095: ex Wellcome collection

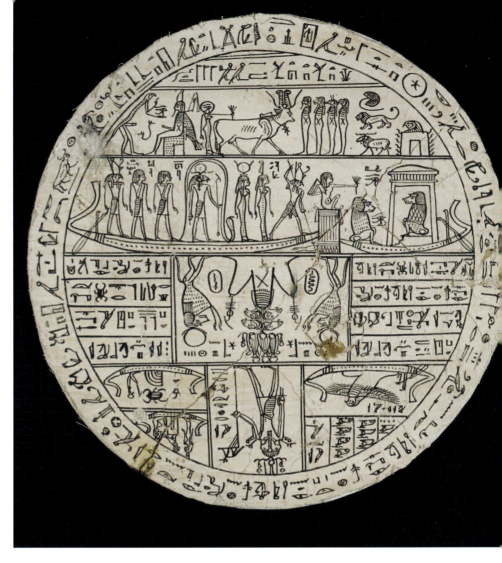

journey of the night-time sun through the underworld. Below the scene with the cow, the ram-headed sun-god Re is shown making his night-time voyage, protected by the benevolent *mehen*-snake, while the god Horus at the prow of the boat spears the arch-enemy, the evil snake Apophis who tries to block the sun's course to rebirth at dawn. The smaller moon-boat with the god Thoth as a baboon is shown to the right. The dead person will share this nightly voyage with the sun, through the underworld towards morning.

Instead of being 'a new papyrus scroll', the disk is a more solid artefact, made of cartonnage – a kind of Ancient Egyptian papier mâché, formed of layers of linen or papyrus alternating with gesso (plaster mixed with an organic binder). Depending on the number of layers and the thickness of the material, cartonnage could be stiff or quite flexible: it could be shaped into

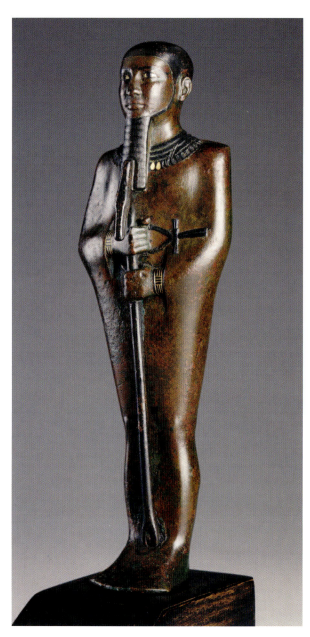

Solid cast bronze, surface patinated black in places and inlaid with gold and silver, sceptre cast separately, modern wooden base; ht. 17.9 cm excl. tang. Provenance unknown; 26th Dynasty, 664–525 BC
1986.50: bequeathed by Miss M.R. Tomkinson, ex Trist collection

something as extensive as a form-fitting cover for a mummified body. The smooth white finish presented an excellent surface for painted decoration, gilding, or writing. Cartonnage was employed for all sorts of funerary accessories, and, as it is relatively light in weight, it might also have been the medium for the elaborate headgear shown in ritual scenes and worn in reality by temple personnel.

57. Statuette of the god Ptah

The god Ptah was the protagonist in an intellectual version of the Egyptian creation myth in which he thought and spoke the world into being. In a more material role, he was the patron of craftsmen of all kinds; his chief priest at Memphis, his most important cult centre, bore the title 'Supreme Leader of Craftsmanship'.

This figure of Ptah is, appropriately, the work of a master bronzesmith: a miniature piece of sculpture in which even the finest details, such as the rippling lines of the god's beard and the animal-head of his sceptre, have been flawlessly reproduced in a lost-wax casting. It is also a rare surviving example of 'black bronze', a medium to which Egyptian texts refer when describing prestigious metalwork in temples as 'black bronze inlaid with gold' or 'inlaid with electrum'. On this statuette, details of the god's head, jewellery, and sceptre have been blackened and further enhanced with precious metal inlays. As always, his body is shown enveloped in a wrap from which only his hands emerge to hold an *ankh*-sign (inlaid in silver) and a forked sceptre topped with the head of the mythical Seth-animal; but the sculptor has skilfully suggested the anatomy beneath the wrap.

Bronze statuettes such as this were made in quantity from the beginning of the Late Period until Roman times. They were personal devotional objects, often dedicated at the temple of the divinity they depicted; they would be fitted on to an inscribed base naming the donor and expressing a wish that the god might grant to the donor and his or her family. The base could be made of bronze or wood, and the figure would be fitted

on by means of the spike under its feet – this useful 'tang' was actually the cast of the channel through which the molten metal would have been poured into the mould for the figure. The base for statuettes of Ptah typically had a raked front, usually formed as a flight of steps conveying the idea of approaching the god. The base of this figure has not survived, and we do not know the name of its dedicator.

Although the statuette belongs to a time when there was a much more personal engagement with religion, its form harks back to a remote period when only the king and the priesthood interacted with the gods. Ptah's serene and confident face recalls the sculptural ideals of the Old Kingdom, and suggests that this statuette was made in the 26th Dynasty: at that time his cult was enjoying a revival at Memphis, and the timeless perfection of the sculpture produced over 1,500 years earlier served as an artistic and ideological model.

58. Board from the coffin of Khahap

One of the three inscribed antiquities that Robert Huntington gave to Oxford University in 1683, this substantial piece of wood comes from the lid of a coffin. When Huntington saw it during one of the two visits he made to Egypt (Introduction, pp. vii–viii), it had been put to practical use: he later wrote of '… the Board I brought from a Door in the Village *Succara* (which is next to the *Mummies*) the largest piece of *Egyptian* Writing, perhaps, at this day in Europe'.

The board would have formed the greater part of a type of coffin lid datable to the Ptolemaic Period; the inscription also shows the particular forms of this time. The five vertical columns of inscribed hieroglyphs, reading from right to left, contain the text of chapter 72 in the Book of the Dead, opening with a formula which puts this spell into the mouth of the deceased: 'Words spoken by the Osiris Khahap, born to Taredet: "Hail to you, possessors of righteousness!"' The spell was intended to ensure that the dead person could leave the burial-place in daytime and receive the

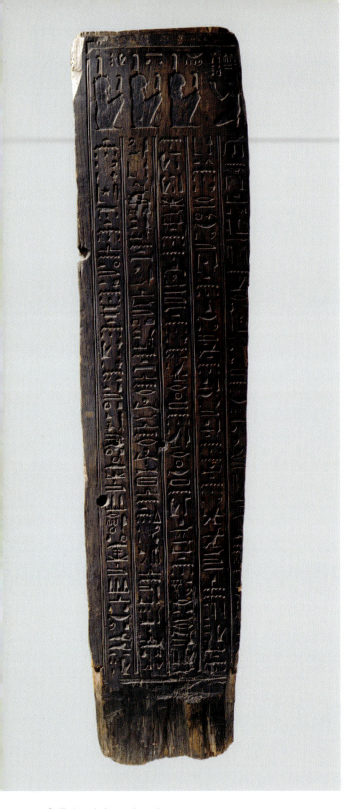

food offerings essential to continued existence. The three figures at the top, facing Khahap, represent the underworld inhabitants thus addressed by him: the 'justified' or 'righteous' ones who have passed successfully through the judgement of the dead, because in life they had maintained *maat*. They bear on their heads, and also hold, the ostrich feather symbolic of *maat* – the concept of perfect order in the cosmos, both in daily life on earth and in the existence of the blessed dead until the end of time.

Travelling in Egypt two and a half centuries before the decipherment of hieroglyphs, Huntington would have been completely unaware of the content of this text, but his specific purpose in acquiring this and other inscribed items was to assemble examples of Egyptian writing. He was unusual for his time in purchasing such large pieces as this board, and the two limestone fragments (see p.54) that he also brought to Oxford. Even more unusual was his perception that the best way to advance scholarship and preserve the ancient monuments was to work directly on such material on site; in this he anticipated the aims of modern epigraphic expeditions. 'If all that is there written were but exactly copied', he wrote of the texts carved on the stone walls of the funerary monuments at Giza, 'it might be then lawful to hope, that the Language so long since dead ... might have its resurrection.' Huntington's inscribed coffin lid figured in the series of plates of Egyptian antiquities published by the antiquary Alexander Gordon in the 1730s, a compilation that helped to foster the growing interest in deciphering the hieroglyphic script.

Coffin board of carved wood, ht. 1.05 m. From Saqqara; Ptolemaic, 3rd century BC
1836.482: gift of Robert Huntington in 1683

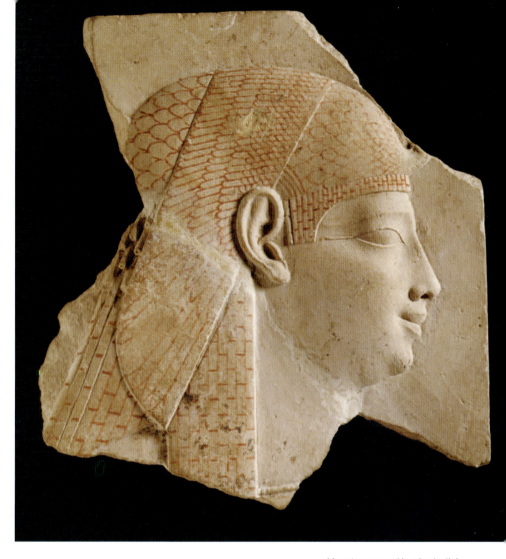

59. Head of a goddess

Small slabs of limestone like this one, carved in relief, sometimes on both sides, are usually described as sculptors' models or trial pieces. A number of them have dedicatory inscriptions which show that they had been used as votive offerings. The carving – typically showing single figures, busts or heads, or individual hieroglyphs – is often unfinished, and carries the red or black draft lines used by Egyptian craftsmen. Both paintings and sculpture were initially sketched on a square grid, enabling the artists to maintain the canonical proportions of the human body which were fundamental to formal Egyptian art. In sculpture, the draft lines were repeatedly renewed as the cutting of the stone proceeded.

This exceptionally fine carving is one of a number showing the bust of a royal or divine lady in right

Limestone, carved in raised relief, with guidelines in red; incomplete, reassembled from two fragments, with small areas of fill; 10.3 x 9.7 cm. Provenance unknown; Ptolemaic, 3rd century BC
1919.50: gift of Sir John Beazley, ex Norton collection

From the Late Period to the Arab Conquest

profile. The face has been completed, but the details of the wig and the cap, in the shape of a stylized vulture (the tail is missing), are indicated in red lines and remain mostly uncut. The first few echelons of corkscrew curls at the back have been fully carved, and cuts have been made down the strands of curls below. A start has likewise been made on the curls of the wig beside the ear: the lines of these continue upwards into the vulture cap, where feathers might be expected – apparently a mistake in drafting, but one which also appears on a similar sculptor's model in Cambridge which has been fully carved.

The cap in the shape of a vulture is associated with various goddesses, but especially with Mut, whose name was written with the vulture-hieroglyph, 'mother'; she shared her role as divine mother of Egyptian kings with the goddesses Hathor and Isis. It was also worn by Egyptian queens, mothers of the heir to the throne, and in this context the vulture head was sometimes replaced with a rearing cobra, protector of royalty. The extended neck which can be seen at the broken upper right edge of this slab indicates a vulture, so this is the image of a goddess, as represented in relief on the walls of temples built in traditional style during the Ptolemaic Period. The face is smoothly modelled, the chin rounded and fleshy; the eye, seen in full view with a firm cosmetic outline, is set slightly aslant, but the eyebrow above is a mere suggestion, merging with the line of the nose. The neck, now mostly lost along with the left shoulder and part of the necklace, would have been quite short. The style is typical of royal and divine images produced early in the Ptolemaic Period. The fragmentary bust on the other side of the slab (left) shows a similarly emphatic, rounded chin, but the massive shoulder suggests that it is male.

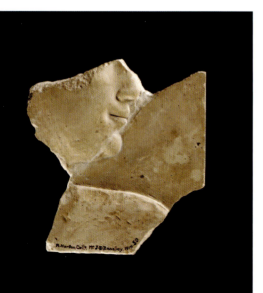

60. Gold jewellery from a temple treasure

In the winter of 1905, two exceptional hoards of gold and silver vessels, jewellery, and coins were discovered by men digging for fertilizer in the ruins of a small temple at Tukh el-Qaramus in the Nile Delta. The decayed refuse of ancient sites (*sebakh* in Arabic), is rich in nitrogen, and discoveries like this have from time to time been made by such diggers (*sebakhin*). In this case, the initial find was later attributed to the group's donkey, said to have put its foot through the floor of one of the two mud-brick rooms in which the hoards were concealed. Because of the manner of its discovery, the treasure did not remain intact; although the major part found its way within the year to the Cairo Museum, individual pieces such as these were dispersed on the antiquities market and only later identified as likely to have come from the Tukh el-Qaramus finds.

Armlet, diam. 8.3 cm: formed of a pennanular, tapering sheet of gold with the edges turned inwards; the medallion, struck like a coin, held in a flanged collar.
Earrings, diam. of largest 3.9 cm: hollow gold hoops decorated with wire, granulation, and beads, terminating in animal heads.
From Tukh el-Qaramus;
Ptolemaic, late 4th–early 3rd century BC
1926.98 (armlet), 1926.99, 100, 101, 104, 102, 103 (earrings, clockwise from top right): Grenfell bequest

From the Late Period to the Arab Conquest

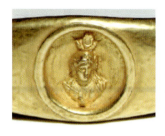

The small temple at Tukh was probably dedicated to Isis, and the treasure seems to have been buried in response to some unknown catastrophe in the mid-third century BC. The armlet shown here is decorated with a medallion showing a bust of Isis, in the form in which she is depicted early in the Hellenistic Period; at this time, worship of the pre-eminent Egyptian goddess had begun to spread outside Egypt. She wears a miniature form of her traditional Egyptian crown, composed of a disk framed by cow's horns, surmounting a Greek-style diadem. Her luxuriant ringletted hairstyle, and the fringed mantle tied in an 'Isis knot' over her tunic, are typical of her Hellenistic image.

The hoop earrings are of Hellenistic form, richly decorated with wire, beads, and granulation. They are fastened by means of wire hooks held in the mouths of animal-heads (bull, wild goat, and ram) which form the terminals at the wider end of the hoops.

61. Silenus mask of glazed faience

Egyptian mastery in the manufacture of faience continued undiminished after the Macedonian conquest of 332 BC, but new types of objects and designs based on Greek forms and iconography began to appear, to meet the demands of a different clientele. New specialities were the production of moulded bowls and vases with intricate and finely-detailed decoration in relief, and two or more complementary colours produced by varying the depth of the glaze. Vessels were also decorated with motifs in high relief, moulded separately and attached before firing.

This expressive face was made as an appliqué of this kind, and depicts a silenus, half-man, half-animal (goat or horse). Companions of the god Dionysus, the sileni, together with their younger relatives the satyrs, were the mythical exponents of bad behaviour, but their wine-fuelled antics were also a source of amusement, and they were regarded as essentially benevolent creatures. The ambivalent features modelled here, however, seem to hint at some intent to destabilize polite society. The vessel to which this was

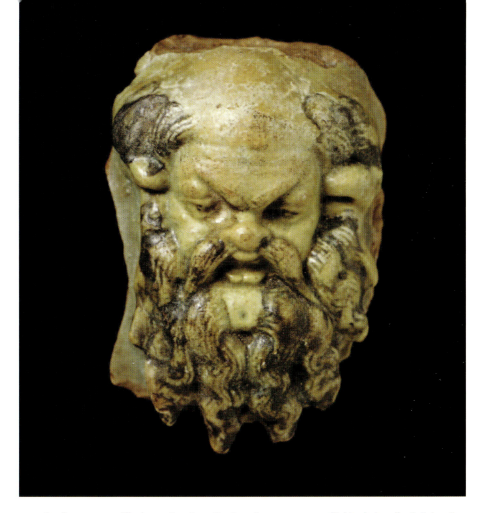

attached was most likely a wine-jug (in Greek, an *oinochoe*), with a satyr mask at the top of the handle and a silenus at the bottom. This style of jug was particular to Alexandria, and many have been found in its ancient cemeteries. Associated with festive, religious occasions, they are known especially in the form of 'royal oinochoai', which were decorated on the body with relief images of Ptolemaic queens. The cult of Dionysus was prominent in Ptolemaic Alexandria, and many decorative themes were derived from its associated imagery.

Remote in time and style from the pharaonic material with which Howard Carter's archaeological career was concerned, this head was once in his private collection of antiquities. 'Carter had an excellent eye for quality and workmanship, particularly in small objects ...', as the equally discerning Egyptologist and curator John D. Cooney observed, and this piece testifies to his connoisseurship.

Flat-backed appliqué of glazed faience, moulded, ht. 5.7 cm; late 4th–first quarter of the 3rd century BC
1960.725: gift of Phyllis Walker, ex Howard Carter collection

62. Mummy of an ibis

Greek and Roman visitors to Egypt were especially struck by the prominence of animals in Egyptian religious cults. Almost all divinities were associated with at least one creature which could be revered as the living manifestation of that god or goddess, and animals in general were considered to be the medium through which a god's vital spirit, his or her *ba*, might manifest itself.

During the Late Period, and especially from the 30th Dynasty onwards, the worship of sacred animals came to play an increasingly prominent part in the cult of all the major deities. These animals were bred and kept within the temple enclosure of their particular god, and when they died (not always of natural causes), they were mummified and wrapped, and perhaps offered as votives in the temple before being buried in a manner similar to that accorded to human deceased. To meet the cost of a sacred animal's embalming and burial was an act of piety.

The scale of this 'temple industry' can be seen in the extensive animal catacombs at Saqqara: underground galleries were filled with the packaged, mummified remains of baboons and ibises, both sacred to Thoth, as well as hawks, dogs, and cats. The largest of the animals to be mummified, bulls and cows, were especially notable in connection with the local cult of the Apis bull and its mother.

The black and white ibis (*Threskiornis aethiopica*), sacred to Thoth, was raised in special enclosures (*ibiotrophia*) mentioned in contemporary papyri. Associated with the moon, Thoth was also revered at Saqqara as the father of the goddess Isis. The mummified bird inside this cocoon of bandages has been given elaborate decorative treatment on the outside, with an appliqué figure of the god himself, bewigged but with a bird head (now missing) and a human body, seated on a block throne and holding an *ankh*-sign and staff. The figure is almost dwarfed by the tall *hemhem*-crown on its head.

The mummy was deposited in the 'Home of Rest of the Ibis', the southern catacomb of these birds at

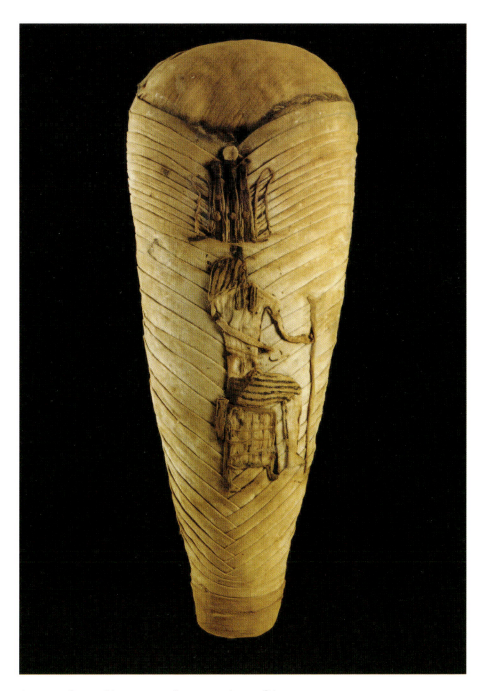

Saqqara, located in an area where members of the early Egyptian elite had been buried more than two thousand years earlier. Under the tomb of a 3rd Dynasty official, the birds lay packed in pottery jars or wooden coffins.

Mummified bird wrapped in linen bandages, decorated with linen appliqués, some details missing; ht. 50 cm. From Saqqara, area 3508–174; Ptolemaic–Roman
1969.486: EES excavations (Emery), given via the Griffith Institute

From the Late Period to the Arab Conquest

63. Shroud for a boy named Nespawtytawy

The multicultural nature of Egyptian society during the Roman Period is reflected in the variety of burial practices adopted then. These show local variations, as well as the intermingling of the two major strands of culture which had been present since the later fourth century BC – indigenous Egyptian and immigrant Greek. Egyptians and Greeks (and other ethnic groups which had settled in Egypt) intermarried, and exchanged aspects of their social life and beliefs; the resulting cultural mix is apparent in personal names and art forms, as well as the complexity of funerary practices. A deceased person's family could choose a number of different ways to express that person's identity in this life, and the way in which they hoped for some continuation of life after death.

The area around the ancient city of Thebes in Upper Egypt, capital of the pharaohs of the New Kingdom and chief cult place of the god Amun, continued to be a centre of traditional religion. This linen shroud is stylistically related to a group of coffins and textiles associated with a family of rank, at least one member of which, a man named Soter, apparently held public office. Laid to rest in Western Thebes, which contained the thriving settlement of Djeme but also ground hallowed by over two thousand years of use for tombs and mortuary temples, these people made a conservative choice for the afterlife.

The hieroglyphic inscription down the centre of this shroud reads: 'I am the cloth of the two goddesses ... my two arms extend to envelop the Osiris Nespawtytawy, forever.' The size of the shroud is less than an adult man's, and the name ('He belongs to [the god] Pawtytawy' ['He of the Two Lands', a name of Amun]) an Egyptian one. The dead boy is represented with the attributes of Osiris, the god of the dead to whom the deceased were assimilated: tall *atef-*crown, beard, regal crook and flail in his hands. His body is covered in the bead network associated with the mummiform god, but a textile decorated in Greek

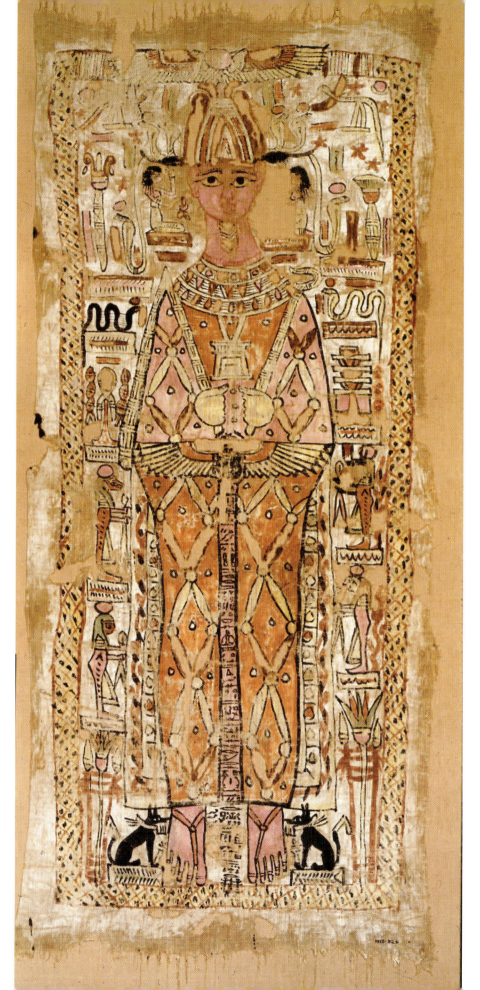

Linen, tabby-weave with warp fringes, the surface painted white and decorated in pink, red, brown, yellow, green, and black pigments, some of which have eroded the textile; ht. 131 cm. Probably from Western Thebes: 2nd century AD
1913.924: gift of Mrs Henry Stobart, acquired in Egypt in the 1850s by the Revd H. Stobart

style is depicted as though hanging behind it.

Shown frontally within a lattice-patterned frame surmounted, door-like, by a winged disk, Nespawtytawy is covered and flanked by symbols to protect him and ensure a proper burial. A shrine-shaped pendant hangs over his chest, and a winged scarab covers his abdomen. Mourning women flank his head, the jackals of Anubis with keys to the afterlife sit at either side of his sandalled feet, and the Four Sons of Horus hold bandages to wrap the body. Around his head is a mélange of symbols derived from the imagery of the underworld and the spells and amulets necessary for the deceased's safe passage through it. The little painted strips which punctuate these images are the last vestige of the traditional hieroglyphic captions which accompanied and explained ritual scenes: the essential writing on these had already begun to disappear from use hundreds of years before this shroud was painted.

64. Portrait of a young man

Only in Egypt have painted portraits survived in quantity, although images comparable to these would have existed throughout the Greek and Roman world in antiquity. They have been preserved by the dry climate, but also because they were used to fulfil a particular Egyptian requirement of funerary beliefs – the preservation of an image of the dead to ensure rebirth and survival in the afterlife. Whereas coffins and masks prepared in the traditional manner depicted faces with no individualized features, these portraits (some of which may have been painted and hung as pictures in the subject's lifetime) are strikingly personal. Like all such 'mummy portraits', this one was placed over the face of the deceased and held there by the linen bandaging which framed the image and swathed the rest of the mummified body in a tight, ornamental covering. The body had been buried in the cemetery which served as the resting-place for the inhabitants of a settlement called Tanis (modern Manashinshana), on the north-eastern side of the Faiyum.

Encaustic paint on a limewood panel, with traces of linen around the damaged edges; ht. 30 cm. From the cemetery at Fag el-Gamus, Faiyum; AD 193–235
1896–1908 E.3755: EEF excavations of 1902 (Grenfell and Hunt)

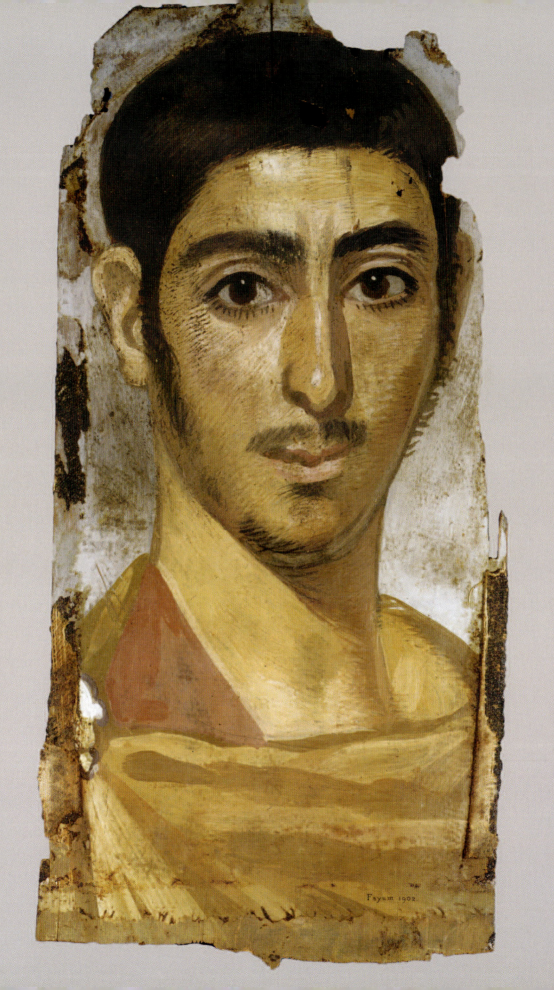

When first recovered from the Roman cemeteries of the Faiyum in the later nineteenth century, these unexpected images, so recognizably close to the aims of portraiture in western art, were received with rapturous enthusiasm. A century and more of further discoveries has shown that they were not confined to the Faiyum but used in burials elsewhere in Egypt from the first to third centuries AD. Detailed comparison with Roman portrait sculpture has placed them in a chronological sequence determined by the subjects' hairstyles, dress, and jewellery. Latterly the focus of study has shifted to questions about the subjects themselves, the beliefs that made them choose this style of burial, and their view of themselves in the mixed Greek and Egyptian society of their time.

The young man in this portrait is wearing the cloak of a soldier, fastened over his right shoulder with a metal fibula. There is no sign of the sword-belt which characterizes several other portraits whose subjects have been identified as military men, but under the cloak he wears a red garment, rather than the usual civilian male attire of a white tunic with a vertical coloured stripe (*clavus*) on either side of the neck opening. His cropped hairstyle places him in the reign of the emperor Septimius Severus, and his wispy beard and light moustache suggest that he has just attained adulthood. The soft, fresh colouring of the picture contributes to a rather wistful impression of youthfulness.

65. Rag doll

In January 1888, W.M.F. Petrie set out for Hawara, at the mouth of the Faiyum, to investigate the pyramid and funerary temple of King Amenemhet III of the 12th Dynasty. In its immediate vicinity he found 'what I did not expect, a great cemetery ... covering perhaps 100 acres'. Over the next four months, and in the following season, his efforts were perforce concentrated on this rather than the pyramid. The cemetery contained burials dating from the Late Period to at least the fourth century AD, and was particularly rich

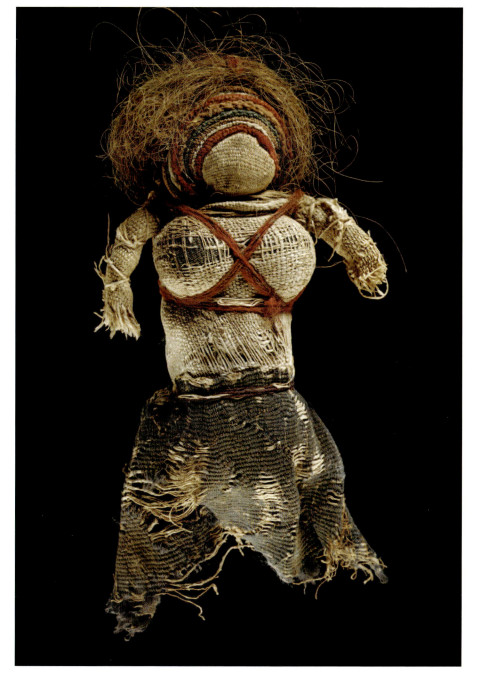

in the 'mummy portraits' which were just then arousing great popular interest in Europe.

Like all ancient cemeteries, this vast field of bodies in the protective lee of a royal pyramid presented poignant evidence of the high rate of infant mortality. Many of the graves contained children's toys, including dolls. This example is of particular interest, since the other grave-goods included a wooden box containing a coin struck for one of the successors of Constantine the Great in the mid-fourth century AD, thus providing a date for the burial and its contents. As

Body and clothing made of plain tabby weave, undyed and dyed, and fragments of tapestry weave in dyed wool and undyed flax, plus human hair and woollen yarn; ht. 16 cm . From Hawara; *c.* AD 350–360
1888.818: *gift of H. M. Kennard, from Petrie's excavations*

in other late Roman burials in Egypt, the body was not mummified, but dressed in everyday clothes – typically, tunics of linen or wool decorated with tapestry-woven roundels and bands, in dark purple or blue. Like most children's clothing, the textiles found in this grave had been reused at least once, and the doll herself demonstrates their ultimate re-use: her body is formed of a rolled-up scrap of tapestry weave, covered in coarse linen, while another tapestry scrap has been used for her skirt. Her arms are made of a roll of undyed linen, secured crossways over the body with red yarn, so as to define an ample bosom, in the manner of the 'body chains' sometimes depicted on statuettes of women.

She has real hair, fixed over a colourful array of strips of cloth which form the bulk of the head, with a face made of finer linen. This 'hairband' perhaps recalls the festive garland on the heads of terracotta figures of women shown seated with legs apart and arms raised in the gesture of prayer. One such was found in this grave, bejewelled but nude, her mature sexuality emphasized by the detailing of breasts and pubis. Akin to the pottery 'fertility figures' of pharaonic Egypt, these statuettes were probably intended to assist both the living and the dead with procreation. When placed in the grave of a child – in this case, certainly a girl – they seem to testify to a belief that those who died young would nonetheless attain adulthood and family life in their next existence.

66. Sin and redemption in a Biblical tapestry

Writing in the fourth century AD, Bishop Asterius of Amaseia in Turkey criticized the misguided piety of Christians who, 'like painted walls', wore clothing decorated with scenes from the Gospels. He might have been especially struck by the ambitious pictorial programme of this roundel, one of a group of red-ground ornaments woven in Egypt several centuries later than his censorious text. They belong to the tradition of tapestry-woven ornaments used to enhance both garments and textiles such as table

cloths and hangings from at least the second century AD on, but in their exuberant use of colour and depiction of Biblical scenes, they are a distinctive product of Christian (Coptic) Egypt.

The best-known textiles of this group show episodes from the story of Joseph, a favourite Old Testament narrative in the Coptic church because of the local interest: Joseph's rise from servitude to the highest office under Pharaoh. These woven versions of the Joseph story have been shown to have a close relationship with illustrated manuscripts produced from the sixth century on. This particular roundel, however, is so far a unique example of scenes selected from the very beginning of the Old Testament – the creation of man (Genesis 2:7). He is shown at the lower left as though being pulled 'from the dust of the

Tapestry-woven roundel in dyed wool and undyed flax; diam. 23 cm. Provenance unknown (Akhmim?); 8th–10th century AD
1892.605: G.J. Chester collection

ground' by the Lord God, who is seated on a throne. At the right, an apprehensive Adam and Eve are firmly expelled from Paradise (a lush background of fruiting trees) by the Creator. Seated above in triumph is Christ, in a mandorla flanked by three unidentified figures, gesturing emphatically towards the saviour of mankind. The scene is completed with hovering angels, a small animal (a lamb, perhaps), and perhaps another angel standing behind God's throne; all remaining space is filled with starry motifs.

Like many of these visually crowded and rather naive depictions in woven textile, the details of the imagery here are quite difficult to make out without reference to similar scenes in wallpaintings and manuscripts – but that fact in itself points to the important interrelationship of these Coptic textiles with the wider world of Byzantine art. The roundel was acquired in Cairo by the Revd Greville Chester, with the information that it came from Akhmim in Middle Egypt, a noted centre of textile weaving from antiquity until the present day.

It was also in this area that such textiles were first discovered, in the cemeteries where Egyptians of the late Roman and Byzantine periods had been buried with their everyday clothing and domestic textiles. The date of manufacture of these red-ground tapestries, none of which has so far come from a dated archaeological context, has been tentatively set in the seventh century AD (the time of the Arab conquest of Egypt) or later. Recently, however, radiocarbon dating of one of the Joseph pieces in a Swiss collection has produced a date range of AD 776–972.

Ancient Nubia

The territory comprising ancient Nubia extends from the First Cataract of the Nile in southern Egypt to the confluence of the Blue and White Niles near Khartoum, in northern Sudan. The Egyptians knew the land between the First and Second Cataracts (Lower Nubia) as 'Wawat'; the territory to the south was the 'Land of Kush'.

Nubia had its own cultures and languages, but also a long history of involvement with Egypt, during which Egyptian rulers exerted intermittent control over varying extents of Nubian territory. Their goal was to secure the trade routes by which luxury products from Africa reached Egypt, and to exploit Nubia's own assets – goldmines, mineral sources, and cattle. These intrusive episodes left a strong Egyptian imprint on some parts of Nubia. In their turn, however, the rulers of the Kingdom of Kush briefly reversed the process, invading Egypt and establishing themselves there as the pharaohs of the 25th Dynasty.

The Ashmolean's Nubian collections, largely derived from the fieldwork initiated and directed by F. Ll. Griffith (pp. xix–xxi), merit a book in their own right. The brief conspectus here provides a complement to the Egyptian section in reflecting Egyptian control of Nubia in the New Kingdom, the achievements of their shared rulers in the 25th Dynasty, and the culture of the Meroitic Period which followed the retreat of the Nubian rulers to the south of their country.

Chronological outline

Approximate dates

	Upper Nubia	Lower Nubia	Egypt
3500–3000	Khartoum Neolithic	A-group	Predynastic, Naqada II
3000–2500	Pre-Kerma	Classic A-group	Early Dynastic, Naqada III
2500–2000	Early Kerma Culture	Early C-group	Old Kingdom–1st Intermediate Period. Expeditions as far as 3rd Cataract
2000–1500	Kerma Culture	C-group	Middle Kingdom and 2nd Intermediate Period. Egyptian border at 2nd Cataract
1500–1069	Egyptian domination	Egyptian domination	New Kingdom. Egyptian border extended as far as 4th Cataract
900–270	Kingdom of Kush, Napatan Period		3rd Intermediate Period and Late Period. Kushite 25th Dynasty (beginning in 747) ruling Egypt, *c.* 715–657
270 BC–AD 350	Kingdom of Kush, Meroitic Period		Ptolemaic Period, Egyptian control re-established as far as 2nd Cataract. Roman Period, frontier set at el-Maharraqa (Hiera Sykaminos) then withdrawn to Aswan
350–543	Post-Meroitic from *c.* 400	X-group: Ballana culture	Byzantine Period
543–1323	Christian Kingdom of Makuria	Nobadia	Byzantine Period

Ancient Egypt and Nubia

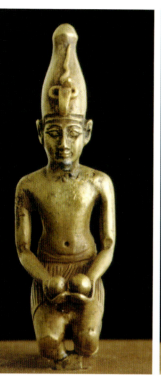 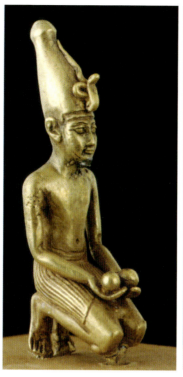 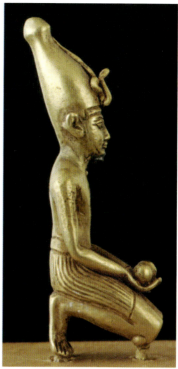 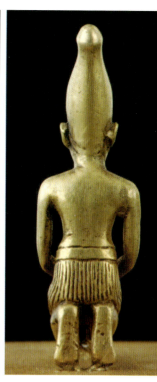

67. King offering wine

This minute but finely-detailed figure is a masterpiece of goldsmithing. The unknown king kneels to present a god with wine, cupping in his hands the globular vessels (*nw*-pots, here represented by simple spheres) containing the liquid. The White Crown of Upper Egypt towers over his head, carrying the rearing cobra which protects the royal person, its body looped behind the hood, then snaking to a point just below the bulbous end of the crown. The king's face is outlined with the straps to which a false beard was attached, but the beard itself is now lost, only a stump remaining, of different colour to the rest of the metal. Slim and straight-backed, the king is modelled as a lithe figure, his long feet with toes poised as though he is ready to spring up at the completion of the ritual. The small tangs under his knees and feet show that he was fixed on to something else, perhaps a base on which he faced an image of the divinity to whom he was offering wine.

The figure was found in the temple of Amun-Re at Kawa dating to the reign of Tutankhamun, at the end of the 18th Dynasty. It was lying on débris in a room on

Electrum, solid cast, details cold tooled, uraeus and jars added separately; ht. 2.8 cm. From Temple A at Kawa; New Kingdom, 19th Dynasty. *c.* 1292–1190 BC
1931.480: OU Excavations in Nubia (Griffith)

the east side of the sanctuary, seemingly dropped there by robbers or plunderers. Despite its golden colouring, the metal is in fact the gold-silver alloy electrum.

There are many surviving depictions of specific New Kingdom rulers, from Amenophis I to Ramesses IX, kneeling to perform the wine-offering. The style of this one suggests that the king here represented might be a ruler later than the time of the temple's construction – perhaps a pharaoh of the 19th Dynasty, during which time the name of Tutankhamun was replaced on some of the inscribed temple columns with those of Ramesses II and IV.

The block illustrated below, also from Tutankhamun's temple, is inscribed with the king's prenomen, Nebkheprure, written in a cartouche in the inscription at the right. Carved in sunk relief, it shows an official named Satepatenkhay, Superintendent of the Southern Lands, presenting a sacrificial bull. At this time, the site was called *Gempaten* ('The Aten is perceived'), a name compounded with that of the Aten sun-disk. The last traces of the cult of the Aten introduced by Akhenaten (40) were eradicated with Tutankhamun's accession to the throne; in the subsequent restoration of orthodox religion, the cult of Amun assumed its dominant position. References to the Aten were systematically hacked out of the monuments of Egypt – but this remote Nubian place kept its 'heretical' name for centuries to come.

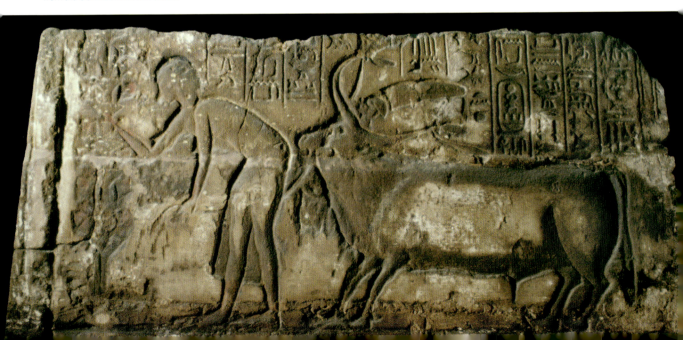

Sandstone block carved in sunk relief; 53 x 121cm. From Temple A at Kawa, *c.* 1333–1323 BC; subsequently incorporated in a wall of Temple T, plastered over and ultimately damaged by fire 1931.552: gift of F. Ll. Griffith, from the OU Excavations in Nubia

68. Ram of Amun

Six hundred years after the building of Tutankhamun's temple at Kawa, the site was revivified by the pharaoh Taharqa (reigning 690–664 BC). He was the last but one of the Nubian kings of the 25th Dynasty who ruled over Egypt as well as the Kingdom of Kush. Passing through Kawa on his way north to Thebes in the sixth year of his reign, he noted the ruined state of the sand-filled temple, and expressed the wish 'to rebuild the temple of my father Amun-Re of Gempaten, since it was built (only) of brick and covered over with soil, a thing not pleasant in the opinion of men'. This resolve was recorded on a stela subsequently placed in his new temple, completed in the tenth year of his reign.

Amun was the chief divinity worshipped by the Kushite rulers, and the imagery derived from his manifestation as a ram is everywhere apparent in their

Statue and plinth of granite gneiss, cracked in antiquity; l. 1.56 m. From Temple T at Kawa; c. 680 BC
1931.553: acquired from the OU Excavations in Nubia with the assistance of the Art Fund (NACF)

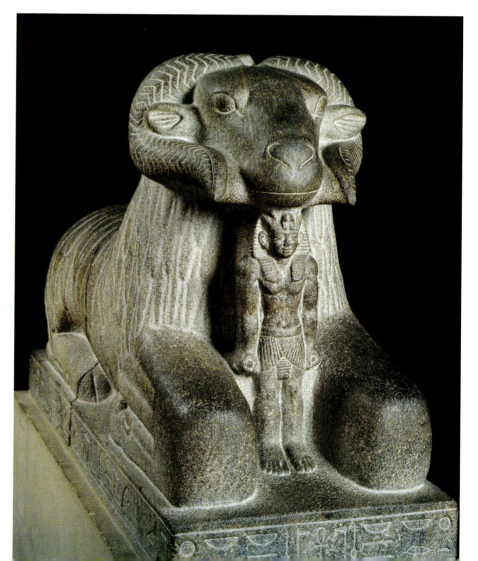

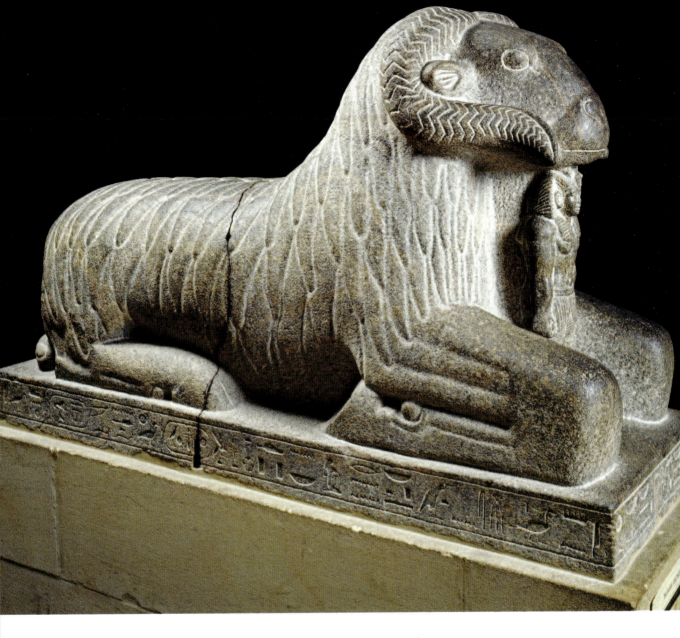

buildings and royal accoutrements. In Taharqa's temple, paired rams guarded the significant thresholds: two pairs stood outside the entrance pylon, and a pair flanked the doorway from the forecourt to the hypostyle hall. This is the ram that stood on the south side of the entrance to the hypostyle hall; its companion on the north is in Khartoum.

The life-sized ram sits with a figure of Taharqa, childlike in relation to the animal's bulk, symbolically placed under its divine protection. The little king, his limbs heavy in proportion to the slim body, stands calm and static under the ram's head and between its

folded forelegs. Carved almost three-quarters in the round, the king's figure is completed by the back profile incised in outline on the 'negative space' created by the stone left under the animal's head.

This type of statue was long familiar in the ram-sphinx avenue which preceded the great temple of Amun at Karnak in Egypt, but the Kushite version has its own distinctive qualities, combining stylization with naturalism: the texture of the ram's horns and woolly coat are suggested by pattern-like carving, the long forelegs are block-like, their musculature suggested in geometric fashion, yet the face is quite straightforwardly sheep-like. The hard stone used for the statue – the granite gneiss quarried at Tumbos, near the Third Cataract of the Nile – was an admirable medium for the crisp carving of hieroglyphic inscriptions: an identical text on both sides of the ram's base expresses the wish for life for '… the good god, Lord of the Two Lands, lord of [doing things], the son of Amun … Taharqa'. The inscriptions begin with the *ankh*-sign for 'life' placed directly under the image of the king.

Two sculpted feet orientated towards the temple were found in front of the ram at the north side of the doorway, implying that worshippers who would not be able to enter the temple proper could at least have advanced as far as the forecourt. There they dedicated these symbols of their presence before the king who would mediate on their behalf with his protector, the god Amun.

Dark-brown quartzite, ht. 33.6 cm. From the temple of Amun at Sanam; 25th Dynasty, c. 664–657 BC
1922.157: OU Excavations in Nubia (Griffith)

69. The god Amun

The head of a half life-size statue, this shows Amun wearing his typical headdress of a flat-topped cap surmounted by two tall plumes and a solar disk. The inscribed back-pillar, rounded like a stela at the top, is carved in hieroglyphs with the beginning of the titles of Tantamani, last king of the 25th Dynasty, and the last Kushite to rule Egypt as well as Nubia. His Horus name, *Wah-merwt*, is written in a *serekh* – the rectangular frame incorporating a palace façade, here depicted with a pair of bolted doors, in the lower part. During his reign, Tantamani was forced to retreat southwards by the invading Assyrians acting in conjunction with the Saite ruler Psamtik, who subsequently ruled as Psamtik I of the 26th Dynasty of Egypt.

(*opposite*) Hollow-cast bronze, distorted by burning, repaired and set on a modern base; ht. 29.5 cm excl. tang. From Temple T at Kawa: 25th–26th Dynasty, c. 715–525 BC
1932.773: OU Excavations in Nubia (Griffith)

The Kushites' patron god is here shown in a conventionally serene and timeless image, remote from the political and military troubles of the dynasty. The high surface polish given to the hard stone is typical of the period; more unusual is the depiction of the pupils of the eyes in slightly raised relief, giving the divine face a watchful aspect. The statue was found in the temple of Amun built by Tantamani's predecessor, Taharqa, at Sanam; the site lay across the river from Napata, the capital of the Kushite kings which was sacked by Psamtik II in 591 BC.

70. The goddess Isis

Despite its damaged and imperfect state of preservation, this elegant figure exemplifies the style set by representations of goddesses and queens of the 25th Dynasty: the sensuous shaping of the body, with its full, rounded breasts, narrow waist, and rounded belly, enhanced by the figure's attenuated height. The goddess's face is broad and rounded, framed by her wig. A hole in the top of the head would have held a separately-made headdress, and a smaller one above her forehead would have held the two cobras (double uraei) whose tails can be seen at the back of the wig. The thin plinth on which she stands has a tapering tang below, which would have secured the statuette to a larger base, possibly made of wood.

The figure was one of about 100 bronzes found lying in two heaps in a layer of ash in the hypostyle hall of Taharqa's temple. All had suffered some damage from fire, and it is likely that they met their fate when the temple was sacked and burnt in the third century AD. The goddess Isis was greatly revered by the people of Nubia until late antiquity. The earliest blocks of her temple on the island of Philae date to Taharqa's reign, and graffiti in Meroitic on its walls testify to the visits of Nubian pilgrims. This sacred site at the border between Egypt and Nubia was the last outpost of her worship, until the suppression of pagan cults there under the Emperor Justinian in the sixth century AD.

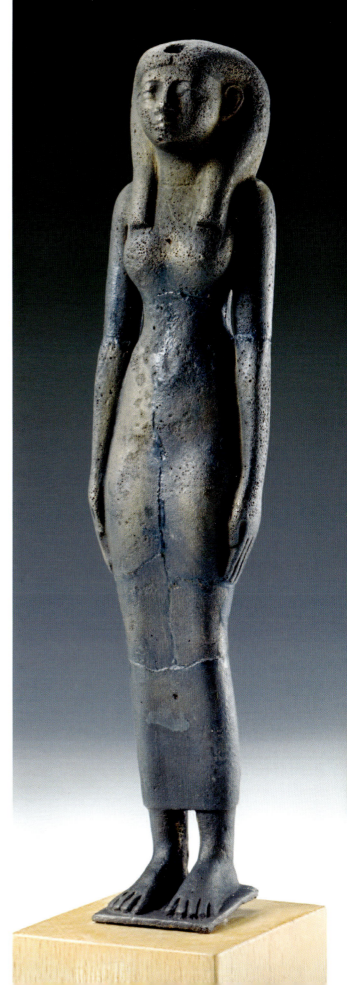

Glazed faience, incomplete; ht. 8.2 cm. From Temple T at Kawa: 25th Dynasty, *c.* 747–657 BC
1932.736: OU Excavations in Nubia (Griffith)

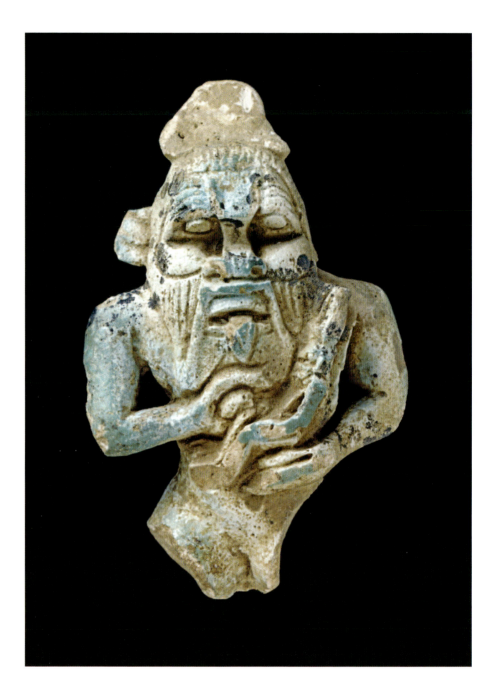

71. Bes nursing a new-born child

Dwarfish in form but wearing a ferocious lion-mask, Bes was the god who looked after both divine and mortal children and their mothers, especially at the time of birth. He was also associated with music and dancing, and his prancing figure, playing a variety of musical instruments, is carved on the walls of the 'birth-houses' (*mammisi*) attached to the great temples, where the arrival of the divine child was

celebrated. This figure seems to have been made as a large Bes-pendant which would serve as a protective amulet: there is a suspension loop at the top, behind the broken surface from which the god's feather headdress has been lost. Other Bes-figures found, like this one, in temples, may have served as ritual percussion instruments, threaded with pieces of metal and fitted with a handle: the music and dancing of Bes warded off harm as a child was being born. Either as an amuletic statuette or a sistrum-like instrument, these Bes-images could have been deposited as votive offerings from women hoping to ensure a safe delivery and a healthy child, or they may have played a part in temple birth-rituals.

In this figure, the crudely linear modelling of the features of Bes and the child he holds intensifies the contrast between his savage appearance and the protection and nurture which he was thought to extend to children. Below the rigid locks of his mane and his protruding tongue, his right hand cups an ovoid object, suggesting a piece of fruit or a dom-palm nut being proffered to the child – but the gesture is also reminiscent of the way a lactating mother cups her breast to feed a baby. The divine child he holds, seated stiffly in the crook of his arm, is usually identified as the infant Horus, or a Bes-child: the modelling of this one suggests the latter.

72. Swimming girl

Spoons for use with perfumed ointments or liquids were often made in the shape of beautiful swimming girls. Most of them have been found in funerary contexts, where it has been suggested that they had some specific use – perhaps for dispensing myrrh or wine in the last rites for the deceased. This example came from the grave of an adult whose head was resting on an ivory headrest; amongst the other grave good were amulets, pottery vessels, and an alabastron (a cylindrical stone container for perfume).

This smiling Nubian swimmer, proffering a rectangular receptacle, is particularly alluring, with her curvaceous figure and thick bunch of hair held by a

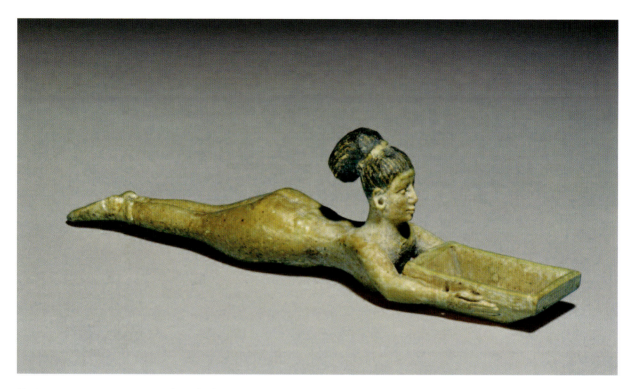

Modelled in glazed faience, with details in black; l. 11 cm. From Sanam, grave 963; 25th Dynasty, c. 747–657 BC
1921.735: OU Excavations in Nubia (Griffith, 1912–13 season)

band. She wears anklets (modelled in relief), and her ears are pierced to take earrings; small holes between the inner side of her wrists and the receptacle seem to have served for the attachment of bracelets in some unknown material, which has left her wrists marked with lighter-coloured bands.

73. Bronze mirror-cover

Ancient Egyptian mirrors typically consisted of a polished disk of copper or bronze, fitted with a handle; this type was known in Nubia also, from the early C-group culture onwards. Essential aids to grooming, mirrors were often placed in women's graves, along with related cosmetic implements. In Hellenistic times, Greek-style folding mirrors came into use. In these the polished reflective surface of the disk was protected with a hinged cover. This is a particularly elaborate example of such a cover, and it was found, with its mirror disk, in the grave of a man, together with three bronze vessels – perhaps the value of the metal vessels, or the deceased's lifetime occupation as a craftsman, was the reason for this deposit.

Cast bronze with incised decoration, applied bust cast in relief, handle made separately and riveted to circumference; diam. 19.4 cm, excl. handle. From Faras, grave 2589; 1st century BC–1st century AD
1912.460: OU Excavations in Nubia (Griffith)

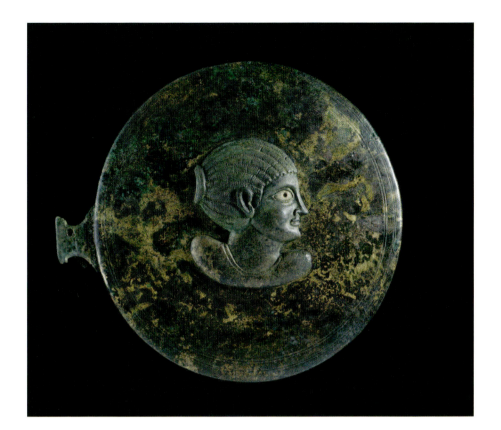

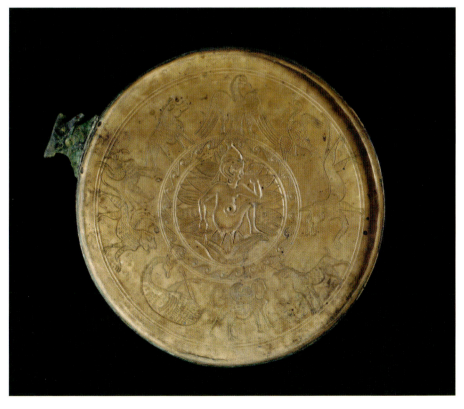

The outside of the cover is decorated in relief with the bust of a woman, her hair dressed in the Hellenistic 'melon style' finished with a chignon at the back. She faces right, away from the hinge; her unnaturally large eye is shown almost in frontal view, the white inlaid in stone, and the pupil hollowed for a dark inlay, now lost. The hatched band around her neck might represent a chain necklace, or the neckline of her garment, the folds of which are faintly incised on her shoulder. The bust has been cast separately and applied to the cover: on the interior, the fixing point has become the navel of a central figure shown in shallow relief within a circular design which has been incised and punched.

The central figure is an infant sun-god seated on a lotus flower, and surrounded by lotus petals and sepals. Of the several divinities who may be shown in this guise, Harpocrates (Horus-the-child) is the most common from the Ptolemaic Period on. Finger to mouth and with the sidelock of hair denoting his childish state, he would normally wear the Double Crown of the Egyptian king who was his adult manifestation. His cap-like headgear here, however, is different – perhaps the White Crown only, with a streamer falling behind. It seems almost like an afterthought of the metalsmith, who has tooled the outline quite deeply over the inner border of the frame which surrounds the god. The bulbous end of the headdress extends almost to the outer border.

Outside this decorous frame is a wilder world inhabited by nine birds and beasts, some mythical, some real. The mixture of creatures is reminiscent of the protective beings shown on the ivory 'magic wands' carved many centuries earlier in Egypt, but their forms are completely foreign to pharaonic Egyptian imagery and mostly untypical of Greek, too. The composition is reminiscent of circular zodiacs where the twelve signs are arranged around a central solar divinity. The mirror's place and date of manufacture are as enigmatic as its decoration: the rather naive style of the designs on both sides suggests that it was perhaps a local product, somewhat later than the Hellenistic type of mirror which it was copying.

74. Head of a *ba*-statue

In Egyptian funerary belief, the spirit thought to remain after a person's death was conceived as twofold: the dead person's *ka*, a double that remained in the tomb, and the *ba* that was free to travel abroad from the tomb during daytime, and was expressed in the image of a human head on the body of a bird. This concept was manifested in the later cemeteries of northern Nubia, where statues of the deceased as *ba*-birds were set upon their tombs or in the tomb-chapels. The facial features sometimes reflected those of the tomb-owner; the body was that of a bird with folded wings, but the feet were human and shod in sandals (typical lifetime footwear, but equally important for travelling in the next life).

The yellow paint on this head indicates a fair-haired Kushite, and the curving hairline suggests a woman. Indeed, the general aspect of this oval face is pleasantly curvaceous, beginning with the arched brows and finishing with the upturned mouth, giving it an

Grey sandstone painted in red-brown and yellow; ht. 15 cm. From Faras, cemetery 1, grave 2502: 1st–3rd century AD
1912.456 : OU Excavations in Nubia (Griffith)

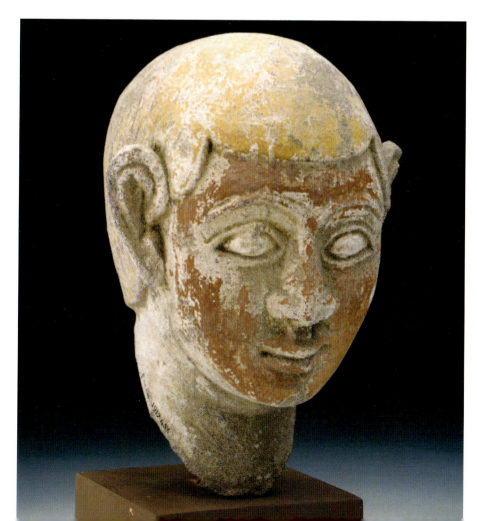

appealingly quizzical but contented aspect. There is a hole in the top of the head into which a sun-disk would have been fitted.

75. Crocodile and companion bird

This cup was found lying in the rubbish above a grave. Thin-walled and precisely shaped, it is typical of the fine pottery made in Nubia, in a ceramic tradition which lasted for more than five millennia, and belonged to several different cultures. The craft of hand-made pottery, which was dying out in Egypt even before the end of the prehistoric period, continued in Nubia for another millennium and a half. Even with the advent of wheel-made wares, such as this cup, Nubian pottery remained outstanding for its technical quality and lively decoration.

The decorated surface of the cup is occupied by two crocodiles, each with a companion bird standing on its tail – a Nilotic scene probably observed from life. Several kinds of bird interact peacefully with crocodiles in this way, picking parasites off their skin and even, in some cases, entering their mouths – a phenomenon recorded with amazement by classical authors. Of the various species which may co-exist with the crocodile in this way, the bird depicted here may be the Egyptian goose (*chenalopex Aegyptiacus*).

Nile silt, wheel-turned, with a white wash and painted decoration applied before firing; ht 8.7cm. From Faras, cemetery 1, grave 1063Z: 2nd–3rd century AD
1912.401: OU Excavations in Nubia (Griffith)

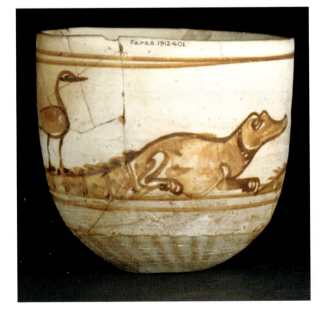

76. Dove lamp

Seen as the messenger of peace, symbol of the Holy Spirit, or the righteous soul released into eternity, the dove is one of the most familiar images of Christian art. In late antiquity, it was one of several birds, including the peacock, whose form was used for metal lamps, with the body serving as the receptacle for oil, and the tail containing a single or double wick-hole. This plump dove is a particularly fine example of the type, its head turned a little to the right, beak open, and feathers depicted in detailed incised work. The filler-hole in the centre of the back is covered with a hinged triangular lid, around which are the rings holding three suspension chains held on a large ring above. The lamp could be used hanging or standing: in addition to its two firmly planted feet, it has a third 'leg' at the back which keeps the heavy body stable. A fourth chain attached to the large ring ends in a forking, bent plate of metal (not shown in the picture) which had apparently served as a suspension-hook.

Some dove lamps have been found in clearly Christian contexts: one was excavated in the Coptic church at Medinet Habu, in Western Thebes. They were probably also of secular use, and this one certainly had no Christian connection in its latter context, at any rate. It was found in the undisturbed earth of one of the large tumuli in the cemetery at Firka. These mounds were the superstructures of multi-chambered tombs cut into the ground beneath, almost all of them plundered in antiquity by robbers who tunnelled through the base of the mounds. The people buried in these conspicuous tombs were elite members of Lower Nubian society during the period which saw the final fragmentation of the Kushite empire. They were richly supplied with grave-goods, and accompanied by humans and animals who had been ritually sacrificed. This plundered tomb was dated by its excavator to the fifth or early sixth century, although the dove lamp itself seems to be of a type datable about a century earlier. Two separate chambers in the tomb contained the bodies of a woman and two young girls.

Cast bronze with incised details and added chains; l. of bird 14.5 cm. From tomb A12, Firka; X-group, late 4th century AD
1935.488: OU Excavations in Nubia (Kirwan)

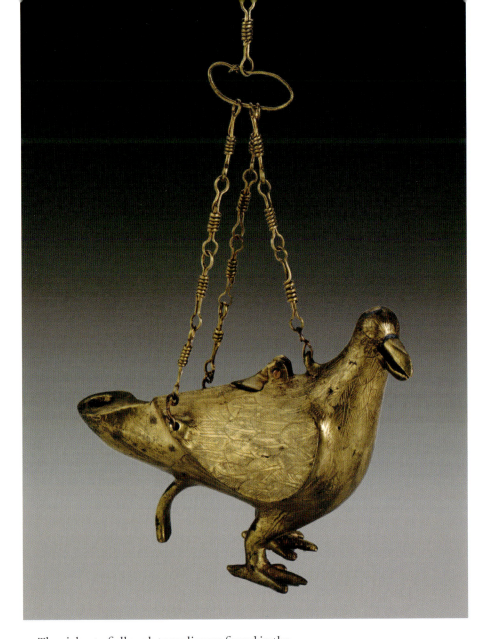

The richest of all such tumuli were found in the royal cemeteries of Ballana and Qustul. Tomb 14 at Qustul contained a dove lamp similar to this one, found in front of a wall blocking the burial chamber, and a Christian reliquary and spoons were found at Ballana. The official conversion of Nubia to Christianity did not take place until the mid-sixth century, and objects such as these found in earlier contexts were probably valued simply as prestigious items of metalwork. They may well have come from Upper Egypt as gifts or imports over the frontier at Aswan.

Glossary

BSAE The British School of Archaeology in Egypt, the body created by W.M. F. Petrie in 1906 to promote fieldwork in Egypt.

Book of the Dead Modern name for the collection of spells to help the dead in the underworld; supplied as an item of funerary equipment from the New Kingdom on, in the form of a papyrus roll with illustrated texts. The compilation was drawn from the earlier Pyramid Texts, created for royal use, and the Coffin Texts of the Middle Kingdom.

Cartouche French word for an ornamental panel bearing an inscription; in Egyptology, applied to the frame in which the two most important of the five names of an Egyptian king were written – the name he assumed on becoming king, and his birth name. Depicted as a rectangle with rounded corners, made of a double rope tied at one short end, the device expressed the idea that the Egyptian king ruled over everything encircled by the sun. The earliest surviving cartouche dates to the 3rd Dynasty.

Coptic The language and culture of Christian Egypt from the third century AD on; the Coptic language was the last form of Egyptian, written with the Greek alphabet plus seven additional letters derived from Demotic. The term Coptic (derived from *Aiguptos*, the Greek name for Egypt) is also applied to the historical period corresponding to the Byzantine elsewhere. It ended in Egypt with the Arab invasion of AD 641, after which Arabic gradually became the primary language.

Demotic The form of spoken Egyptian and the cursive script in use from the seventh century BC on, gradually supplanted by Greek and Coptic.

Dynasty An ordered succession of kings (not always blood relatives) forming a 'family'. The traditional division of the rulers of Egypt into 30 dynasties is based on the scheme used by the Egyptian priest Manetho for his history of Egypt, written early in the third century BC.

EEF The Egypt Exploration Fund, founded in 1882 (known since 1919 as the Egypt Exploration Society, EES); the principal British body active in Egyptian archaeology.

ERA The Egyptian Research Account, created by Petrie in 1893 to fund his excavations and assistants.

Faience Glazed ceramic medium with a body of silica (sand or crushed quartz), mixed with soda (plant ash or 'natrun') and lime, and fired at about 800° C; most usually coloured blue-green through the addition of copper to the glaze. The core material could be modelled, moulded, or (rarely) wheel-turned. The name was borrowed from the French term for the kind of glazed earthenware first produced in Faenza during the Renaissance. Glazed pottery was not produced in ancient Egypt.

Fibula Clasp or brooch fastened like a safety-pin.

Haematite Iron ore; in the form of a dark, metallic stone, used to make beads and amulets; in its red-brown form, ground to make pigment (red ochre).

Hieratic The cursive form of Egyptian writing derived from hieroglyphic signs and used for written communications from early in the Dynastic Period to the seventh century BC, when it was supplanted by Demotic for all except religious texts. The hieroglyphic script was reserved for monumental display, most typically carved in stone.

Hypostyle Covered temple court with many columns, lit by a clerestory; usually the first enclosed space in a typical temple layout, accessed only by temple personnel and the ruler.

Intermediate Period Phase of Egyptian history when central control weakened and the unified dynastic structure broke down. Three such phases have been identified, following the periods of stability named the Old, Middle, and New Kingdoms.

Mastaba Arabic word for a low brick-built bench outside a house, used to describe the similarly-shaped brick superstructure of some tombs. The typical shape of the royal tombs of the Early Dynastic Period, thereafter used for private tombs.

Ostracon A piece of pottery or limestone used as a writing surface; from the Greek word for a potsherd (plural, ostraca).

Serekh The earliest type of frame used to distinguish the royal name in writing: a rectangle surmounted by the Horus falcon, with the name written in the space above a depiction of a palace façade. It continued to be used for the king's 'Horus name' after the introduction of the cartouche (see above) for the two principal royal names of the five which formed the full title of an Egyptian king.

Shabti (variants: shawabti, ushabti) Statuette intended to work on behalf of a dead person when they were called upon to do manual labour in the afterlife; usually in mummy form, inscribed with the deceased person's name, and spell 5 from the Book of the Dead, to activate the shabti.

Sistrum Musical instrument similar to a rattle, used in the worship of the goddess Hathor.

Stela Inscribed slab of stone or wood, usually with a rounded top; placed in a temple (with a dedicatory or documentary inscription), or in a tomb (with an inscription naming the dead person and invoking offerings for them).

Further reading

General background

J. Baines and J. Malek, *Ancient Egypt. A Cultural Topography* (revised edn, Oxford, 2000)

W.R. Dawson and E.P. Uphill, *Who was Who in Egyptology* (3rd rev. edn by M.L Bierbrier, London, 1995)

G. Hart, *The Routledge Dictionary of Egyptian Gods and Goddesses* (London, 2005)

B.J. Kemp, *Ancient Egypt. Anatomy of a Civilization* (2nd edn, London, 2006)

P. Nicholson and I. Shaw (eds), *Ancient Egyptian Materials and Technology* (Cambridge, 2000)

R.B. Parkinson, *The Tale of Sinuhe and Other Ancient Egyptian Poems, 1940–1640* (Oxford, 1998)

G. Robins, *The Art of Ancient Egypt* (London, 1997)

I. Shaw (ed.), *The Oxford History of Ancient Egypt* (Oxford, 2000)

The Shire Egyptology series (Princes Risborough) provides short introductions to many aspects of Ancient Egypt.

The lists below suggest further reading with particular reference to the objects described in this book. For two of the most familiar products of Egyptian material culture – pottery and faience – see:

J. Bourriau, *Umm el-Ga'ab. Pottery from the Nile Valley before the Arab Conquest* (Fitzwilliam Museum, Cambridge, 1981)

F.D. Friedman (ed.), *Gifts of the Nile. Ancient Egyptian Faience* (Rhode Island School of Design, 1998)

Identifications of animals and birds are based on the information in:

P.F. Houlihan and S.M. Goodman, *The Birds of Ancient Egypt* (Warminster, 1986)

D.J. Osborn with J. Osbornová, *The Mammals of Ancient Egypt* (Warminster, 1998)

1–24 The Predynastic and Early Dynastic Periods: J.C. Payne, *Catalogue of the Predynastic Egyptian Collection in the Ashmolean Museum* (repr. with addenda, Oxford, 2000); K.M. Ciałowicz, *La naissance d'un royaume. L'Egypte dès la période prédynastique à la fin de la 1ère dynastie* (Krakow, 2001); D. Wengrow, *The Archaeology of Early Egypt. Social Transformations in North East Africa, 10,000 to 2650 BC* (Cambridge, 2006)

With reference to specific objects/topics:

3: (flint tools) D.A. Stocks, *Experiments in Egyptian Archaeology. Stoneworking Technology in Ancient Egypt* (London, 2003). **4:** E.S. Hall, *The Pharaoh Smites his Enemies* (Munich, 1986). **5:** T. Phillips (ed.), *Africa. The Art of a Continent* (Royal Academy of Arts, London, 1996), 60, 192–3. **7:** M. Baba and M. Saito, Experimental studies on the firing methods of Black-topped pottery in Predynastic Egypt, in S. Hendrickx et al. (eds), *Egypt at its Origins. Studies in Memory of Barbara Adams* (Leuven, 2004), 575–89. **9:** T. Kendall, in I.L. Finkel (ed.), *Ancient Board Games in Perspective* (London, 2007), 33–45. **11:** N. Harrington, in K. Kroeper et al. (eds), *Archaeology of Early Northeastern Africa* (Poznan, 2006), 659–70; The Jagiellonian University Museum, *Ivory and Gold. Beginnings of the Egyptian Art* (exhibition with catalogue, Krakow, 2007). **12–17, 20:** J.E. Quibell, *Hierakonpolis, Part I* (London, 1900); id. and F.W. Green, *Hierakonpolis, Part II* (London, 1902); current excavations at the site are reported in *Nekhen News*, published annually for The Friends of Nekhen; see also www.hierakonpolis.org. **16:** B. Adams, *Ancient*

Hierakonpolis (Warminster, 1974). **17:** E. Porada, in *Iranica Antiqua* 15 (1980), 175–81. **23:** Z. Hawass, *Hidden Treasures of the Egyptian Museum* (Cairo, 2002), 4 (the Manshiat Ezzat spoon).

25–54 Dynastic Egypt: *Egyptian Art in the Age of the Pyramids* (Metropolitan Museum of Art, New York, 1999); J. Bourriau (ed.), *Pharaohs and Mortals. Egyptian Art in the Middle Kingdom* (Cambridge, 1988); *Egypt's Golden Age: The Art of Living in the New Kingdom 1558–1085 BC* (Museum of Fine Arts, Boston, 1982); C. Aldred, *Jewels of the Pharaohs* (London, 1971)

With reference to specific objects/topics:

27: J. C. Harvey, *Wooden Statues of the Old Kingdom: A Typological Study* (Leiden, 2001). **29:** H. Frankfort, in *Journal of Egyptian Archaeology* 14 (1928), 239. **33:** W. Decker, *Sports and Games of Ancient Egypt* (New Haven and London, 1992). **39:** M.A. Littauer and J.H. Crouwel, *Chariots and Related Equipment from the Tomb of Tutankhamun* (Oxford, 1985); B.J. Sandor, in *Oxford Journal of Archaeology* 23 (2004), 153–75. **40–42:** C. Aldred, *Akhenaten and Nefertiti* (Brooklyn Museum of Art, 1973); D. Arnold et al., *The Royal Women of Amarna* (Metropolitan Museum of Art, New York, 1996). **43.** C.A. Hope, in *Cahiers de la Céramique Égyptienne*, 2 (1991), 17–92. **44:** G. Robins, *Women in Ancient Egypt* (London, 1993). **47:** E. Frood, *Biographical Texts from Rammessid Egypt* (Atlanta, 2007), 192–5. **48:** J. Malek, *The Cat in Ancient Egypt* (rev. edn, London, 2006). **49:** D. van der Plas, *L'Hymne au Crue du Nil* (Leiden, 1986). **50–51:** A. McDowell, *Village Life in Ancient Egypt. Laundry Lists and Love Songs* (Oxford, 1999); W.H. Peck and J. Ross, *Drawings from Ancient Egypt* (London, 1978).

55–66 Ptolemaic, Roman, and Byzantine Egypt: R. Bianchi (ed.), *Cleopatra's Egypt. Age of the Ptolemies* (The Brooklyn Museum, 1988); H. Willems and W. Clarysse, *Les Empereurs du Nil* (Leuven, 2000); F. R. Friedman, *Beyond the Pharaohs. Egypt and the Copts in the 2nd to 7th Centuries A.D.* (Rhode Island School of Design, 1989)

With reference to specific objects/topics:

55: C. Andrews, *Amulets of Ancient Egypt* (London, 1994); G. Pinch, *Magic in Ancient Egypt* (London, 1994). **56:** R.O. Faulkner, ed. C. Andrews, *The Ancient Egyptian Book of the Dead* (revised edn, London, 1985); E. Hornung, trans. D. Lorton, *The Ancient Egyptian Books of the Afterlife* (Ithaca and London, 1999). **58:** J. Malek, in *The Ashmolean* 4 (Christmas 1983–Easter 1984), 12–13. **59:** P.E. Stanwick, *Portraits of the Ptolemies. Greek Kings as Egyptian Pharaohs* (Austin, Texas, 2002); N.S. Tomoum, *The Sculptors' Models of the Late and Ptolemaic Periods* (Cairo, 2005). **60:** M. Pfrommer, *Studien zu alexandrinischer und grossgriechischer Toreutik frühhellenistischer Zeit* (Berlin, 1987). **62:** S. Ikram (ed.), *Divine Creatures: Animal Mummies in Ancient Egypt* (Cairo, 2005). **63:** C. Riggs, *The Beautiful Burial in Roman Egypt. Art, Identity, and Funerary Religion* (Oxford, 2005). **64:** E. Doxiadis, *The Mysterious Fayum Portraits. Faces from Ancient Egypt* (repr. with revisions, London, 1996); S. Walker and M. Bierbrier (eds), *Ancient Faces. Mummy Portraits from Roman Egypt* (London, 1997). **66:** H. Whitehouse, in C. Eyre et al. (eds), *The Unbroken Reed. Studies in the Culture and Heritage of Ancient Egypt in Honour of A.F. Shore* (London, 1994), 379–90.

67–76 Ancient Nubia: D. Welsby, *The Kingdom of Kush* (London, 1996); D.A. Welsby and J.R. Anderson (eds), *Sudan. Ancient Treasures* (British Museum, 2004); S. Wenig et al., *Africa in Antiquity. The Arts of Ancient Nubia and the Sudan* (two volumes, The Brooklyn Museum, 1978)

With reference to specific objects/topics:

67–8: M. Macadam, *The Temples of Kawa, II. History and Archaeology of the Site* (two vols, Oxford, 1955); L. Török, *The Image of the Ordered World in Ancient Nubian Art* (Leiden, 2002). **71:** J. Bulté, *Talismans égyptiens d'heureuse maternité. Faïence bleu-vert à pois foncés* (Paris, 1991). **73:** I. Hofmann, in H. Altenmüller and R. Germer (eds), *Miscellanea Aegyptologica. Wolfgang Helck zum 75. Geburtstag* (Hamburg, 1989), 97–118